778.2 STE

D1398982

SLIDE
SHOWMANSHIP

778.2 STE

SLIDE
SHOWMANSHIP

ELINOR STECKER

AMPHOTO
An Imprint of Watson-Guptill Publications/New York

Elinor Stecker is a freelance photographer and Associate Editor of *Popular Photography*. She has written on photography for other publications as well, including *The New York Times, The Journal of the Society of Motion Picture and Television Engineers,* and *Time.* Stecker also writes on creating and using audiovisual materials for many popular and trade magazines and has a monthly column on that subject in *Meetings and Conventions* magazine. Her books include *How to Create and Use High-Contrast Images*.

Editorial concept by Marisa Bulzone
Edited by Liz Harvey
Graphic production by Hector Campbell

Each of the photographs and illustrations appearing in this book is copyrighted in the name of the individual photographers or artists. The rights remain in their possessions.
Copyright © 1987 by Elinor Stecker

First published 1987 in New York by AMPHOTO,
an imprint of Watson-Guptill Publications,
a division of Billboard Publications, Inc.,
1515 Broadway, New York, NY 10036

Library of Congress Cataloging-in-Publication Data
Stecker, Elinor.
 Slide showmanship.
 Includes index.
 1. Slides (Photography) I. Title.
TR505.S74 1987 778.2 87-14525
ISBN 0-8174-5879-4
ISBN 0-8174-5880-8 (pbk.)

All rights reserved. No part of this publication may be reproduced or used in any form or by any means—graphic, electronic, or mechanical, including photocopying, recording, taping, or information storage and retrieval systems—without written permission of the publisher.

Manufactured in Japan

1 2 3 4 5 6 7 8 9/92 91 90 89 88 87

No book is created by the efforts of just one person. This manual has been enhanced by the contributions of knowledgeable people and talented photographers. For their help and advice, I thank Robert Beeler and Edward Howell of Eastman Kodak Company and John Stokes of Stokes Slide Services. For sharing their photographs and artwork, I thank Leslie Appel, Harvey Augenbraun, Karen Brogno, Michael Fowler, Tony Gagliano, Tony Gezirjian, Jack Hollingsworth, Stephan Jacob, Walter Maimborg, Robert Mayer, Rusty Russell, Charles Seton, Carolyn Livingston, and Jeanne Whitney. Thanks, too, to my willing models and to the manufacturers who provided me with pictures of their products. And a special thanks to my daughter, Jan Perrin, for her line drawings and illustrations.

This book is dedicated to Beth, Jan, and Lee for their help, inspiration, confidence, and love.

CONTENTS

Introduction

Of all the ways to make and show images, none is more beautiful or more exciting than projecting slides. You just can't compare slides and color prints. The slides are more brilliant; their colors, more dazzling. This, combined with an enlargement 40 times the size of the original, makes the images vivid and lifelike. In a darkened room, they command every moment of the viewer's attention.

You might argue that movies (both motion picture and video) are more lifelike. I love movies, too. But if you compare a motion-picture or video image side by side with a slide, the award for the brighter, sharper image has to go to the slide—no contest. Movement gives motion-picture images their realism. But did you know that you can make slides appear to move? This is just one of the special things you can do when you put on a slide show.

That's the key word: show. Or, more specifically, showmanship.

Showmanship is a bit more than taking all the slides from their small cardboard boxes and plunking them into a slide tray in whatever order you happen to grab them. Showmanship requires thought, planning, and a number of little tricks and techniques.

Showmanship is editing the slides. It's taking out bad, boring, and similar ones. It's putting the good slides in an order that's interesting and visually pleasing. It's the timing and pacing, so the im-

 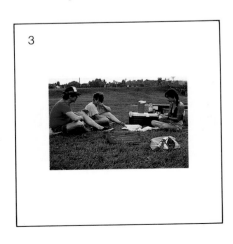

Organize slides into interesting and visually pleasing sequences.

© Visual Horizons

Words and graphics are important to slide presentations, especially when used to support a lecture.

For my parents' fiftieth anniversary, I rephotographed some of their old pictures to tell their story.

ages move and carry your audience with them.

Showmanship is also retouching, if you're a perfectionist. It's adding shaped masks or combining several images on one slide, if you want to do something unusual. It's creating titles and special effects on the copystand, using music, and preparing a narration.

The job can be a simple one, taking not much longer than it would for a presentation that makes everyone hope for a power failure when they see a projector. It can also be an elaborate production, requiring time, several projectors, and the willingness to accept thunderous applause.

You'll find suggestions in this book that you can use whether you are an experienced photographer or a novice. The book will be helpful even if you aren't very interested in taking pictures, but have to use slides in your business or

profession. Many speakers use slides to enhance their presentations rather than depend on words alone. If that's how you work, your audience will be appreciative if you know what kinds of slides to use and how to put them together effectively.

If you're a photographer, however, I'm assuming you know how to take reasonably good pictures. (Other books can give you information on exposure, focusing, and composing.) Most of the time I will be concerned with what happens after the film is shot. I will also talk about photography that is unique to slide shows. Slide shows often have special photographic requirements and can make clever use of subjects photographed on the copystand.

I'm excited about slides. Like most people, I've thrown a trayful together in a hurry so that the family can see the canoe trip down the

Mohawk River or the children feeding the geese. Much better, though, were my thoughtful presentations with carefully organized pictures. Of all the shows I've done, my favorite is the one I did for my parents' fiftieth wedding anniversary, complete with music, narration, sound effects, and sepia-toned nostalgia. There wasn't a dry eye in the house, and everyone thought my parents had a very clever daughter. The reaction from family and friends made the effort particularly rewarding.

That's the purpose of this book. Because you're interested enough to shoot slides, your pride in your work should make you want to put them together with real style. Whether you're showing slides from your vacation or using slides to document a business project, this book will help you present them in a way that will earn applause from everyone watching.

Slide-show Basics

Passing a handful of slides and a tiny viewer from person to person is not the ideal way to look at such pictures, but it could be the most basic form of a slide presentation. Maybe primitive is more accurate, and we can consider the one-projector presentation the basic format. If you add the niceties of music or your own commentary, or both, it can be extremely effective. All it takes is a little effort. You'll know it's worth it when your audience applauds rather than looks at their watches, wondering if the coffee is ready.

Slide shows start in several ways. You can plan the show before you buy the film, deciding on a subject, outlining a script, and envisioning just what type of pictures you will need to communicate your message. You can also use the opposite approach, taking slides you already have and grouping them into a show. You probably have boxes and boxes full of slides and want to know how to make them excite the people who are coming to your house next Saturday night. So, start there.

Selecting the Slides

You can't use every slide you have. Scenes of the Bronx Zoo, your vacation in London, and the Fourth of July picnic are not going to meld logically. You need a theme. This could be the trip to London or a day at the zoo, or you could select pictures of animals taken at both places and work with them. Although it's obvious that you can make a show out of a specific activity, you can often find a common denominator in the slides of many different and unrelated days of shooting. As you go through your slides, think about subjects that can work together: flowers, boats, architecture, cats, a child changing over the years, or the building of a kayak. The pictures should not be too similar or the whole effort could be boring. What you're looking for is a framework.

If you're an organized person, this won't be difficult. You flip through your slide-file pages, which are neatly categorized according to subject, and pull out those you want to use. Then you can begin to arrange them. But your slides may not be filed in such a superlative manner. They're probably in their little yellow, orange, or green boxes, some labeled "summer," "1975," or "miscellaneous" and some not labeled at all, which is as bad as "miscellaneous." Unfortunately, the shoebox storage method is the most popular. Since you'll never get to make a slide show until you can locate the slides, the place to begin is with an easy-retrieval storage system.

Storage and Filing of Slides

If you have only a few hundred slides, storage and retrieval aren't much of a problem yet. But the earlier you start organizing your collection, the easier and more fun

making slide shows will be. I waited until I had accumulated thousands of slides. And only after I spent an entire day frantically searching for one particular picture did I decide to do the job properly. My back ached and my eyes were tired, but I've been pleased with myself for doing this ever since.

You can break down the systems of storage into two kinds: bulk and flat. Both have advantages, and the "yellow-box" system isn't a bad one—if it is a system.

Storage Devices. In bulk storage, the slides are stacked in small groups. You can keep them in lab processing boxes or in boxes made specifically for slide storage. While the processor's boxes usually necessitate your piling slides one on top of the other, boxes that you buy let you stand the slides on edge. This makes it easy to pull them out for viewing.

You can buy boxes made of metal, wood, or plastic. Some are small and hold no more than 40 slides. Some are larger cases with latches and hold about 700 slides. Others are actually drawers that fit into cabinets. Most compartmentalize the slides; some have separators for every slide.

Another bulk storage method involves clipping as many as 36 slides together with the Slide Clips designed for use with the Carousel stack loader. You can also keep slides in slide trays, but you would require an enormous amount of storage space. It's best to use trays for storing slides only after they have been organized into presentations.

Bulk storage can be compact, but it can sometimes be a nuisance. Suppose you want to find a nice picture of your cat. After you locate the box, you have to lay out all the slides on a light box or hold them up one by one in front of a window. And then you have to put them all back. That's why I like a flat storage system. With it, you

can pick up a sheet of 20 slides, glance at them, and easily find the ones that are just right.

These slide pages are usually made of plastic, although one manufacturer makes them in cardboard. One type of slide page is made of thin plastic, with rows of pockets, which open at either the tops or the sides. I find the top-loading pages easier to use. Another type is made of rigid plastic and has slots in which to insert the slides. Some of these open slide pages have plastic flaps to keep out dust. Acetate sleeves slipped over individual slides are also a way to protect the slides from dust when they are in slide pages. For filing, you can put the sheets of slides into ring binders (they come punched), stack them in boxes, or hang them in filing cabinets.

If you have thousands of slides and need to examine them easily, you can get storage cabinets fitted with large plastic frames, mounted either vertically or horizontally. Each of these frames holds as many as 120 slides, and some cabinets have built-in illuminators.

A clever device from the Quickshow company, called Page-Vu, enables you to project slides without removing them from their plastic storage pages. This is a holder that is mounted between the projector and lens. Slip a slide page into the holder and then move the holder horizontally or vertically to project a particular slide.

Many people find a combination of flat and bulk storage a good idea—flat storage for slides you know you might want to use in a presentation and bulk storage for slides that are not quite as good, are very similar, or are duplicates. (As you'll see later, there are uses for slides that have poor composition, are grossly overexposed, or have other faults, so keep them in boxes until you need them.)

Cataloging. Once you have the incentive to file your slides and have chosen a storage system, you must

Storing slides in little boxes is a popular, but disorganized, method.

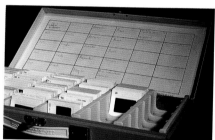
A Smith-Victor storage box holds small groups of slides in separate compartments.

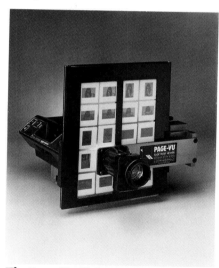
The Page-Vu Slide Page Viewer allows slides to be projected without being taken out of their storage pages.

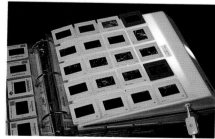
After slides are stored in plastic pages and filed in three-ring notebooks, it's easy to look at them using a wedge-shaped illuminator called Lite-A-Page.

decide how you're going to organize them before you put them away. Doing this by date is the easy, but usually not the best way. Unless you have a prodigious memory or very few slides, you'll have difficulty locating a specific image. You can search for hours trying to find a particularly beautiful sunset if all you have to guide you are dates. It's better to group all the sunsets together.

The most workable system is one that's organized by subject as are books in the library. Then you can file the slides alphabetically, or you can assign each subject a category number and subnumber. I like to use words as identifiers, but a numbering system gives you a code that fits on the slide mount and identifies slide pages or boxes.

The categories evolve naturally from the kinds of pictures you take. If you decide to use words as identifiers, a "flowers" category, for example, can be broken down into "flowers, closeup" and "flowers, massed." But if you're a naturalist or an enthusiastic gardener, you'll probably want to organize them according to specific varieties. A less horticulturally inclined person might use "flowers,

red" and "flowers, yellow." You'll find that as the years go by and the number of slides increases, the subdivisions become self-evident.

In a numbering system, flowers might, for example, be number 5.0. As you acquire more pictures, 5.1 might be orchids and 5.2, roses. With further specialization you could use 5.11 for ladyslipper orchids and 5.12 for phalaenopsis orchids. If you're really an orchid photographer, you can use 5.111 for ladyslipper orchids: Albion and 5.112 for ladyslipper orchids: Maudiae. The more specific you are, the faster you can locate the slides you want.

What do you do with a picture of a landscape with a bird sitting on a snowy branch? Does it belong with landscapes, winter, or birds? Obviously, you'll also need a cross-referencing system, with subjects listed alphabetically, showing that pictures of birds can also be found among the landscape slides. Although you can use a notebook with sheets of lined paper, index cards are ideal for this purpose. List each subject on its own card and indicate the different places it is located, or simply put a notation in the pockets of the correspond-

ing slide pages to refer yourself to other categories. In this example, you might file the bird-in-winter picture with landscapes and note under both birds and winter that you should also look at the landscape section.

Getting started is the hardest part of cataloging. After you've begun the system, try to file away each new batch of slides as soon as you've had a chance to look at them. It's simple to file 36 slides because one roll of film is apt to include only two or three subjects. But filing 108 slides is a chore, and filing 180 becomes a big task you may put off repeatedly.

There is one slide category you should try not to use, that catchall "miscellaneous." When you can't think of the appropriate place to put a slide, it's all too easy to slip it into this meaningless grouping. I've solved the problem by putting a slide in "miscellaneous" if it's the *only* slide of that particular subject. As soon as I acquire another one, I create a new category.

Storage boxes and some filing pages have places where you can write the identifying information or use tabs made for indexing looseleaf notebooks. These are self-adhesive plastic strips, into which the label can slip. Another way to label slide-file pages is to write the information on a 2 x 2-inch piece of paper and put it into one of the pockets. Use the same location on each sheet. Marking the page location on the slide mounts will help you file the slides again after you remove them from storage.

When you have a large number of slides, you may want to use a personal computer as a filing reference system; there are programs designed for just this purpose. You can also use an ordinary word processing program that has a search feature.

Protection. Being able to find slides easily is not the only reason for filing them. The other is to pre-

Snow laden trees can be categorized under "Trees" and "Winter." Cross-referencing helps make a system functional.

vent them from being sat on, spilled on, or made the resting place for dust particles. Slides are delicate and easily damaged. As indicated on the film carton label, color dyes are not permanent. But proper storage of slides can protect them from possible horrors.

Light, heat, and humidity are the enemies most apt to fade your images. They are also going to be subjected to the heat and light of the projector. The best precautions are to be sure you leave no slide in front of the lamp for more than 30 seconds at a time and to find a storage place that is cool, dry, and dark. Ideally, you should keep slides in a refrigerator or, better yet, in a freezer where the relative humidity is between 25 and 30 percent. (Most refrigerators and freezers have high relative humidities.) But this is not a practical storage method for most people. For specific information about archival storage, read Kodak's booklet E-77, *Kodak Color Films*, and *The Life of a Photograph* by Keefe and Inch (Focal Press, 1983).

Slides can also be harmed by some of the many fumes floating in the air. Clothes closets are not good places to keep slides if mothballs or fabrics treated with permanent press and stain-inhibitor chemicals are kept there. Keep slides away from the fumes of such harmful substances as industrial gases, motor exhaust, paints, solvents, cleaners, formaldehyde compounds, chipboard, glues, mildew preventatives, foam-in-place insulation, insecticides, sulfides, ozone, peroxides, nitrogen oxide, sulphur dioxide, oxygen, and nitrogen.

Paper envelopes, unless they are specially made to contain no chemicals harmful to film, should not be used for prolonged storage. The same is true for cardboard and wooden boxes. Metal or baked-enamel file boxes and drawers make the best containers for slides when the storage area is not refrig-

erated. If your slides are in boxes, don't try to force an extra slide into a little space; the slides need air circulating between them.

I'm partial to storing slides in plastic pages. In recent years, there has been a great deal of evidence that pages made of polyvinyl chloride (PVC) contain such chemicals as hydrochloric acid that can seep out and harm the slides. Fortunately, molded pages made of semirigid polypropylene and thin pages made of polyethylene are both safe. Use them. You don't have to remember the chemical names; just check to see that the products aren't made of PVC. And if you put the pages into ring binders, be sure the binders aren't covered with plastic, as that plastic may contain PVC, too. Cloth binders are safer. Never overload a binder, and put it in a slipcase to keep out dust.

The Basic Slide Show

I believe that most people take more photos while on vacation than at any other time, and that these are the slides most eagerly shown. Let's start here, with shots you've already taken.

When you work with existing slides, the pictures will have to suggest their own theme. It could be something general, such as a documentation of a trip to a foreign country, or you may want to concentrate on specific aspects of a trip, such as the architecture or the food. Unless chronology is part of your theme, the pictures do not all have to be within a certain time span. If you are a prolific photographer, you will have enough slides to develop into a show.

After you have decided on the subject or theme of your show, you have to decide on an objective. It can, of course, be purely to entertain. But it also can be to document a carnival or to explain how stained glass windows are made.

It is equally important that you know who your audience will be.

Members of your family and members of your luncheon club are not always likely to be fascinated by the same subject. Similarly, a show for children should not be identical to one for your contemporaries. As you select slides, consider the age, interests, and education of the viewers.

Preliminary Editing. After you know, at least in a general fashion, what you are going to do, putting your slides together starts in earnest. This is the editing phase—a task that's challenging and, ultimately, extremely satisfying. It can be as creative as the actual picture taking.

The first step is both easy and hard: weeding out the poor shots and the duplicates. The easy part is deciding whether a slide is of good quality or not. You probably did this before you filed away the slides, but you may have made a quick decision without projecting them. Sometimes you can just hold a slide in your hand and know immediately that it's grossly over- or underexposed. It's not as easy to identify a slightly out-of-focus shot or one in which someone blinked.

UTILIZING EXTRA SLIDES

The photography club I belong to has a worthwhile use for extra slides. Members regularly donate their superfluous slides, and a committee puts them together into shows they take to nursing homes and hospitals. The images include local areas, foreign countries, people, and animals, and the patients are delighted. The method of presentation, not only the images, makes this project an outstanding success. The leader uses the slides as a starting point to involve the people and get them to interact by eliciting their comments. The slide shows have brought benefits far beyond mere entertainment.

A stack loader facilitates the projection of slides.

Instead of guessing about them, project the slides so you have an image several feet wide. If the image is small and bright, such as those you get when the screen is close to the projector or a preview screen is built into the projector, you may *think* the focus is acceptable or the exposure correct. Work in a darkened room with a large screen. The conditions should be similar to those of the actual show.

A stack loader, which fits on top of a projector, can be of immense help at this stage. You can place up to 40 slides in the holder and project them. This is much faster than dropping them into the projector one by one or loading them into trays. One minor inconvenience is that the device does not operate in reverse. You can, however, remove a single slide by pressing the "select" button; then replace the slide on the feed side and project it again.

One of the difficult parts of this first editing activity is that it requires ruthlessness. It doesn't matter that you waited three hours for the light to be in the right position or that you had to stand in the rain, balancing an umbrella over the camera, to get the picture. Eliminate the picture if it is below your standards. At least, put it into a discard pile.

Even more difficult, emotionally, is discarding good but similar slides. More than one slide taken of the same thing, from the same angle, and with the same focal length is boring. Such slides may

be enjoyed by you and the other people in them, but they will be repetitious to an audience.

Set these good duplicates aside. You may be able to use some of them as part of an introduction or a fast-paced conclusion that summarizes the show. At any rate, you'll probably be able to include them in another presentation.

You have to remove one more type of slide: the family-in-front-of-the-monument shot. Many vacation pictures of family members grinning at the camera don't add any information to a story. Save them for a separate presentation for the people involved.

Check the slides again, seeing if still others should come out. Look at the composition, lighting, drastic differences in color balance; eliminate, for example, the slides of bald skies when the rest have blue skies. But be cautious. You may need some of the less-than-perfect pictures to tell your story. (In Chapter 4, you'll find techniques for turning mediocre images into great ones.)

Now, as you go through the slides, you will be looking for pictures that communicate an idea or an emotion and contribute to your objective. At this point, you should know what you want to say with your pictures and how you want your audience to react. Why did you take the picture? Does this come across quickly? The pictures shouldn't need much verbal explanation. They should add to the viewers' grasp and enjoyment of the subject. You'll be undecided about many slides, but that's all right at this stage; you'll be able to judge the slides more easily when they are in order.

In an organized presentation, a picture that is meaningless by itself takes on meaning when it is part of a sequence—a closeup shot, for example, of an architectural detail. If the audience sees it out of context, it would rate a "zero" on the communication

scale. But if the slide sequence starts with a shot of the entire building and moves in to show details, the closeup would be valuable.

Run the slides through the projector once again, but this time jot down some notes. You'll see slides that are outstanding: they are exciting and really make a point. You'll want to remember those. Many will naturally seem to belong together as a sequence; others will be logical choices for an introduction or transition; group them. Give each slide a number, marking it lightly in pencil on the slide mount. Then write your notes on index cards, numbering each one so that it corresponds with the slide. Use pencil because this is not going to be the final order. The index-card method allows much of the editing to be done by shuffling cards rather than slides, and it makes writing a commentary easy. As you become more experienced, simply writing a one- or two-word description, with no numbers, may be all the help you need.

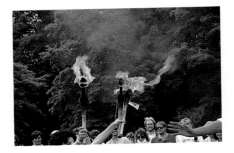

This closeup of flaming torches is unclear by itself, but its meaning becomes apparent when it is part of a sequence.

Make notes about the slides, and then number the slides to correspond to the cards.

© Leslie Appel

Editing Aids. The fun part of editing is putting the slides together into a sequence—and finding that it works. Although you make your initial evaluation of the slides with a projector, editing requires a way to view a large number of slides on one surface at the same time.

You can buy small illuminated viewing surfaces that accommodate 36 or 40 slides, but they are more frustrating than practical. For any serious work, you'll want to spread out at least 80 slides at a time. You can use a lightbox. You might want to get a slide sorter; it slopes at a slight angle and has ridges to hold rows of slides. A professional illuminator is lit with special fluorescent lamps that make it possible to accurately judge the colors on a slide. Most consumer versions have low-wattage light bulbs. Although the nonprofessional units are adequate for most sorting and editing tasks, they can be misleading if you are trying to evaluate color.

Fortunately, you can build many slide-show devices instead of buying them. For example, it's actually easy to improvise a large viewing surface. I took a stool, turned it upside down, and laid a storm window on top of its legs. A sheet of glass can be placed on top of any supports of equal height, as long as there is room to put a small lamp underneath it. Diffuse the light by taping tracing paper or waxed paper to the underside of the glass. Make sure the lamp is far enough away so it doesn't scorch the paper. For more even illumination, bounce the light on white paper or reflect window light from a mirror.

Similarly, it's possible to construct a slide illuminator using a sheet of opal plastic and fluorescent lamps. Use cool-white lamps or ones that closely match daylight. Verilux (made especially for photographic purposes), Vita-lite, Ultralume, and Chromaline are others that can be used. (See the list of suppliers at the end of the book.)

A small but vital piece of equipment is a good slide magnifier, with which you can examine details of a slide without running back and forth to the projector. Get a slide magnifier that lets you look at the entire area of the slide at once.

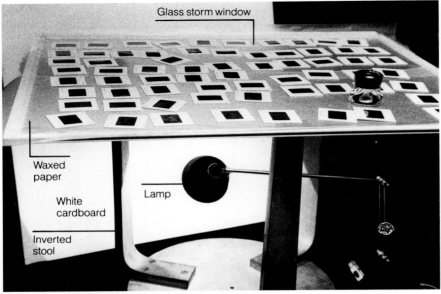

Glass storm window

Waxed paper

White cardboard

Lamp

Inverted stool

An improvised light table.

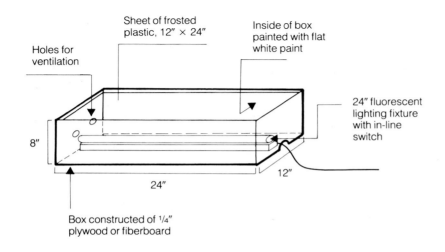

Holes for ventilation

Sheet of frosted plastic, 12″ × 24″

Inside of box painted with flat white paint

24″ fluorescent lighting fixture with in-line switch

8″

24″

12″

Box constructed of ¼″ plywood or fiberboard

Constructing a light table.

Basic Editing. The purpose of editing slides is to give them continuity: a logical flow of images that tells a story or carries out whatever objective you set for this presentation. Equally important, maybe even more important, is to create a visual flow from slide to slide; the effect must be pleasing to the eye. A slide show, like a motion picture, adds the dimension of time to a series of still pictures. Many of the principles of editing apply equally to both media.

Logical Editing. Let's begin with editing based on logic. This approach is determined by what

When editing slides, start with an overall view and proceed to closer and closer shots.

Build a collection of slides that can serve as transitions from sequence to sequence. This transition shot, taken from an airplane, ties together pictures taken thousands of miles away from each other.

viewers would notice when they look at a real scene for the first time and what they would want to see next. Usually, you don't want to jump abruptly as you go from one slide to another, leaving your audience bewildered and disoriented. It is, however, possible that you might want to confuse the audience, but hold back on breaking the rules until you are skilled enough to carry it off effectively.

Logic dictates an orderly telling of a story or presentation of facts—with a beginning, a middle, and an end—even if the shots you use do not represent the chronology of the photography. A vacation trip might begin with a shot of someone packing a suitcase, the waiting room of an airline terminal, or someone pleading with airline personnel not to X-ray film. You'll need the bulk of the slides for the

middle of the show, and a few more to bring it to a satisfying close.

Consult your notes and group all the slides that might serve as an introduction, as a conclusion, and as transitions. Unless you have limitless amounts of space, it's less chaotic to work with small sequences at a time.

Within a particular sequence, logic usually progresses from the general to the specific. A long shot—an overall view of the location—is a good way to orient your viewers. Follow this shot with closer and closer looks, concentrating on detail. This is an excellent rule to follow, but doing every sequence this way becomes monotonous. Besides, the opposite approach can be exciting because it teases the viewers. Begin with several closeups and then, after

you've aroused the viewers' curiosity, reveal your subject. Whenever you change locations, or when you've dwelt a long time on a series of closeups, it is important to remind the audience where they are by showing an overall view.

Since you want to grab your audience's attention immediately, you need a strong series of slides to start with. The most exciting sequence, however, should be shown toward the end. In your initial logging of the slides, note those you think will most effectively arouse interest. With this in mind, organize your other slides so they build to a climactic moment.

Logic may also require that you use some kind of transition between sequences to prevent awkward leaps from one geographical

area to another or from one period of time to another. Good transitional devices include shots taken from a car or airplane window or pictures of walking feet. A photo of an object followed by a similar picture taken in a different location can also work as a bridge; try flowers or food. Highway signs and maps are logical and helpful, and an occasional word slide is meaningful, too. (Word slides, maps, drawings, and material rephotographed from printed pages are quite useful in many parts of a slide show. You'll find the tricks and techniques of doing them in Chapter 3 and 4.)

As you edit, you may find gaps in your visual story. Don't despair. It's possible to shoot additional slides later. There are things you can photograph on the copystand or that you can do live. For example, you can take closeups of some souvenir objects; if the background is neutral, no one will know they were photographed hundreds of miles away from and long after the other pictures. Another option is to take a picture of your spouse looking at a map. If you choose a low camera angle, with the sky as the background, your cheating will not be evident—as long as the sky matches the sky in the other pictures. You may be able to use slides that you purchase rather than take, which give you pictures you weren't permitted to photograph or weren't able to photograph with the equipment you had. The quality of these slides can range from excellent to horrible.

It's a good idea to photograph scenes you can build into a collection of stock slides. These pictures can come in handy in numerous presentations. Shots of water, sun-sets, and airplanes, as well as pictures taken from airplanes, are always good to have available.

Editing for Meaning. Years ago, a Russian film director tried an experiment. He had an actor pose with an expressionless face, and the camera operator took a lengthy, closeup shot of the actor. The director then edited it so the picture of the actor alternated with pictures of a beautiful woman, a table laden with food, and a funeral. The audience was shown the edited film and was asked for their impressions of the actor's ability. They all felt he convincingly expressed the emotions of desire, hunger, and sadness, respectively. Such is the power of editing.

This classic editing experiment is just as valid for slide presentations as for motion pictures. The sequence of the images affects, or determines, their meaning. If you

In this sequence, the selections on the menu appear to please the customer.

With the same slides arranged this way, the customer seems to be disappointed.

rearrange a sequence of pictures, it can have an entirely different meaning.

You have power when you sit in front of the slide illuminator. You can make your slides tell just about any kind of story, create any kind of a mood, or promote any kind of idea. Think about this as you push the slides around.

Editing for Visual Flow. Using a succession of visually related slides is an important editing consideration because it can enhance the aesthetic appeal of your show. In terms of shape and form, it's pleasing to see one circular shape follow another, or a horizontal one follow another horizontal. Carried to extremes, an entire show will include only circular or horizontal shapes but it does create a sense of unity.

When you want one radically different shape to follow another, the shift will be smoother if you separate them with a transitional slide. You can use a subject with a diagonal line, for example, or one that is amorphous between slides having predominately horizontal and vertical lines.

Another technique that unifies a succession of slides is having the center of interest on roughly the same part of the screen. Whether the subjects are large or small, this ties the slides together by preventing a tennis-match effect. To link slides having centers of interest on opposite sides of the screen, use a transitional slide whose center of interest lies somewhere between the others'.

Even stronger unifiers are color and tonality. The colors don't have to be identical, but it's better if the dominant hues are in the same part of the spectrum. One slide might show a dog in a red sweater; the next might have a great deal of red in an awning. Even a small amount of color in one slide can link it to a slide that contains a larger amount of that color: a small blue ball in one picture and a closeup of a child in a blue sweater in the next. Obviously, this works best when there are few colors in the pictures.

You can edit by form and center of interest occasionally, but you should *always* consider tonality and color. Following a dark, low-key slide with a light one—or vice versa—will disturb the viewers. When editing, it's best to make a gradual transition between such slides by inserting slides of intermediate brightness. But jumping from one bright color to another, especially when the colors are "opposites" on the color wheel, can be electrifying. For the times when you want to jar your audience, such abrupt color changes will achieve this effect. Usually, though, you'll want to make a smooth shift. You can do this by using several intermediate images, letting the dominant hue of each slide in the progression pass through the colors of the spectrum. For example, you might want to follow a scenic view that has a great deal of bright green with a fiery red sunset. You can soften the transition by separating these shots first with a slide that has a lot of blue and then with one that contains purple or both red and blue.

Editing for Direction. You have to be concerned with very few things if you are taking only one picture of a subject. One of these is where you stand in relation to the subject. Ordinarily, you position yourself so you can take the best photograph. But you have something else to think about when you want to use two or more pictures of a subject in a slide show.

After the picture of the red leaves, the blue of the sky of the bottom slide would be discordant. The yellow and green of the slide of the weeds help bridge the transition. The yellow and red of the second slide smooth it out even more.

1

2

3

4

Projecting a bright slide and then a dark one, or vice versa, jolts the audience. Insert a slide of intermediate tonality.

Consider the following situation. A parade is coming down the street, crossing your field of view from left to right. You take some pictures, and then go to the other side of the street to take pictures from there. Now the parade is moving from right to left. If you project these two slides one after the other, your viewers will assume that the marchers have turned around or that another group is coming down the street and is going to collide with the first group.

Clearly, you need to preserve the continuity of screen direction, which means simply that movement should appear to be going in the same direction from shot to shot. You can take care of this best when taking the pictures, but you can also do it while editing. When the slides are spread out before you, it's easy to choose those that are all facing the same way. You can flip a slide, but any lettering would then be backward and the slide may be out of focus when you project it.

There is a solution if you feel you must use slides with the subject facing in the wrong direction. A directional change will not be obvious if you place another slide between the two. A picture taken head-on or from directly behind the subject is an excellent neutralizer; it's even called a *neutral* shot. You can also show a different but related picture. For the preceding example, a closeup of a person watching the parade would be ideal.

The directional problem also occurs with static subjects. When you select your pictures, be sure you don't create unintentional gymnastics, with subjects jumping from side to side. Careful sequencing will eliminate the problem.

One other point about direction is actually a convention rather than a strict rule. People assume that vehicles facing left are headed west and those facing right are going east. You can take advantage of this when you lay out your slides.

Editing for Contrast. You can vary the logical progression of your pictures by using your slides to show opposites. I once did this by showing several slides of a large jet plane, followed by shots taken of a six-seat commuter airplane. Alternating between slides of the two, which included pictures taken from the cockpits, made interesting comparisons between the two flights.

You, too, may be able to adopt the filmmaking techniques of parallel editing and flashbacks. In parallel editing, you show two things that are taking place at the same time by alternating groups of images. The subject doesn't have to be melodramatic. It can be as simple as showing someone building a barbecue fire while others are preparing food in the kitchen.

Flashbacks start with a se-

quence taking place in one period of time and then change to a sequence showing events that took place earlier. You can show, for example, slides of your daughter preparing for her wedding; then flash back to when she was small. Both flashbacks and parallel editing are storytelling techniques, and you should approach them carefully in order not to confuse the audience.

Editing for Variety. You can forget everything else I've said if you remember to put variety into your

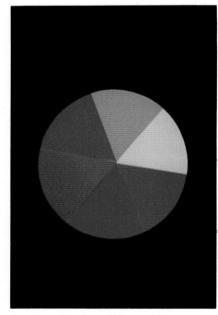

A color wheel can be a guide to arranging a sequence of slides. Hues next to each other on the color wheel are pleasing if they follow one another; opposing hues can be jarring.

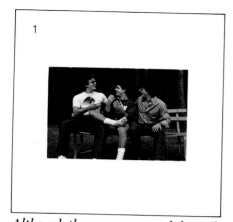
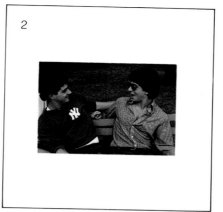
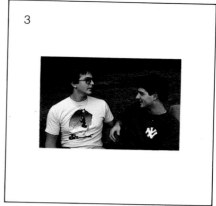

Although these young men did not change places, it would look as if they did if the pictures were projected this way.

show. The most splendidly photographed pictures will bore your audience after a while if they are all taken with the same settings and from similar perspectives. Twenty shots of buildings or 20 shots of tossing bread to seagulls is monotonous.

Weed out the near duplicates. Use closeups, medium shots, and long shots. Include some photos that you took when lying on the ground and others when you scrambled to the top of the wall. Vary the colors and sizes of objects. Add a humorous picture if it's appropriate. Use some of the special effects slides described later. And be sure you include people: human interest is what keeps us interested in pictures of buildings and machinery. All the changes you make should keep the audience's eyes glued to the

screen, wanting to see the next slide.

One change, though, is not recommended. Most slides included in a slide show should be horizontal. These fill the screen in a way that's more acceptable to our eyes and our horizontal view of everything. Some people advocate never using vertical slides. I think that's extreme. In fact, I've seen prizewinning shows made up of nothing but verticals. If you use vertical slides, group several of them rather than interspersing them, which can be annoying. The most important point to remember in switching from one orientation to the other is to provide a transitional slide. Your audience will accept the change if the horizontal slide contains a strong vertical image, and vice versa. Another way of disguising the change is to

use a slide that has a black background. The shape of the slide is then invisible.

Subjects for Slide Shows. Althought I've used vacation travels to explain how to edit a group of slides in a show, the basic principles of editing hold for any pictures you put together. There's no limit to the subjects you can make into a show. Almost anything that interests you can be visualized in some way.

To make it interest your audience you'll want to choose some aspect of the subject you can explore in depth. Subjects can range from the very pragmatic to the purely evocative. You can show a person performing a skill and edit the slides in a strictly chronological order. You can put together photographs of people, objects, or scenery; abstracts of color and form; or drawings and graphics created on a copystand. You can even tell fictional stories with slides. Your challenge will be to find a fresh approach and to link the images effectively.

How Long Should a Slide Show Be? While you are editing, you have to consider the number of slides you are going to use. If you shot 360 slides on your trip and 250 didn't end up in the discard pile, should you use all 250? No.

Most photographers—amateur and professional alike—make their

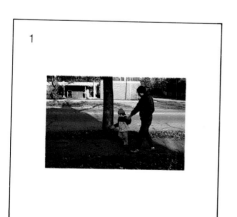

Projecting these two slides in succession makes the walkers seem to have changed direction.

presentations far too long. Much depends on how entertaining the slide show is. An excellent series of pictures might take 30 minutes and be well accepted; a weaker show can become boring in less than 3 minutes. If we accept 15 minutes (900 seconds) as the average length of a presentation, the number of slides we use will naturally depend on how long each slide is held on the screen. It's a

SLIDE MAINTENANCE

Slides can pick up dust and fingerprints easily, and these blemishes are magnified unmercifully on the screen. To prevent these problems, always hold slides by their mounts; never touch the film with your fingers. Wearing editing gloves is a good idea.

Clean your slides before loading them into trays. You can do this by blowing dust off with pressurized air or using an antistatic brush.

After laying out the slides in horizontal rows, oriented the way the pictures should look on the screen, put a mark in the lower left corner of each slide mount.

Slides correctly placed in a projector tray.

very unusual slide that is on more than 15 seconds. Ten seconds is the norm, and many slides should pass by even more rapidly. A slide should stay on the screen no longer than is necessary for the images to be seen and understood. Using an average of 10 seconds per slide, I divide 900 seconds by 10 seconds and arrive at 90 slides.

Editing the Preliminary Tray. Laying out the slides on an illuminator is an unbeatable way to edit. You can compare the brightness and color of the images, and you can juggle their order until they tell your story. Continue moving and discarding the slides until the show looks right.

Do some preliminary arranging by consulting your index cards. I like to put the slides I am evaluating on the illuminator, placing the edited slides in horizontal rows, with the first slide of the show at the upper left. When I reach the end of the row, I start another row below it, working left to right.

All the slides should be facing you so they "read" correctly—that is, so they are oriented the way they should look on the screen. Usually, the smooth, shiny side will face you; this is most obvious with Kodachrome slides. On slides processed by Kodak, the side with the date, not the trademark, will face up. Put a mark in the *lower left corner* of each slide. You can use a felt-tipped pen on cardboard slide mounts, but you'll need a special marker for plastic mounts. You can use self-adhesive round dots, available in photo or stationery stores, but a pen is faster.

When you reach a point at which your slides seem to be in a satisfactory order, load them into a slide tray for a preliminary run-through. Someone once commented that there are eight ways to put a slide into a tray, but only one of them is correct. Slides must be put into the projector upside down, with the emulsion side facing the screen. The marks you

made will help. Pick up a slide and rotate it so the mark is in the *upper right corner*. Now place it in the tray. When you stand behind the projector, all the marks will be in the upper right corners of the slides.

It's best to have the tray off the projector when you load it; otherwise two slides are apt to drop into the projector gate, jamming the works. When loading a tray this way, place it so the first slot is at roughly the three o'clock position when you are seated at six o'clock. I find it easiest to pick up a slide with my left hand, transfer it to my right hand, and drop the slide into the slot. Then place the slides in the slots so that the marks are in the upper right corners. When you fill about 10 slots, rotate the tray counterclockwise a bit and continue loading.

The last slide in the tray should be an opaque one. At no time should you leave a blank slot between slides. The resulting blast of white light is an inconsiderate jolt to the viewers. Many projectors now have dark screen shutters that prevent light from reaching the screen when there is no slide in the gate. With other machines, you can either simply use a blanking slide, which you can buy, or cut out a 2-inch square of cardboard. *Now, lock the slides in the tray.*

Examine your project critically, and evaluate whether or not your slides tell a cohesive story with good visual continuity and variety. If you are not completely satisfied with the organization of your slides—chances are you won't be—take the time to add to, subtract from, or rearrange them. Sometimes the problem is just a matter of one slide, so it's not difficult to move the slides to new positions. When several slides have to be rearranged, it's usually easier to remove all of the slides past a certain point and put them back on the illuminator. Place the slide that comes earliest at the top of the

row. Make your corrections and replace the slides in the tray.

When you are fully satisfied with the order of the slides, number each one in sequence, next to the orientation dot. Then make sure the slides are once again locked in the tray. If you've ever spilled a tray of slides, you don't need these reminders!

Pacing. One more crucial element can make the difference between giving a true slide presentation and just projecting a bunch of pictures. This is pacing: how quickly or how slowly you move through a series of slides. Some projectors have an automatic timer that advances the slides after a specified, fixed interval. *Do not use this device.* It might be all right if you have no one to operate the projector, but it's a good way to encourage yawns.

Just as you vary the images, you must vary the length of time those images are on the screen. The viewers can get the message quickly from a closeup shot of a hand holding a pencil, but they'll need more time to take in all the details of a wide view of an office. Determine how slowly or how quickly the information jumps from the screen and can be comprehended by viewers. Remember, too, that ideas are communicated faster to people who are acquainted with the subject than to those who aren't. You have to consider your audience.

A few general rules can guide you on the relative lengths of time to hold a slide on the screen, but, for the most part, you will use your intuition.

• Look at your show critically.
• Get a second opinion from someone who hasn't been involved with the editing process.
• Always aim to use the shortest amount of screen time possible. Obviously, slides with a great amount of detail need more time than simpler pictures.
• In order to make extensive comments about a subject, show several views of the subject for variety. Don't bore your audience.
• To create a frenzied impression, project a series of brightly colored slides at a snappy pace.
• To create a languid impression, so viewers can appreciate the beauty of the images, project a series of pastel-colored slides at a slow pace.
• Control the audience's involvement and interest in what they see by varying the length of time each visual in a sequence is on the screen. Certain sequences should change quickly; others, more slowly.
• Learn how quickly to move from one slide to the next by rehearsing. Sit where the audience will be, and project the slides. Experiment: press the slide-advance button at various intervals.
• Rehearse the presentation several more times, especially if you will make comments as you show the slides.
• As a final touch, find some appropriate music and play it while you project the slides. Make sure that the mood and pacing of the music complements the images.

Now that you're acquainted with the basics of doing a slide show, you may want to jump around in this book. You'll learn how to take exciting pictures, salvage slides you thought were unusable, make titles, and, of course, prepare a narration and edit music. And you'll want to know all the fine points about projecting the show. Perhaps the only part I've left out is how to make the popcorn.

2

Getting Started

The best way to make a slide show is to know exactly what shots you want to take and how you will arrange them, even before you buy film. If you do most of your shooting on vacation trips or at family celebrations, however, you may feel there is no way you can decide ahead of time what you will photograph. Every photographer likes to look at a scene or an event, decide if it has possibilities, and then take pictures. Many great photographs are shot spontaneously when a visually interesting subject appears within the range of the viewfinder.

Planning a slide show still gives you this freedom, but it reminds you that you need to take specific types of pictures to maintain continuity and tell a story. With a notebook tucked into your camera case, you'll remember to take important shots. Planning does

not restrict you; it gives you a framework.

Although you can put together a slide show about a vacation or a 10km road race without planning every picture ahead of time, other shows cannot succeed with such a flexible approach. You will realize this if you are going to have a lengthy narration or if you are going to make a speech that will be accompanied by slides. Planning is necessary so pictures correspond to the words.

Before you select specific photographs, decide on your reason for putting the slide show together. Your purpose, as mine often is, may just be to satisfy your love of taking pictures. But a slide show is more than lots of pretty pictures. The presentation will be a winner only if you have a well-defined reason for putting those images together. As I mentioned in Chapter

1, when working with existing slides, you probably had limited objectives. Unless you shoot hundreds of slides on dozens of different subjects, you probably do not have many that can be grouped for such purposes as instructing, motivating, or convincing. So, by taking a planned approach to slide shows, you expand the range of possibilities.

Slide presentations can have all sorts of purposes. One may be to show off your slides, but that should be secondary. Compile them with a more specific idea in mind, such as impressing people with the beauty of the Grand Canyon, motivating people to record for the blind, or demonstrating how a group of third-graders benefited from a special program on computers. Write down your idea. Then remember your goal and direct everything you plan and pho-

tograph to it. It helps to plan in terms of what you want the audience to do or think after they've seen your show. For example, you might say to yourself, "After the show, I want the audience to know how to make a silk-screen print," or, simply, "I want my audience to appreciate the work Ms. Smith has done during her years of service."

The first step, then, in planning a slide show is deciding what you want the show to do. After you get your purpose down on paper, you'll see that it is easier to organize your picture taking without going off on tangents.

There are many things about the members of the audience you'll want to consider. Most likely, the first slide shows you put together will be for family and friends. They may have interests and attitudes similar to your own, so analyzing the audience won't be a major part of your planning. But as you get more proficient at and excited about making slide presentations, you'll be doing them for other groups. This is when it becomes vital to know a great deal about the audience. You'll want to be aware of such facts about the individuals as occupation, age group, education, knowledge of the subject, and strong beliefs and feelings about it. It even helps to know if they will be watching the show voluntarily or if an employer or teacher has required them to see it.

You would handle a show about a community blood bank drive differently for a group of doctors and nurses than for people who aren't members of the medical profession. But audience differences become a problem mainly when you combine the visuals with a narration. Frequently, the same pictures can be appreciated by completely different groups and only the words need to be changed. You would be able to show the same blood drive pictures to separate groups of medical and lay peo-

ple if you use a different narration for each. (It's best not to even attempt to give a presentation to a mixed group.)

Script

If you are going to speak while you show the slides, you will have to think about the words while you plan the visuals. Some people write the entire narration first and then plan the pictures. Others do just the opposite: they plan the pictures and write the words around them. The most common practice is to plan the words and visuals simultaneously.

Slide shows are primarily visual, but the audio element is also important. Planning one without giving any thought to the other would be impossible. That's why "script," in the broadest sense of the word, means a description of the pictures as well as the words. My approach is to plan them together. I concentrate on the visuals, jot down notes about the appropriate words, and then write the narration after I have planned all the pictures. (In this chapter, I'll discuss the words you'll say, but I'll leave the nitty-gritty details of scriptwriting until Chapter 5.)

Don't think that you must have a narration to make your slide show terrific. Most of the time, the pictures speak for themselves. But, as far as I'm concerned, music and sound effects are necessary.

Gathering Information. Some of the subjects you will photograph are things you know well. If you

are an expert on roses or ham radios, your knowledge is your source of information. When traveling to a city or country for the first time, though, you'll need help. Obvious sources are guidebooks, maps, hotel brochures, and books written for the traveling photographer. These will tell you which photographic spots of interest, local arts and crafts, festivals, foods, or other aspects of the culture you may want to document. Use them to liven up your pictures.

Similarly, let's suppose your employer wants you to do a presentation about a department you are unfamiliar with, or the community hospital wants a show about occupational therapy. Gather newspaper clippings, brochures, and any relevant printed material available from the public relations office. Ask for help at the library. And, of course, talk to the employees. Most of all, get help from the person who has all the information: your technical advisor. He or she can tell you what you must include. Arm yourself with more information than you think you'll need, and then you will be ready to start the actual planning.

Planning

There are two commonly used ways to plan a show. If you anticipate taking relatively few pictures or if you will not be taking pictures of many different subjects, you may want to do all your planning on sheets of paper. I prefer lined paper because it automatically

A TYPICAL SHOOTING PLAN

Sign or some other identifying title
Unloading canoe from car
Other preliminary preparations
Putting canoe in water
Scenes of race
Looking at scoreboard

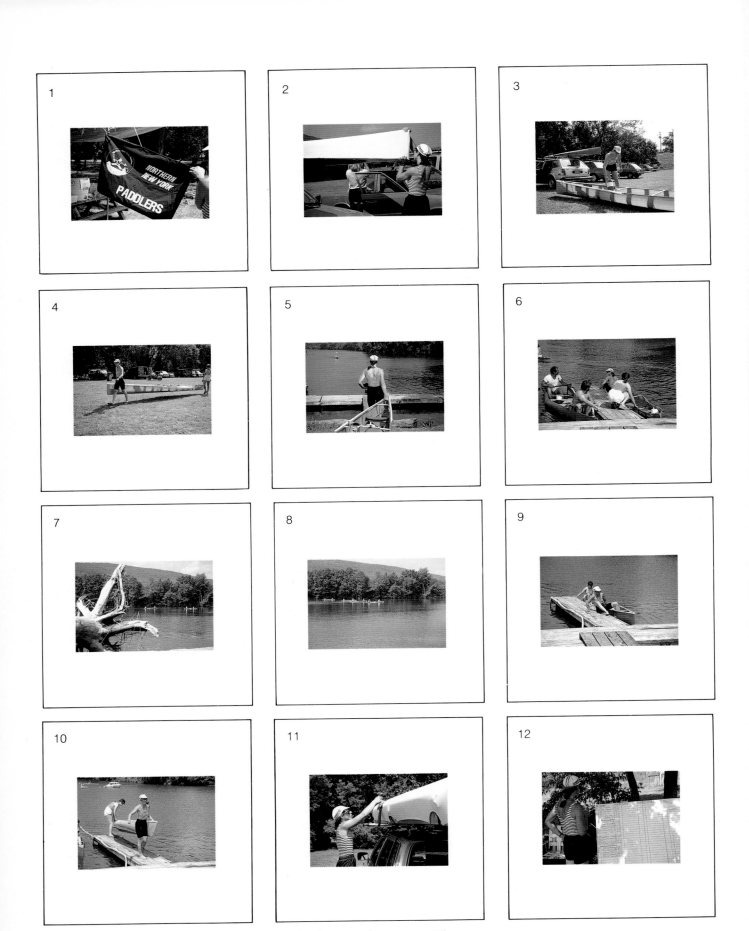

Pictures of a canoe race, which correspond to the shooting plan on page 25.

makes my jottings more organized. Such a script is called a shooting plan; a typical one is shown on page 25. This plan might not be a masterpiece, but it tells a story. It has an opening and a closing, as well as a built-in title: the entrance sign. These really are only to remind you to get the necessary overall shots and closeups, with suggestions for undoubtedly delightful pictures. As you can see in the plan, the majority of the slides are grouped in item four and allow for spur-of-the-moment decisions about what pictures to take. Planning doesn't have to be elaborate unless the topic warrants it.

Planning cards are a good idea if your show is more involved than the simple family excursion I detailed. Buy a few packs of 4 x 6-inch index cards. You can use these for notes, letting each card represent the idea for *one* slide.

A typical format for a planning card includes a 2 x 3-inch rectangle, in the proportion of a slide, in which you can sketch a picture of the scene. Don't worry: it doesn't matter if you aren't an artist. The object is not to make a detailed drawing of what you'll photograph, but merely to give a general idea of how it will look. Stick figures are fine, as are any rough outlines that indicate location, size, and camera angle. Sometimes you may not even need a sketch. A couple of words may do just as well, although an idea does come across faster when it is drawn.

You have room on the card for other essentials. There's a place for the number of the slide (but you will not use this until later in the show's planning stage). The section for "description" can include any other pertinent information: camera position, special lens or filter, time of day—even the color clothes the subject should be wearing, if that's important. There is also a place for writing down any words that you might want to use in the narration.

And now, the important part: deciding on the images. Tack your statement of purpose on the wall in front of you. Then, using one card for each again, write down every idea that will contribute to the purpose. *Every one.* You can eliminate the superfluous ideas later. At this stage, you may want to use blank index cards. Then, when you are more sure of what you want, transfer these notes and an accompanying sketch to the planning cards.

Don't worry if some of your suggestions seem outlandish. They, in turn, just might suggest something that will be perfect. This is called brainstorming, and it is an effective approach when used by yourself or with someone else interested in the project. When you feel you've run out of ideas, try again another day. With any creative project, a lot of ideas come after you stop working at it so hard, and many of these come during the night, when your mind and body are relaxed.

Next, you'll need a place to put these cards. Instead of just piling them up, lay them in front of you. One method is to spread the cards out on a large table, or even the floor. You'll find it more convenient, though, if you pin them to a vertical board. This makes the cards easier to see and move around and, certainly, easier to store. Most important, this will help inspire new ideas and will get you started in organizing them.

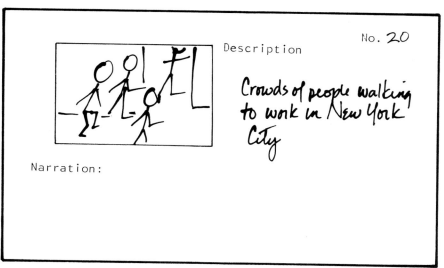

Description No. 20

Crowds of people walking to work in New York City

Narration:

A planning card need only suggest what to shoot.

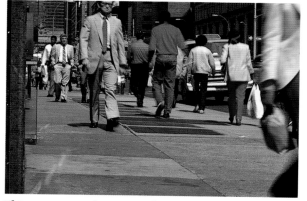

This scene was close enough to fill the need for a shot of a busy New York City street.

Many photographers use one or more planning boards. These are large sheets of plywood with plastic retainer strips to hold the cards. You can buy such boards or make them yourself. Almost as good are 3 x 4-foot sheets of soft composition board, insulating material, or corkboard. Use pushpins to attach the cards.

Major Sequences. Once the planning cards are on the board or the table, all you need to do is put those that logically belong together into rough sequences. Although you could plunk down the cards randomly, it's better to start organizing as soon as you can. This is fairly easy because you will be thinking in sequences.

When you have come up with all the ideas you can, you're ready to start organizing in earnest. This is one of the most critical phases in developing a slide show. And it is often the most difficult one because some pictures seem equally able to go in one place as in another. But that's the beauty of planning cards: they let you see how your ideas flow together and make it simple to shift them. (If your first cards are simply plain in-

dex cards with notes jotted on them, redo them on the type of planning card I mentioned, include a sketch or written notation, pertinent production notes, and key words of the narration. Now you're set to go.)

The task at hand is to decide how you want to organize the major sections of the presentation. The opening, closing, and transitions are easy. Subjects that need a chronological order are straightforward because the story develops logically. There are other approaches you might want to use. For example, you may try flashbacks or parallel action, which are variations of a chronological approach (see Chapter 1). Another way of organizing is to use cause and effect. One example is to alternate slides showing poor safety procedures in the darkroom with pictures of the consequences. Another is a longer sequence showing several unsafe practices followed by a sequence showing the disasters that result. You can also organize by showing the problem and solution or the right way compared to the wrong way. Logical thinking will help you with other subjects in which certain basic

principles or background information must be shown first.

Group all the related cards together. Although many of them will already be organized if you place them on the planning board thoughtfully, you'll find cards that have to be moved to other groups and some that have to be combined into new sequences. You're sure to have a few that don't seem to belong anywhere; put them in a separate section for now.

Once you've decided on the order of the sequences, you might want to stack the cards and put rubber bands around them. Place a card at the top of each pack that identifies the sequence. As when editing slides, it's more convenient to work with just a few at a time rather than 100 or so.

Editing
When editing a script, you move index cards around. You can handle the planning cards roughly, picking them up and touching them, without having to worry about damaging irreplaceable images. For identifying the pictures, this editing system is better than squinting over a slide illuminator to see which slide has the red sweater or the red shirt. Most important, though, is that as you edit, you will see where there are gaps, for which you'll need additional slides. All you have to do is make up new cards.

Lay out your planning cards sequentially, left to right, starting new rows when necessary. Add, delete, and rearrange the cards so they indicate a logical flow of information. If your notes about the slides are specific enough, you may even be able to edit for shape, form, and color. Give each card a number, stack them, put the card identifying the sequence on top, and proceed to the next sequence.

Photography
You're now about to embark on the photography—finally—and you'll see how the preliminaries help.

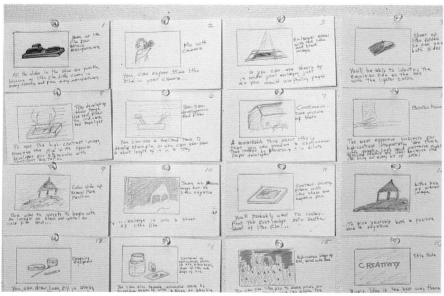

Tack the planning cards to a planning board; this makes it easy to organize them into sequences.

FILMS AND FORMATS

I promised I wouldn't discuss the ins and outs of photography, but a slide show requires some special considerations. One is the type of camera. I am assuming that you use a 35mm camera, which is good because the most versatile slide projectors are those that take 35mm slides.

110 and 126 Formats. If you work with a 110-format pocket camera, you may have a correspondingly small projector. If you want the versatility of a 35mm projector, you can have your 110 slides mounted in larger, 2 x 2-inch mounts. You can also buy adapters that enable you to use the 110 slides in a regular 2 x 2-inch slide projector. Slides from 110 cameras project a considerably smaller image than 35mm slides do, but they make good shows if your audience is small and can sit close to the screen. Cameras that take 126 film produce slides a little more than 26mm square, which will fit in a 35mm slide projector.

"Super-slide" Formats. You may have heard of "super-slides." These 38mm-square slides really are super. Super large and super costly, too. To shoot these slides, you need a medium-format camera adapted to make them. Hasselblad offers a film back for this format. With other medium-format cameras, you can trim the images to fit into super-slide mounts. Some projection lenses crop off the corners of super-slides, so be sure your lens works satisfactorily. If you don't want to trim the slides taken with a medium-format camera, use a special projector that accommodates them.

There are many excellent slide-transparency films from which to choose. You may prefer the color rendition of one manufacturer's film to that of another. Just remember to *be consistent*. Whatever film you choose, use it for as many of your slides as possible.

Emulsion Batches. Different emulsion batches sometimes show slight differences in color. Ordinarily this is not much of a problem, but you can avoid it completely if you buy 10 or 12 rolls of film with the same emulsion-batch number. You'll find this three-digit number printed on a side panel of the film box. Refrigerate all of the film to be sure the colors do not change. Let each roll come to room temperature for 1 1/2 hours before you open the package to use it.

Inconsistencies from one emulsion batch to another are nowhere as conspicuous as a change from one film brand to another. I mixed brands in one slide show and it disturbs me every time I see it. The films are equally beautiful, but the variation in color rendition is definitely noticeable.

Film Speeds. There are also obvious differences when you switch from a film with a low ISO number to one with a higher rating. The grain of an ISO 1000 film is much more evident than that of a slower one, such as ISO 100 film. Color rendition and contrast differ with speed as well. But some low light levels and the need for a small aperture make it necessary to change from a slow to a fast film.

Duplication. The need to make duplicate slides will also influence your film selection. Very likely, you may want to rephotograph a slide using a special effects technique, to have duplicate sets of slides made for distribution or for protection of the originals, or to convert the slides into a filmstrip or a videotape. Kodachrome films are magnificent projection films but they do not rephotograph well. Ektachrome films, however, can be duplicated with much less buildup of contrast.

Black and White Versus Color. You may not have thought about it, but slide shows can be done in black and white as well as color. It's an unusual treatment, which is one of the reasons it can be effective. Some documentary programs benefit from the stark, less realistic treatment of black and white.

To make black-and-white slides, shoot with either Panatomic X or Kodak Direct Positive Panchromatic Film 5246. Both can be developed to yield a positive rather than negative image. Both have ISO ratings of 80 in daylight and 64 under tungsten lights, but until you are well acquainted with them, bracket 1/2 and 1 *f*-stop each way. There are special developing kits for these films. The processing requires a development and redevelopment step, which takes a little longer than ordinary black-and-white processing, but it's not difficult. You'll find the directions with the Direct Positive Film Developing Outfit from Kodak or from Sprint Systems. After you've processed the slides, slip them into mounts.

The fastest way to make black-and-white slides is to use Polaroid's Polapan film. Use it in your 35mm camera as you would any other film, but process the entire roll of film in one minute in the special Autoprocessing unit.

Another approach to creating black-and-white slides is to shoot the pictures on conventional black-and-white negative film and make contact prints of it on vesicular film (see Instant Image Films in the list of suppliers at the end of the book). You can also make black-and-white photographic prints and then rephotograph them onto slide film—or let a lab do it for you.

Some of your planning cards probably have extremely specific notes, such as, "closeup of technician soldering," "picture taken from high angle over his left shoulder," or "background out of focus." If so, be sure to take that shot. Then look at your subject from a different angle or location and take another picture. It might look better than the one you planned.

Some of your other planning cards may be quite vague, indicating nothing more than "several shots of foot racers doing warm-up exercises." This gives you the freedom to photograph whatever looks appealing, but it, too, reminds you that you need certain pictures. As such, you can set them up or rearrange objects and people to make the composition suitable.

Planning cards also help you organize your photography expeditions. Most likely, you won't take the pictures in the order they will be presented in. You'll plan the photography according to the location or the people involved instead. For example, all the pictures in a playground, even though they will appear in different sequences, will be taken at one time, as will shots inside the classroom and those of a certain person.

Look over the planning board and gather all the cards for pictures that you can take at one session. After you've taken each photograph, put a check mark on the card. Later, this will tell you if you actually took the picture or just thought about it and got distracted, which can happen.

Simplicity. In a fast-paced slide show, in which images change every five seconds or so, it's best to aim for simplicity. Keep the pictures uncomplicated and uncluttered because the audience won't have time to look into every nook and cranny.

To ensure the simplicity of my pictures, I move furniture, pick up scraps of paper, and position my

subjects in front of a plain wall whenever possible. I also look for intruding shadows and distracting reflections. Sometimes all I have to do is move the subject or the camera a few inches; other times I might rearrange the lighting or minimize a reflection with dulling spray or Pan-Cake makeup. I've asked people to remove rings or watches because they competed with the main subject in a closeup. These are good practices when taking a single picture; they are even more important when shooting for a slide show. There are exceptions, of course. You may want the picture to indicate confusion or mass excitement, which a busy slide can do.

Another rule to follow in shooting for slide presentations is to take horizontal pictures. Remember that horizontal photographs are preferable to vertical shots, when you are taking pictures and sketching planning cards. You may decide to do a show with all vertical slides, which can be pleasing, but if you alternate between horizontal and vertical, be sure to take transitional pictures (see Chapter 1).

Lighting. Lighting and exposure in a slide presentation demand consistency. Over- or underexposed pictures don't look good by themselves, and they look worse when they're part of a sequence of correctly exposed slides. In order to get all the needed slides, remember every photographer's favorite technique: bracketing. You don't have to do this with every picture, but it's a good idea for difficult situations, such as backlit subjects and high contrast conditions. Take your meter reading from the subject; use that as your main exposure reading, and then bracket by making additional pictures 1/2 or 1 *f*-stop over and under the main one.

The color and quality of the light can change without your being aware of it. But you will notice

the difference in your shots. Pictures taken in hazy sunlight will have softer colors and shadows than those taken in bright sunlight. Pictures taken close to sunrise and sunset will be much redder than those taken at other times of the day. And you know the greenish cast you can get under fluorescent lights. It's best to shoot all the slides for a particular show under similar circumstances or, when you can, use color-correction filters so the color balance matches.

Camera Viewpoint. There are two points of view you must choose between during the planning stage: subjective and objective. Photographs are almost always taken with an objective point of view, in which the camera acts as an anonymous observer of the scene. The camera records—objectively— what is going on in front of it and, therefore, the audience observes the scene objectively. From the subjective point of view, the audience becomes part of the picture, experiencing and seeing things with the camera acting as its eyes. This is often used in instructional

An objective picture is seen from the viewpoint of an observer.

A subjective picture is seen from the viewpoint of a participant.

ANOTHER DIMENSION

You've seen 3-D in the movies, on television, and even in some prints, but I bet you didn't know you can achieve it with slides, too—without a special camera or projector.

First, it helps if you understand how we perceive depth. Try this: take a film box and, with one eye closed, place the box in front of you so you see only the front surface, not a side. Open one eye and close the other. Now you should see the side of the box. Because our eyes are spaced slightly apart, each eye sees a slightly different view of an object, and the brain combines these two images into one that has depth. An ordinary picture, or slide, shows objects as seen with one eye, and it looks flat.

If you could make two photographs of a subject, each from a slightly different viewpoint, and project them so each eye would see only one of the pictures, the brain could then interpret them as having depth: the third dimension. Actually, the only tricky part of doing this is determining how far the pictures must be offset from each other. Our eyes are approximately 70mm apart, and this interocular distance is a good starting place for experimentation. As you get closer to your subject, you need less distance; as you get farther away, you need more. Since objects in the distance look flat to our eyes, objects at infinity don't lend themselves to 3-D pictures.

For a subject 6 feet away, move the camera 70mm between the first two exposures; try another pair, making the offset 80mm, and so on. Then focus on a subject 10 feet away, and vary your distances

by 15mm for each pair of exposures. With subjects closer than 3 feet, move the camera in increments of 5mm. Be sure to keep good notes so later you will be able to judge how much to move the camera.

One way to position your camera is to make a sliding bar of slotted aluminum. It will look like the base of a flash bracket; in fact, if you have an old bracket, you probably can use it after you've removed the vertical portion. Put the bar on a tripod and take two pictures, moving the camera laterally between the exposures. It helps if you mark the bar in millimeters, do some trials, and vary the lengths for different subject-to-camera distances.

If you have two camera bodies and two lenses of identical focal length, the process is easier. Mount them together on a tripod or other support, placing them as close to each other as possible. You can use a homemade slider bar or a sophisticated platform that has two attachment screws. Again, you'll need to do some testing to see how far apart the cameras should be for subjects various distances. Use a double cable release to trip the shutters. With two cameras, you can photograph subjects in motion.

The easiest way of all is to acquire a stereo camera that accepts slide film. The Nimslo camera won't do, but old Stereo Realists are available from used-camera dealers and private enthusiasts.

You'll want to keep track of which slides are for the right eye—or, more accurately, the right projector—and which for the left. Jot this in a notebook or simply assign all odd-numbered

frames to the right and all even-numbered ones to the left.

To project the slides, you'll need two projectors, a metallized screen, a sheet of polarizing material, black photographic tape, and special polarizing glasses. (See the list of suppliers.) Some silver screens work especially well, but a metallized lenticular screen will also be fine.

Turn on both projectors and, with a pair of alignment slides, adjust them so the images coincide. Next, cut the sheet of polarizing material into two squares, each large enough to cover a projector lens. Put on the polarizing glasses and turn on the left projector. With no slide in the projector gate, hold a piece of polarizing material over the lens, and rotate the polarizer until the screen appears almost black as you look at it with just your right eye. The next step is to tape the polarizing material in place.

Now, turn off the left projector and turn on the right one. Repeat the procedure until the screen appears almost black as you look at it through your left eye. The polarizers make it possible for the viewer's eyes to see only the slides projected by the corresponding projector. Only a metallized screen will retain the polarization of the light.

Load the projectors, making certain that the slides for the right and left eyes are in the corresponding right and left projectors. You'll be projecting the images simultaneously from both projectors. Next, to advance the slides easily, work with the projector remote controls, which have been joined. Now you're ready to do an in depth presentation.

presentations because it allows students or trainees to view a procedure the way they would see it if they were doing the task.

The subjective use of the camera is a powerful emotional device. I did a show documenting one of my own hospital experiences, and the subjective camera conveyed my reactions to the situation more dramatically than objective pictures ever could have. The only pictures of myself were reflections in mirrors or images on a video monitor. Another production that used a subjective viewpoint was one of the most clever I've ever seen. Shooting from the viewpoint—and eye level—of a dog, the photographer had to do a lot of slithering on his belly. Some shows are shot entirely subjectively, although it's more common to let only specific sequences be subjective.

Clearly, when shooting from the subjective viewpoint, place your camera where the subject's eyes would be, which is at different heights for someone standing or seated, a small child—or a dog. Instructional pictures may be a little more difficult to take because you are generally shooting over the shoulder of another person. To take an objective picture of a person sewing, for example, you face the person or stand to one side. To take a subjective picture of this individual, you stand behind him so the camera sees the person's hands and materials just as his own eyes would. You'll find you'll have to shift your position—most likely, you'll be standing on a chair. Be

especially careful that nothing obscures the subject.

Point of View (POV). A point-of-view shot falls somewhere between objective and subjective ones. It is an ordinary, objective shot viewers interpret as subjective because of the way the pictures are edited. Here's an example that will help explain. Suppose you show a person looking to the left or right, out of the picture area. You then follow that slide with a scenic view. The audience regards the second picture as what the person is looking at. The camera momentarily changes place with the person in the picture and the audience sees the scene through that person's eyes. It's an excellent device. In the first photo, the person can look left, right, up, or down. The following slide must be shot from the appropriate camera angle. This naturally brings us to our next subject.

Camera Angle. The camera angle is another technique that you can decide on in the planning stage, but you may want to experiment with other angles when you are face-to-face with your subjects.

Level Camera. Most photographs are taken with a level camera. In objective viewpoint pictures, the eye level is that of a photographer of average height. If you are much taller or shorter than average, you may it helpful to alter your position a bit.

There are many exceptions. If you are photographing a seated person, you will want your sub-

ject's eyes and yours to be on the same level. You should squat or sit in a chair. If you are standing and your subject is sitting, the shot is no longer level. Do the same when photographing your children or your cat.

Level cameras may not produce pictures as interesting those taken from other angles, but they usually are best for general scenes and closeups. The audience can comprehend these pictures quickly because they appear the way viewers would normally see such scenes. People's faces are usually more flattered by an eye-level shot. The level shot can be dramatic if you photograph a vehicle head-on and closeup, giving the impression it is rushing toward the viewer in a subjective manner.

High Angle. A high-angle shot is one in which the camera tilts downward from a lofty vantage point. You can climb on chairs, stand on tables, or even rent a helicopter. These shots add variety to your pictures. A high angle is excellent for orienting the audience because it can give an unencumbered view of the area. This could be a landscape, a room, or the top of a table. In an eye-level view, foreground objects obscure background objects. In a high-angle shot, the viewer can see everything, and the relationship between more important and less important things is made clear. This type of shot can also minimize the importance of your subject, making it seem small or insignificant.

Another advantage of the high-

A shot taken at the eye level of the subject is usually most flattering, but high and low angles can be more interesting.

angle shot is that it can keep both near and far objects in focus because both foreground and background objects are relatively the same distance from the lens. A level shot would have a more limited depth of field.

Consider using a high angle when your subject is arranged in a pattern on the ground. A formal garden with flowers, hedges, and winding paths cannot be fully appreciated in a level shot. But if you stand on a hill above the garden, the planned designs reveal themselves. Industrial complexes, cultivated farmlands, racetracks, and highway cloverleafs are other examples of subjects with interesting patterns that can be appreciated from above.

How high is high? All camera angles are relative to the subject being photographed, and any shot in which you tilt the camera downward is a high-angle one. You may have to perch on the branch of a tree for one shot and put the camera below eye level for a still life, yet both are high-angle shots.

Low Angle. Naturally, the camera is tilted upward in low-angle shots. There are many reasons to use this type of picture. Sometimes this angle is the best one to show a person's features or the details of an object. It can also let a particularly handsome ceiling become the background for your subject. A low angle can make a picture—especially a landscape—more interesting because it lowers the horizon and exaggerates the convergence of lines of perspective.

More important may be the drama a low angle can impart. From this camera position, the subject looks larger and more impressive. A building, tree, or person can be made to dominate the scene. To further emphasize the effect, try using a wide-angle lens along with the lowered position. This low position also creates a greater separation between people or objects, or between subject and

A Dutch tilt can convey a catastrophe or a highly emotional state.

background. It also emphasizes the speed of a moving vehicle.

If you want to give one person prominence in a group, try placing him or her slightly in front of the others while you crouch down to take the picture. This will cause your subject to tower over the other people. Any person photographed this way will seem more powerful or authoritative. Sometimes you need only a slightly lower angle to make an unimposing, short person seem more impressive. When the person is already an authority figure, you can use the angle to emphasize this. A low camera angle is all you need to make the audience be in awe of something or someone.

You can eliminate the foreground and the background when you work from a low camera position. This comes in handy when you need a reaction shot of a person against a neutral background. And, as with a high camera angle, the difference in camera position is relative to the subject. It's not always easy to get the camera below a small subject. The solution is to raise the subject—on a stool, on a table, or on top of the refrigerator.

Dutch Angle or Dutch Tilt. A picture taken with a Dutch angle or tilt is taken at an angle that makes the image slant. You may have taken shots with slightly tilted horizon lines; this is more extreme. This type of shot doesn't look like a mistake because it isn't. It is a deliberate tilt of the vertical lines. If used sparingly, it can suggest that a person is drunk, delirious, or in some highly emotional state. It is especially effective when combined with a subjective shot.

The Dutch tilt can also be used to suggest a catastrophe. It is ideal for an earthquake or a shipwreck, but it can be used to convey the confusion of other disasters as well. Most of the time you will want to use several tilted photographs in quick succession. You might even choose the tilted camera when taking a series of pictures for a montage that creates an overall impression of the passage of time or of covering a great deal of space. You can also use it for shots that show glimpses of events, such as the phases of a manufacturing process.

The angle of the camera should be sufficient to give the subject a decided slant, but not so much that it appears to be lying on its side. It's wise to shoot pairs of tilted pictures. Images that slant

A *full shot shows the full length of a person.*

A *medium shot of a person places the bottom of the film frame somewhere below the waist and above the knees.*

A *closeup generally shows the area above a person's shoulders.*

toward the right are more forceful and active. Keep this in mind if you change rapidly from one image to another rather than projecting pairs of opposing tilts of the same subject. Dutch tilts are doubly effective if you shoot them from a low camera angle. This throws the images backward in a very crazy angle. Use a wide-angle lens and you'll create a feeling of violence.

Image Size. The term "closeup" is probably familiar, but I think it's best if I define it as well as some associated terms. Long shot, medium shot, and closeup are all related to the size of the image as it appears in your camera viewfinder and on the slide.

An extreme long shot (ELS) shows a vast area and is taken from a great distance. The breathtaking views you've taken when visiting a picturesque area are extreme long shots. A long shot (LS) shows the entire area of the action of your story, perhaps a factory interior or the street where you live. It shows the setting where you photographed the rest of the sequence and acquaints the viewers with the location. It establishes all the elements in the scene and is, therefore, frequently called an establishing shot. As you change locations during your presentation, you should provide a new establishing shot for each place. If you stay in one place for a prolonged length of time, provide a reestablishing shot—another similar picture of the location—to re-

mind the viewers of where they are. A long shot does not necessarily mean the camera has to be quite a distance from the subject. If the subject is small, the camera can be close and still show the complete subject and the locale.

A full shot (FS), sometimes called a medium long shot (MLS) to make it confusing, does not show the entire setting. It shows only the full length of a person or an object.

Probably the most useful and frequently used shot is the medium shot (MS). It is somewhere between a closeup and a full shot in size, and everyone has his or her own definition of the exact area it takes in. When talking about a picture of a person, I think of it as placing the bottom of the film frame somewhere between the knees and just below the waist.

A closeup (CU) is, of course, taken even closer to the subject. For a picture of a person, this might mean showing an area from just below the shoulders to just above the head, but, again, there are a variety of definitions. As long as you know what *you* mean when you specify a closeup, you won't have a problem.

An extreme closeup (ECU) greatly magnifies a tiny object or a small portion of a large object. A closeup of an insect, flower stamen, or an eye can be quite effective on the screen.

Lenses and Filters. Good photography for a slide show, as for all photography, depends on knowing

what lenses will produce the effects you want and being comfortable using the lenses. For these details, you can consult basic photography books. Filters of all kinds play a role in photography for slide shows. Color-correction filters, polarizing filters, and neutral-density filters can improve your images when used appropriately. You'll especially want to explore the exciting world of special effects filters and lens attachments. When ordinary scenes look too ordinary, you can do hundreds of things to keep them from being banal.

Diffusion and fog filters can add an ethereal, misty look to scenics and closeups. Some of them have color combined with the diffusion; if you don't have one of these, you can stack a color filter with a diffusion filter. Color filters cast an overall tint on the scene. Some are graduated, so the color reaches only part of the area.

Star filters turn any bright point of light into a star. Diffraction-grating filters put rainbows of colors in streaks, spokes, or other configurations into your pictures. Multiple-image attachments do just that: multiply the number of images of your subject by two, three, five, and more.

This is only a partial list of the wondrous things you can do with lenses and filters. Such effects can change the mood of or add impact to your presentations. Just don't yield to the temptation to overdo it. Two or three special effects may be all you need; too many, and they're not special any more.

With a star filter, bright points of light become stars. Some star filters also add colors to the spokes.

A diffraction-grating filter adds rainbows to pictures. The effect can be subtle, as it is here, or obvious.

Number of Pictures to Take. Be prepared with a lot of film. You will have better choices when you're ready to put the show together if you have several slides of every subject on your planning cards—as well as some pictures that are not on your planning cards. You'll need to take extras when bracketing in tricky lighting situations, of course. Don't restrict yourself to one image, especially of people. To get a good facial expression, you may need to take several exposures.

You will also find that pictures taken from different angles and with different image sizes may be terrific in addition to—or in place

of—the planned shot. These extras will prevent the images from becoming monotonous during a long segment of narration. You probably won't have written a narration when you go out to take the pictures, and it's quite likely that you'll underestimate how many pictures you will need. Because no more than 5 to 10 seconds of screen time is desirable for any one slide, you may need several slides to go along with one paragraph. Remember: don't let your planning cards limit you to just one shot.

Sometimes you will want to use the same picture in different parts of the show. The best way to get these duplicates is to take several originals, one after the other. You could, of course, have duplicate slides made of a favorite shot later, but the color and contrast of the duplicate most likely will not be identical to the original.

As a rough estimate of how much film to buy, figure on a shooting ratio of 4:1 (four pictures for every planning card). It doesn't hurt to take extra film with you. You can always store what you don't use for the next time.

Identifying the Pictures. Some photographers find they can sort pictures faster if they identify each roll of film, then log it in a notebook. This is especially helpful if you are taking pictures of unfamiliar subjects, such as buildings in a foreign city.

There are several ways to do this.
- One way is to put an identifying number on the film itself. Stretch out your arm and photograph one, two, or five fingers. They may be out of focus, but this shot serves its purpose.
- Have a friend hold up the appropriate number of fingers when you're using more than five rolls.
- You can also write the information on a sheet of paper and photograph that.
- Another method is to mark the

film canister. When you send it for processing, transfer this number to the receipt or to the address label of the mailer.

Putting It All Together

You've planned, you've photographed, and now it's time to put the show in order. Take the planning cards out of your camera case and arrange them in numerical order as you put them back on the planning board. Project the slides several times so you can pick out the best ones. Using the planning board as your guide, arrange the slides on the illuminator. It will probably be less confusing if you place them in horizontal rows. Many people, though, prefer to set them up vertically. Try both arrangements and see which works better for you.

You can start editing even if you do not yet have all of the pictures. Make stand-ins for the missing slides by substituting blank slides that you can write or draw on to indicate what is to come. As you edit, you may find something that will improve the show that you didn't think of earlier. And you'd be unusual if there isn't at least one picture that has to be rephotographed. Make a note of any such slides and reshoot them.

The rest of the editing procedure is substantially the same as that described in Chapter 1. With a good plan—and good photographs to correspond to that plan—this should go quickly.

FILM SPEEDS

The term "ISO" has replaced the familiar ASA as a designation of film speed. The higher the number, the faster—the more light-sensitive—is the film. Thus, a film rated ISO 200 is twice as fast as one rated ISO 100.

Word Slides and Graphic Images

Almost all the slides in your shows will be photographs of people, scenes, and objects. But other kinds of images can add the finishing touches to your production. These are word slides and graphic images.

Word slides are most commonly used for titles. Often, you'll want to use a main title for the name of the presentation and several titles within the show to highlight different sequences. It's nice to include a slide to give yourself credit as the producer/photographer or to acknowledge the help of friends who held lights, recorded sound, or went out for coffee. Lecturers make extensive use of word slides to introduce new topics and summarize points they've made.

When there is no way to photograph a certain object or situation, you can use a drawing or sequence of drawings. Illustrations or diagrams can often show things better than photographs. Maps, charts, and graphs can clarify information,

and cartoons are a fun change of pace. Switching the format from ordinary photographs to graphic illustrations can help you capture the audience's attention.

Equipment. For some of the techniques, you probably have all the necessary equipment. For others, you'll need some special items, such as a lens that will let you get very close to the subject, a rigid support for the camera, and a way to light the subject evenly. Your setup doesn't have to be expensive, and you can improvise some of it. But if you're challenged enough to do a great deal of this kind of photography, you will want to invest in better equipment.

Closeup Lens. A standard 50mm lens usually must focus on something that's about two feet away. To fill the frame at this distance, the subject's size must be about 10 x 15 inches. Not many drawings or pages in a book are this big. You can enlarge the drawing, but it's

FIELDS OF VIEW, AT CLOSEST FOCUSING DISTANCE, FOR 35MM CAMERA	
50mm lens	280 × 400mm
with +1 attachment	238 × 349mm
with +2 attachment	156 × 235mm
with +4 attachment	92 × 136mm
with +1 and +2 attachments	117 × 171mm
with +1 and +4 attachments	76 × 114mm
with +2 and +4 attachments	67 × 98mm
macro lens	48 × 72mm
macro lens with 1:1 extender	24 × 36mm

easier to change the focusing capability of the camera.

The most economical solution is to use closeup lenses. These lenses come in various strengths and are termed "+1," "+2," "+3," and so on, up to "+10." The higher the number, the closer the attachment lets you get to the subject, and the closer you get, the more the subject fills the frame. These "plus" lenses, or "diopters" as they are also known, screw onto the front of your regular lens much as a filter does. They are slightly convex, and the convex side goes away from the lens. To further increase the magnification power, you can stack two closeup lens together. That's why I recommend buying a set of three lenses (a +1, +2, and +4). Always put the one with the largest number closest to the camera. This arrangement can give you an acceptably sharp image if you stop the aperture down to $f/8$ or $f/11$ and do not stack more than two of these lenses together. The advantage of using these closeup lenses is economy: you can buy a set of three for less than $25.

The best lens for closeup work is a macro lens. It costs about $300, but you may decide it's the best purchase you ever made. Mine is one of my favorite lenses, and I use it for general photography as well as closeup projects. A macro lens delivers a very sharp image from center to corner—much better than a standard lens with an accessory closeup lens. And, a macro is convenient. A closeup lens can be used only within a limited distance range from the subject, which means you must place it carefully so the subject fills the frame. With a macro lens, you can vary the camera-subject distance to change the image size. In fact, you can come so close that the viewfinder takes in an area as small as 48 x 72mm and, with an extension, you can even use the lens to rephotograph a slide. Zoom lenses with macro capability, although they focus at close dis-

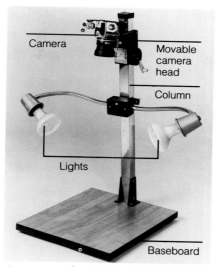

A copystand, such as this Bogen model, is an ideal way to do closeup work.

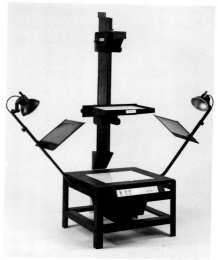

The Bencher stand is a versatile, professional unit, with backlighting as well as toplighting.

tances, do not give as sharp center-to-corner images.

A minor point is that a macro lens needs more light—or longer exposures—than an equivalent standard-focal-length lens. But you'll be supporting the camera on a copystand or tripod (see next section), so this should be no problem. Supplementary closeup lenses need no additional exposure.

Copystand. You need a way to hold the camera and the subject you are photographing. The subject for this kind of photography is called either artwork or copy, and the best place to put the copy is on a copystand. A copystand consists of a copyboard (also called a baseboard), which is a flat surface to hold the copy; a column to support the camera on a movable camera head; and a lamp on each side of the copyboard. The lamps are at a 45° angle to the copyboard. This throws a uniform illumination over the entire surface, so even if the surface is shiny, there won't be a glare. Some copystands have two lights on each side, but they're only necessary if your copy is larger than 20 x 30 inches. Otherwise a two-light unit is fine.

For occasional use, you can improvise a copystand arrangement by putting the camera on a tripod

and using photoflood lamps that are on stands or are clamped to nearby supports. Tripod legs tend to get in the way unless you elevate the copy on a stool or a few books, or unless the tripod allows you to mount the camera upside down on the bottom of the column.

Another way to use your tripod is to keep it in its normal position, camera facing straight ahead. Instead of using a copyboard, tack the copy to a wall or put it in a tripod-extension arm made for this purpose. Also, some darkroom enlargers are designed so you can substitute your camera for the enlarger head. This lets you move the camera on the column and put your artwork on the attached baseboard.

Make sure your lighting is evenly distributed. You can check it with an exposure meter, but I find it easier to hold a pencil in the middle of and perpendicular to the copyboard. The pencil will cast two shadows. If they are equally dark and equally long, the lamps are angled correctly.

Accessories. A few items make major differences in the quality of your work. You should always use a cable release. Your exposures are apt to be 1/4 sec. or longer. As a

result, the slightest camera movement will blur the picture when you're doing closeup work. A flexible cloth release transmits less vibration than the slightly more rigid metal one. Hold it in a flexed position.

If the surface of your copy is extremely shiny, you'll find yourself taking a picture of the reflection of the camera. Very avant-garde, but not necessarily what you want. Block the reflection with a shadowboard. Cut a hole in a large sheet of black paper and slip it over the lens. I cut slashes around the opening to make mine stay in place, but you can hold it on with a lens shade, too.

When working with lamps this close to the copy, always use a lens shade to prevent stray light from entering the lens and fogging the film. You won't need it with a macro lens because the lens surface is recessed.

You'll make good use of a photographic gray card when you're about to take an exposure-meter reading. If you attempt to take one from your copy, the prevalence of the background area can result in an incorrect exposure indication. To just about guarantee the correct exposure, place the gray card where the copy is to go, take a meter reading, and then substitute your copy.

The camera and the copyboard must be parallel. The best way to check is to place a small bubble level on the copyboard and then on the back of the camera. Adjust the equipment so the level reads the same for both.

Lights. Most people make all their word slides and graphics on a copystand setup. There are other clever ways of doing them, but these still require light. Outdoors, there's the sun, of course. Indoors, I recommend quartz lamps or less expensive photoflood lamps placed in reflectors. You can mount either type on light stands, but if you use a socket with a clamp, you can mount a photoflood lamp almost

Lettering styles for titles can suggest mystery or excitement.

A single word filling the screen can be emphatic.

The lettering on the right can be read easily, but that on the left can't.

anywhere. Barndoors are metal flaps that attach to the front of the reflector. They direct the spread of light. I like them because they keep the light out of my eyes.

Word Slides

Letters against a background are the basic ingredients of word slides. Before you put them together, though, you'll want to plan so the combination is successful.

Appropriateness. Everything from the kind of lettering to the color of the background should relate to the topic. An approach that's perfect for pictures of your son's third birthday may be completely out of place in a formal presentation about safety procedures at work.

Decide what fits the mood of your show, too. Is it formal/informal, serious/humorous, 1890s/1980s? It's not sufficient that you think a particular style or technique is beautiful; make sure it is appropriate for the subject—and appropriate for the audience.

Simplicity. Cluttered, busy pictures do not communicate very efficiently; neither do cluttered word slides. Simplify them by reducing the amount of information. If you are planning more than 25 characters on a line or more than six lines on a slide, rethink the words you want to use. You'll find words you can eliminate and still leave your meaning clear. For example, "Volunteers are an impor-

MINIMUM LETTER HEIGHTS FOR TYPICAL WORK AREAS			
WORK AREA	LETTER SIZE		
in inches	mm high	uppercase printer's point size	lowercase printer's point size
2 × 3	2	8	12
3 × 4.5	3	10	16
4 × 6	4	12	18
5 × 7.5	5	16	20
6 × 9	6	18	24
7 × 10.5	7	20	28
8 × 12	8	24	36

Here, the white letters merge with the light-colored building.

Here, there is sufficient contrast between the words and background.

Here, the contrast between the lettering and background is good.

tant source of strength to our hospital" could more clearly be "Volunteers: source of strength," thereby cutting the character count in half.

Pretend you're writing a telegram. You can usually eliminate articles and some verbs. When you do have a lot to say, put it on two or three slides instead of jamming all the information onto one slide. The one slide/one idea concept holds for word slides as well as pictures.

The backgrounds must be simple, too, so they won't conflict with the message. Plain colors and subdued textures are better than loud, bold patterns. Pictures frequently make good backgrounds, but they should not be more attention-getting than the words. You need a clear space for the actual lettering.

Size. If each member of the audience could sit close to the screen, it wouldn't matter what size you made the letters. But you should plan for a large audience and make the letters big enough to be seen by people in the back. The rule of thumb is that the projected letters should be a minimum of 1/25 the height of the image. A quick way to evaluate a slide is to hold it in

your hand at normal reading distance. If you can read it easily, the letters are probably large enough. Better still, hold the actual copy away from you at a distance of eight times its height. Again, if you can read the copy easily, the size is fine. But to be absolutely sure, measure. Use an area that's in the 2:3 proportion of a slide and refer to the chart on page 38 for the minimum size for the letters.

The minimum size for lettering is just that: *a minimum*. Your audience will be happier if the letters are larger because they are easier to read—up to a point. If the letters get too big, the words crowd to the edge of the frame. This is unattractive. You might want to try it occasionally to emphasize a single word, such as "now" or "new." Otherwise, leave some room.

Format. Slides are in a 2:3 ratio, so you must make your copy in that proportion, too. I find it convenient to put my lettering on an art board or background paper that measures 9 x 12 inches. This gives me a 6 x 9-inch work area as well as a safety margin for the background to bleed into. This safety margin is necessary because with most SLR cameras you'll get a lit-

tle more image on the film than you see in the viewfinder. The 9 x 12-inch board also gives me a handling area, so I don't have to be concerned about bent corners or finger smudges showing on the slide.

When all the artwork is the same size, it's easier to photograph; the camera can then stay in one position and at one focus setting for every shot. This also makes it simpler to store the completed work.

Contrast. Can you imagine white lettering against a picture of snow, or dark blue lettering against a black background? I've seen them. Rather, I've tried to see them, but without sufficient contrast, the words were almost impossible to read. The need for contrast is obvious, but people sometimes make slides that don't separate the lettering from the background very well. The most readable slides are those with light-toned letters against a dark background or bright letters against a subdued tone.

You'll notice I didn't suggest putting dark letters against a light background, which would provide excellent contrast. It's hard to look at vast areas of light tones on the screen. Instead of putting blue letters against a yellow background, do the opposite. This combination (yellow letters against a blue background) works especially well. However, white lettering against a black background affords almost too much contrast and is somewhat difficult to look at. It's better to substitute color for the black or white.

Color. Besides being attractive and creating contrast, color can establish a mood. In general, we associate the warm colors—red, orange, and yellow—with joy and excitement, while the cool colors—blue, green, and violet—convey more calm feelings.

Color can also unify a word slide with the slides that come before and after it. Suppose, for example,

you have a picture with a vast expanse of sky. A blue background on the title slide that follows will give continuity to the sequence. But for a bit of excitement, try a drastically different color. It's also worth noting that visually the cool colors seem to recede and warm ones come forward—another reason why blue makes a better background color than yellow.

Some background/letter combinations are unsatisfactory because of the visual vibration effect they cause. This is a shimmering movement at the boundaries of a few combinations of highly saturated, equally bright colors. (This perception is related to a complex set of psychological factors). In practical terms, unless you want to drive your audience crazy, don't put bright red letters against a bright blue or green background, and vice versa.

You can also use familiar color codes to carry a message. A slide says something very definite if it's done in red, white, and blue, or other combinations associated with a country, holiday, or group. *Legibility*. Many lettering styles are eye-catching on a printed page but are difficult to read on the screen. Ornate letters or contemporary letters that bear only a subtle resemblance to our familiar alphabet take a long time to decipher and end up annoying the audience. Because you want to make it as easy as possible for people to understand the message, choose lettering styles that are rather plain, without extra lines and embellishments.

Letters with serifs, those little hooks at the end of the strokes, tend to make words hard to read on the screen. Type styles known as sans serif (without serifs) are much better. Letters with very skinny strokes or very thick ones—fine and bold respectively, as they are known to the typesetter—are also much more difficult to read than those with medium-weight strokes. You'll find that tall letters, whose height far exceeds their width (condensed) and the opposite (extended) are both less legible than letters with squarer shapes.

Interestingly, words printed in uppercase (capital letters) are harder to read than those printed in lowercase letters. It doesn't matter with a line or two, but if a word slide has more than that, it will be easier to read if you use a combination of upper- and lower-case letters, or all lowercase letters, in a contemporary approach. *Spacing*. The spacing of letters and lines of letters is important in making readable slides. When letters are too far apart, they do not seem to belong together. Words in which the letters are extremely close, even touching, are easier to read than words in which the let-

Poor choices for word slides.

These type styles are readable.

Drawings by Karen Brogno

With plain, colored background slides, such as ones from Prima, pictures can be drawn on mounted slides.

news

news

news

Letters with medium-width strokes, such as the example in the middle, are better choices for slides than those with very thin or very thick strokes.

Univers Medium Condensed

Univers Medium

Univers Med. Expanded

Condensed and expanded lettering styles aren't always legible from the screen. Styles in which the height is closer to the width are best.

ters are widely separated. There is no rule about minimum spacing between letters; just leave a little room between them. Uppercase letters need a bit more space than lowercase letters. The maximum amount of space, though, is critical. A good guideline is to keep the distance between the letters a maximum of half the width of an average uppercase letter, such as an "H" or "N."

You need to leave adequate—but not excessive—spacing between words, too. Try a distance that's slightly less than the width of an average letter: "H" if you're working in an all uppercase or "h" with lowercase or upper- and lowercase. Finally, consider, too, the spacing between lines of lettering. If it's too large, you'll destroy the unity between them; if it's too little, the words will get tangled with one another. A distance of anywhere from half the height of to the same height as the letters will look good, but a lot depends on the style of lettering and what else decorates the slide. Put related lines closer together than unrelated material.

Optical spacing can make the difference between attractive and unattractive word slides. Although the distance between adjacent letters can be exactly the same, it can seem different because the shapes of the letters are not the same: some are straight-sided; some, curved; and some, irregular. The difference in shapes changes the amount of space surrounding each letter. Obviously, the letter "I" is narrower than other letters, but the rest are not equal in width. We usually can consider the letter "H" as an average letter. If so, "A," "M," and "W" are wide in almost all typefaces. But letters may be wide or average, depending on the typeface. The trick in optical spacing is to use your eyes to create the same apparent amount of space around each letter. If you place curved and irregular letters

For optical spacing, arrange the letters so the eye sees equal amounts of space surrounding each one.

Optical spacing is important when placing words under each other.

Changes in color, size, brightness, or type can emphasize important words.

closer together than straight-sided ones, you eliminate some of the area between them and balance the additional room at the top or the bottom. Begin by establishing the distance between two straight-sided letters, and relate all the other spacings to this. You'll find you need to place curving sides so close they almost touch, and you'll want to place slanting sides so one undercuts the other.

Lines of printing placed one under the other need optical spacing, too, if you want the left margin to appear straight. When two lines of type start the same distance from the side, the second line may have to be moved slightly to the left so it *looks* even with the upper line. Typefaces vary, and what may be irregular in one style may be regular in another. You'll do most of your optical spacing with uppercase letters because most lowercase letters are similarly irregular. This is one more thing to think about when you assemble letters. Actually, it makes the spacing of letters a game for your eyes rather than a task for a ruler.

Consistency. Whatever colors, letter size, letter style, or type of background you choose, *be consistent.* I saw one odd-looking presentation in which some title slides had been done on a typewriter and others used three-dimensional letters. Unless you have an extremely good reason for changing titling methods midstream, it's best to use the same one throughout.

Emphasis. Often, you will want to emphasize one or two of the words on a slide. You can do this by introducing variety. Change the color of a word, especially to red or another bright color, and that word becomes the center of attention. You can also make it larger, use bolder strokes, set it in a different typeface, or separate it from the other words. Just don't go to extremes. Very thick and very thin letters do not combine well, nor do certain typefaces. A little extra space surrounding a word also emphasizes it; too much space makes it seem isolated. Your judgment is the best key to what works and what does not.

LETTERING METHODS

There are dozens of approaches to lettering, ranging from almost effortless to complicated, time-consuming methods. Here are the easy approaches.

Found Lettering. Some word slides are as simple as point-and-shoot. When someone else has already done the lettering and placed it on an attractive background, you might as well take advantage of it. This is ideal for travelogs because you find road signs and monument markers wherever you go. You won't need any closeup equipment, and since you can shoot them along the way, the title slides will be finished at the same time as the picture slides. You will also find ready-made titles on the fronts of buildings.

Watch the lighting when you take the camera outdoors to photograph words. For a painted sign, make sure you have even illumination, with the sun in front of the subject. For lettering that's cut into the surface or raised, wait for the sun to move to the side to emphasize the dimensionality.

Another suggestion: look for found lettering embellished on products, printed brochures, newspapers, greeting cards, souvenir T-shirts, and shopping bags. Photograph flat copy on the copystand, getting as close as necessary to make the letters large enough.

Precut Dimensional Letters. Every camera store sells three-dimensional letters, which are convenient and versatile. You can place them on any surface and can reuse them almost indefinitely. The most popular are plastic-ceramic letters with adhesive backs (such as those made by Hernard) that can be repositioned or removed without leaving a residue. Another type of plastic lettter has bits of Velcro on the back, which make them stick to a matching Velcro board. The boards themselves come in a wonderful assortment of colors. You can also try magnetic letters, which cling to metal boards—and to the side of your refrigerator. Select a sheet of colored paper for the background before arranging your title.

Toy stores and educational supply houses are also good sources for letters. You'll find alphabet blocks and letters made of wood, plastic, and textured crepe foam. Grocery stores sell letters, too—in the form of alphabet noodles.

When using dimensional lettering, people often err by spacing the letters and words too far apart. Don't make that mistake; follow my earlier suggestions. Be sure to align the letters evenly. A ruler or straightedge can help—unless you opt for a casual look, placing the letters randomly.

What's most attractive about these letters is their dimensional-

Here, one light had a red filter on it; the other, a blue.

Try using large, die-cut cardboard letters.

Self-adhesive vinyl letters are also easy to work with.

ity. Exploit it. Try various camera positions, especially low ones. Instead of using the even illumination needed for most copystand work, try placing just one light at the side, so the letters cast shadows. Move the light around and observe how the shadows look as their direction and length change. Experiment with a colored filter over the front of the lamp. You can also use two filtered lamps, one illuminating the tops of the letters and the other, the sides. Always leave air space between the lamp and the filter. Your photo store should be able to supply the proper filtering material for your lamps. This is especially important if you have quartz lighting because their intense heat requires a heavy-duty material, such as Rosco Laboratories' Roscolux.

Found titles are everywhere.

Precut Flat Lettering. I've done some attractive titling with die-cut cardboard letters attached with double-stick transparent tape to a wall decorated with a mural. These 1 3/4 x 4-inch letters are nice to use on large areas, come in several colors, and are available in toy stores and through school suppliers. If you lay the letters on a flat surface, you'll need to flatten their edges with a sheet of glass or a small amount of rubber cement.

You'll have many uses for self-adhesive vinyl letters. They stick to a variety of surfaces (smooth, curved, bumpy) so you can put them on objects as well as on flat, paper backgrounds. I've found that using a pair of tweezers is the best way to pick them up and put them down. These letters come in black, white, and colors, and you can buy them in stationery as well as art supply stores.

Typeset Lettering. Probably the best lettering method for flat copy is to have the words typeset in your choice of hundreds of typeface styles. When done well, these letters have sharp, clean edges and look beautiful on the screen. Many businesses have their own phototypesetting equipment. If it is not available, go to one of the quick-print shops found in almost every community. Check a sample of the work before you order it, using a magnifying glass to see that the letter edges are smooth and the centers of p's and q's are not filled in.

Printers indicate the size of their type in point size, and 36-point capital letters (about 1/2-inch tall) are convenient to lay out and will give you a cleaner image than smaller type. Of course, printers are different. Some set the entire title exactly the way you are going to photograph it. Others give you the words on strips of white paper, which you can cut and glue onto a sheet of heavy paper. You will have to use litho film to photograph this as described on page 48; otherwise the cutlines will show. Some

Dry-transfer lettering gives professional-looking results.

printers may be able to furnish you with reverse lettering: white letters on a black background.

Dry-transfer Lettering. Dry-transfer lettering can rival the appearance of typeset lettering and can be less expensive for the small-volume user. You can buy these sheets of letters in a fantastic array of type styles and in colors as well as black and white at art and stationery stores.

The letters are printed in ink on large, translucent carrier sheets. The smaller the type size, the more letters you get. But small type is difficult to align, and with the extreme enlargement necessary for legibility, any imperfections become obvious. I recommend 36 point.

The quantity of each letter on the sheet corresponds to how frequently those letters generally are used; therefore, you'll find a lot of vowels but very few x's and z's. If you're going to be printing many words, count how many of each letter you'll need and allow extras for waste.

It's awkward to work with the entire carrier sheet when applying dry-transfer lettering, so you may want to do as I do. Cut the sheet in half, separating the upper- from the lowercase letters. Tape corners of the background paper to your desk or drawing board.

Guidelines will keep the lettering straight. But pencil marks will show, and when you erase them, you're apt to take off the letters, too. If you shoot the title onto litho film, use a nonreproducing blue pencil or paper with a blue grid pattern printed on it. Place a long sheet of paper over the background. Tape it directly to your desk, letting the edge of paper fall where you want the line of letters. Another choice is to apply the lettering to a sheet of 5mil acetate, using lined paper underneath.

Position the first letter. Next, transfer it by rubbing it quickly and firmly with a burnishing tool, the pointed end of an orangewood manicure stick, or a ballpoint pen, preferably without ink. Anchor the sheet of lettering with one hand. With the other hand, rub the burnisher back and forth over the entire letter. Check your work by lifting the sheet slightly, still holding it securely with the other hand. If the transfer isn't complete, drop the sheet and rub the letter again. (Black letters look grayish as they come off.)

After the entire word has been transferred to your satisfaction, make it permanent. Place the backing paper, which comes with the sheet of letters, over the title; then rub it well with the blunt end of the burnishing tool (or the

The Letragraphix lettering guide simplifies aligning and spacing.

broad end of the orangewood stick). The manufacturer of Letraset dry-transfer lettering has a device called Letragraphix that makes it almost impossible to misalign your lettering.

If you want to put the dry-transfer lettering on a more unusual surface—something rough, curved, or delicate—the pre-release method makes it possible. Keeping the backing sheet behind the sheet of letters, rub all desired letters with the burnisher. When they turn gray, they are loose. Now place the letters on top of the desired surface and, one by one, press them off with your fingers. If possible, cover the finished letters with the backing sheet and burnish them.

Don't panic if you make a mistake in spacing or spelling and want to remove a letter. The letters can be removed from most surfaces with a bit of masking tape or transparent tape. If you have to remove a letter that's very close to another one, protect the good letters by covering them with scraps of paper. The letters come off quite easily from smooth, firm surfaces. If you have trouble, loosen the letter with a drop or two of rubber-cement thinner or lighter fluid; then remove it with tape.

Lettering Machines and Devices. Some equipment intended for making signs and labeling architects' drawings, and even typewriters, can be used for titling.

The typewriter provides one of the fastest methods of printing words. Use an electric typewriter with a carbon ribbon and well-cleaned keys. Try to use a typewriter that takes interchangeable elements and produces proportional spacing. The best paper to use is smooth, clay-coated stock, such as duplication and repro paper. To be sure the relatively small letters are legible on the screen, it's important that you confine your typing to an area of 3 x 4 1/2 inches or less and get close when you photograph it.

With the appropriate graphics software, your personal computer can make fine titles. After creating the title, photograph it directly from the screen or photograph the printout. One clever program made especially for slide-show enthusiasts is "Photographix" from Image Concepts. The program provides several type styles; you then photograph the titles from the computer screen. But what's unique is that the letters move across the screen. When you photograph the title with a long exposure, the words streak, zoom, step-and-repeat, or appear in other special patterns, according to the effect you selected.

When taking the photograph, put the camera on a tripod, make sure the lens faces the screen squarely, and fill the viewfinder with the image. Turn off the room lights to prevent glare. You can add color with acetate over the screen or a filter over the camera lens. Put the shutter on "bulb," but experiment to determine the best *f*-stop and exposure time. Mark the brightness setting on your monitor knob, so you can repeat this accurately.

Lettering devices, such as Varigraph, LeRoy, Wrico, and Letterguide, are basically mechanical stencil-tracing devices. Some are more versatile and offer a choice of lettering styles and sizes. You may also want to try Reynolds Leteron, which lets you cut out your own self-adhesive vinyl letters. Rather than struggling with picking up and sticking down one letter at a time, you create an entire line of proportionally spaced letters, which you then smooth down onto the background.

Other Lettering Methods. It's hard to exhaust all the ways to do lettering. You can use stencils and daub them with ink or paint. You can work with rubber stamps, applying the ink to the paper with a rocking motion. You can even take cardboard or rubber letters and splatter paint around them, leaving words in the color of the background paper.

Usually I try to make neat, uniform lettering, but for some shows informal titles with hand-lettering are appropriate. Try colored chalk, crayons, felt markers, paint, and fingerpaints. Make the strokes bold and not sloppy, and don't try for perfection.

Colored chalks, crayons, and markers are good for casual lettering.

Backgrounds

There are seemingly limitless possibilities for materials to use as backgrounds. Frequently, you will choose colored papers. I like the rich colors of Color Aid paper. Pantone, as does Color Aid, comes in several hundred shades. I also like Fadeless, although there are fewer color choices. Construction paper, textured paper, tissue paper, poster board, wallpaper, wrapping paper—your art store can give you plenty of ideas.

One of the most useful surfaces is clear acetate. If you place your lettering on this, you can lay an entire set of word slides, in sequence, over the same background picture. I recommend 0.005 inch (5mil) because it's thick enough to lie flat yet thin enough to cut easily with scissors or a paper cutter.

Fabrics make nice backgrounds, either folded loosely or stretched taut. Whatever else you use, you will find a piece of black velvet indispensable. Stapled to a lightweight board, it photographs with absolute uniformity. Other colors are useful, too, but black is a must.

As with styles of lettering, the material you choose for the background should be appropriate to the mood and content of the slide show. Photographs, drawings, the human body, polished marble, weatherbeaten wood, and burlap have characteristics that make them suitable backgrounds for different projects. Try adding objects that have a symbolic significance: a leaf for a show about autumn, a football for the big game, a sea shell about the beach—whatever relates to the presentation. When using such objects, be sure your depth of field is adequate. At close distances, the camera may not be able to keep both near and far areas in focus at the same time. Stopping down the lens to $f/16$ or $f/22$ will help. If you have a depth-of-field preview feature on your camera, use it to check which areas are in focus.

This chart gets its message across quickly. It's simple and easy to read.

Graphics

Charts, graphs, maps, diagrams, drawings, cartoons, and other work photographed on the copystand make important contributions to slide shows. When you want to show something no ordinary photograph can, some form of artwork may be just what you need.

Format. It's generally best if all the artwork is horizontal. But it must be in the 2:3 proportion of the slide. As with word slides, I find it convenient to work on a 9 x 12-inch background, which gives me adequate room for work, plus the necessary 1 1/2-inch margins for safety and handling.

Simplicity. The basic rule of simplicity also applies to preparing other visuals. If you look at a chart or graph in a book, you'll probably see a network of grid lines, numbers at frequent intervals, crisscrossing lines, lengthy captions, and other details that demand close inspection. These are fine for books because the reader has time to look at them carefully, but they are deadly to a slide.

A slide *must* get its idea across quickly; it is not supposed to be a reference work. So, simplify, simplify, simplify. Use as few lines as possible, only a few important numbers, and abbreviated labels that don't state the obvious.

Charts and graphs can be good ways of summarizing information. For any particular subject, one method may be superior to another. A coordinate graph is almost always clearer than a table, a bar graph shows trends well, and a pictogram makes many subjects easier to understand. The more concrete a symbol is, the more quickly the viewers grasp the information. It's usually unnecessary to put grid lines on graphs and charts. Mark the coordinates with no more than five labeled divisions and possibly a few additional marks. If necessary, you may want to label the peak value of a graph. Number the scales with the simplest units—for example, "1 month" instead of "30 days"—and eliminate zeros wherever possible.

Tables are the poorest form of statistical material to use on slides because they contain too much information for the audience to comprehend quickly. But if you feel you must use tables, simplify them. Use no more than six, preferably four, columns, and limit the number of items to 12 lines per column. You should omit rulings between the columns, too.

When simplifying any type of

graphic, you may want to divide the information among several slides. Each slide in a series, then, can present just one main idea. You can also use the progressive disclosure method, in which each slide in a series reveals more of the picture or diagram.

Legibility. Filling the work area with your artwork isn't enough to guarantee that your audience will be able to see the information easily. You must make important lines thick enough to stand out. Data lines on graphs should be at least 1 1/2 times as wide as coordinate lines, important boundary lines on maps should be thicker than those surrounding other areas, and diagrams should have bold outlines.

Labels. Some graphics need words that identify parts. This lettering, as with all lettering, should be large, simple, and well spaced. It's also important to include only essential information. Abbreviate the captions on charts, maps, and diagrams as much as possible. Limit each label to one or two words; never use complete sentences. The captions only have to convey the essence of the graphic or explain what will not be readily understood. (Some graphics may be just as clear with no caption at all.) Place them close to what they're designating. On maps, indicate just a few key places—six at the most.

Color and Contrast. Color certainly makes artwork more attractive, but it does more than that. It's a fundamental way to emphasize the important parts of your graphic. If one small section is colored differently from the surrounding area, the viewers immediately look at this region. Bright colors, of course, are more attention-getting than subdued colors.

Color is also superb for designating lines and areas; it does the job much better than using different types of dotted and dashed lines or different textures. Try various shades of one color, or a rainbow order to indicate a progression of values. Foreground/background contrast is as important here as it is in making word slides. Remember, too, the vibration phenomenon.

Preparing Your Own Artwork. If you are an artist, you can use almost any method of creating artwork for your slides—as long as you remember the 2:3 format, simplicity, color, and all the other basics. Experiment with watercolors, acrylic paints, felt-tipped pens, chalks, and other media.

Even if you have no artistic talent, you can still turn out creditable artwork. Use copyright-free pictures known as clip art. These consist of thousands of drawings of every conceivable type, which you can cut out and paste onto a suitable background. (You can get these in art stores or from companies in the list of suppliers at the back of the book.) You can also use pictures from magazines and brochures as long as the slide show is not a commercial endeavor. You can use black-and-white photographic prints or drawings, and add color with paint, dyes, or self-adhesive colored acetate overlays.

Some companies that make drytransfer lettering also make illustrations you can rub onto your backgrounds. Modul Art acetate sheets contain full-color pictures in modular form. You can get a selection of heads, legs, mouths, and other body parts to cut out and burnish into place. And art supply stores have a selection of colored charting tapes in a variety of widths. These make it easy to lay down smooth lines for charts and graphs. You can even construct pictures with them.

Copying Graphics from Books. When a book or magazine has a graphic you want to put on a slide, evaluate it carefully. Most such graphics are appropriate for printed material, but are probably too complex to make good slides. If you rephotograph the graphic the way it is, the result is almost always going to be overcrowded— too much information and too small letters. This is one of the downfalls of slide making.

It is sometimes possible to crop the page with your camera, focusing in on a small area. If you can't do this, try cutting the section out and laying it on a sheet of colored paper; otherwise, make a mask of colored paper, cutting a window in it to reveal just the important area. Press it flat with a 1/4-inch-thick sheet of glass. Because white backgrounds are not desirable, put a colored filter over the lens, or use litho or Vericolor Slide film, as described on page 47. For the best results, redraw the graphic so you can simplify it properly.

Films for Word Slides and Graphic Images

Slow color film, about ISO 50, is the best to use for word slides and graphic images because of its fine grain and high resolution. The film must match the type of light you

COLOR-CORRECTION FILTERS FOR BALANCING FILM AND LIGHT SOURCE

FILM	FILTER NEEDED		
	Photofloods (3400K)	Quartz lamps (3200K)	Daylight or flash
Kodachrome 40	none	82A	85
Other tungsten-balanced films	81A	none	85B
Daylight-balanced films	80B	80A	none

are using or your pictures will have an unwanted color cast. Indoors, on the copystand, you will need tungsten-balanced film, such as Kodachrome 40, which is balanced for photoflood lamps, or Ektachrome 50 or Ektachrome 160, which are both balanced for quartz lamps.

If you have quartz lamps and want to use the Kodachrome film, you can correct the color by using an 82A filter. With photoflood lamps and Ektachrome film, use an 81A filter. Filters can also help out if your camera is loaded with outdoor film. Use an 80B filter with photofloods and an 80A with quartz lamps.

You might want to try using Kodak's Photomicrography Film 2483. This is a high contrast, fine-grained film that gives very saturated reds and blues. Because it's balanced for daylight, you'll need to use an 80A or 80B filter. Base your exposure on ISO 32 and bracket, in 1/2-stop increments, one stop in each direction.

Vericolor Slide Film 5072 is an exciting film that can eliminate the problem of white backgrounds when you photograph the pages of a book or lettering on a sheet of paper. It reverses the hues so that anything green becomes magenta, anything black becomes white, and so on. If your letters are black on a sheet of white paper, you can make a slide with white letters against a blue background by putting a yellow filter in front of the camera. (See the chart below for other color transformations you can make.)

This film is very slow (about ISO 6) and is intended to be used with exposures from 1/4 sec. to 8 seconds. Different exposures alter the colors of both the black and the white areas. Because it is a negative film, the more exposure you give, the deeper the color. I suggest making a series of test exposures, bracketed in 1/2-stop increments, and labeling the results. You can then use these as references for future work.

You can process this film yourself with Flexicolor (C-41) chemicals or have it done commercially. If you have a lab do it, leave instructions to *develop only;* otherwise you will get prints instead of slides. Cut the processed strips of film apart and mount the individual frames in slide mounts.

The most economical filters to use with Vericolor 5072 are 3-inch-square gelatin filters placed in front of the lens; they are available from Kodak. Handle them very carefully to avoid fingerprints and scratches. I recommend the following colors: 12 (yellow), 29 (red), 34A (deep magenta), 44 (cyan), 61 (deep green), and 47 (deep blue).

Polaroid makes two exciting films especially for title work. PolaBlue is a high contrast negative film that produces white text on a blue background from black-on-white copy. It can be processed in two minutes in the Polaroid Autoprocessor. The other film, High Contrast PolaChrome, produces more saturated colors than regular Polachrome; as such, it's well suited for titles, charts, and graphs.

Ordinary black-and-white negative film can be turned into colored title slides with toners. Although various toners may work, you'll get the best results with the Berg Brilliant Blue toner and a fine-grain film. The toner converts the black areas of the film to blue. Plan on toning the film right after developing it, so it remains wet and at about the same temperature through the processing and toning stages. After developing and washing the film (use a non-hardening fixer), soak the film in the toner for about eight minutes with periodic agitation. Wash it again, fix in a hardening fixer, and wash once more.

The most useful of all films for word slides and special effects is litho film. It produces opaque blacks and absolutely clear whites. Its contrast surpasses that of any other film. These characteristics make it possible for you to do hundreds of incredible things. (I described them fully in my book, *How to Create and Use High-Con-*

Color transformations with Vericolor slide film. On the left, a yellow filter was used; on the right, a green filter.

FILTERS TO USE WITH VERICOLOR SLIDE FILM

FILTER	RESULT	
	with more exposure	with less exposure
Yellow (12)	blue	purple
Red (29)	deep cyan	light cyan
Magenta (34A)	deep green	yellow
Cyan (44)	deep red	light red
Green (61)	deep magenta	light magenta
Blue (47)	deep reddish orange	yellowish orange
None	black	bright red

trast Images, HP Books, 1982.) Even if you do not do special effects, litho film used in a straightforward manner will help you produce outstanding slides.

Ektagraphic HC film is a 35mm litho film made by Kodak. Kodak also sells it as Kodalith, in 100-foot rolls you put into cartridges yourself. You can also enlarge your images onto 4 x 5-inch, 5 x 7-inch, and larger sheets of litho film. Sheet litho is made by Agfa, Fuji, Ilford, Kodak, and others. Graphic arts suppliers and large camera stores carry these films or can order them for you.

Put the 35mm litho film into your camera, set the film speed indicator to 8, and take your exposure reading from a neutral gray test card. If you can't set the indicator that low, put it at 16 and then double the indicated exposure. Since the exposure is critical, be certain to bracket one stop over and one stop under the reading, in 1/2-stop increments.

The black areas of correctly exposed and processed litho film will be almost totally opaque; you may not even be able to see a light bulb through it. Clear areas should be sharp-edged, with no grayish tinge. You will find you need somewhat less exposure for fine lines than for thicker ones.

Here's how to develop 35mm litho film on a reel in a film-developing tank.
1. Mix together equal parts of the litho developer, a special two-part (A and B) solution, just before using.
2. Make sure the temperature is 68°F (20°C).
3. Agitate the tank by inversion for 30 seconds; then agitate it 5 seconds out of each 15 seconds, for a total development time of 2 3/4 minutes.
4. Follow with 30 seconds in stop bath and 3 minutes in fixer.
5. Wash for 10 minutes, rinse in a wetting agent, and hang to dry. A hypo-clearing agent reduces the wash time to about 4 minutes.

6. When dry, cut the film frames apart and insert them into slide mounts.

You can use sheets of litho film to create special effects by reproducing them over a lightbox. If you have a photographic darkroom, you can expose the film just as you would photographic paper.
1. Photograph your titles or artwork onto an ordinary black-and-white film, such as Plus-X or Ilford FP4.
2. Put this negative into the enlarger's negative carrier, and enlarge it onto the litho film.
3. Working under a red safelight, make some trial tests to determine the exposure time. It will be similar to that for photographic papers: about four seconds at *f*/8 for a 5 x 7-inch enlargement.
4. Process the film in trays, using the litho A and B developer and agitating it continuously for 2 3/4 minutes.
5. Finish processing as for roll film.

There will be times when you need to reverse the litho image, to make black areas white and white areas black. In the darkroom, it's simple to place the litho image on top of an unexposed sheet of litho film, emulsion-to-emulsion, in a contact-printing frame, expose it to the light of the enlarger for about eight seconds at *f*/4, and process it.

Tiny, clear pinholes always occur in litho film. Minimize their occurrence on sheet film by cleaning it well with an antistatic brush. You'll still get some pinholes, but you can block them out easily with a liquid called photo opaque. Stir the opaque well and apply it with a pointed sable watercolor brush, size 00 or 000.

If you don't have facilities for processing your own litho film, you can have your copy photographed and the film processed commercially through your photo store, at a printer who does "stats," or by sending it to one of the companies in the list of suppliers.

When you get it back, be sure the black areas of the litho are opaque. When you look at a light bulb through it, you should just barely be able to see the filament. If you see more than that, the litho was not exposed or developed properly. It helps to tell the lab you'll be using the litho for title slides.

For really quick titling with a litho-like film, try Polaroid's Polagraph. It is an instant-developing, high contrast film that produces a positive image; that is, if you photograph black lettering on a white background, your word slide will have black lettering on a white background. (Regular litho films produce negative images—here, you would get white lettering on black.) Polagraph is available in 12-exposure rolls, with an ISO rating of 400, that is developed in a Polaroid Autoprocessor in two minutes. Polaroid will soon have Polalith, a negative-acting, high contrast film with ISO 4.

Special Effects Titles and Graphics
Working on the copystand lets you transform very simple images into extraordinary ones. You'll need backlit litho film for many of these effects (see Chapter 4).

Creative Filters and Lens Attachments. Manufacturers are continually introducing creative filters, and many can be used in slide making.
Diffraction-grating Filters. A diffraction-grating filter breaks up an image into its component colors and, at the same time, multiplies the number of images. It works best with a litho negative that has fine lines and more black than clear areas. With a yellow acetate behind the litho, the filter splits the colors into red and green. Magenta is quite beautiful when it breaks up into reds and blues.

Experiment. Change the filter's position or combine two similar filters. See what happens with the filter at different distances from the litho. Try rotating the filter

COLORING LITHO SLIDES

The black-and-white slides you make with litho film can become color slides through several methods.

Tinting. Tinting puts color in the clear areas. You can use dyes specifically formulated for litho work, such as Dr. Ph. Martin's Watercolors and Edwal Fototints. You can even use ordinary food colorings if you condition them by adding three drops of wetting agent, such as Kodak Photoflo or Edwal LFN, and three drops of stop bath or vinegar to each ounce of color. Specifically formulated colors have the acid and wetting agent already added to them.

1. Place the film on a paper towel or facial tissue, base side up.

2. To apply the color to small areas—a line of lettering, for example—dip a cotton swab in the dye and apply it to the film with back-and-forth strokes. The secret to even color is continuously moving the color around as you apply it.

3. Dilute the dye with a bit of water if you want a paler tint. The longer you keep applying it, the deeper the color will be.

4. When the color looks right, blot the surface with a tissue.

5. Work carefully if you want to apply more than one color. If the words are close together, mask those you want to protect with a liquid called "frisket."

6. After the color dries, rub off the frisket with your fingers and repeat the procedure on the other portion, with another color.

7. To color large areas quickly, wet the surface with a wetting agent, and then apply the color with a paintbrush. You can also fill a small, shallow dish with the dye and immerse the film in it, continuously agitating the film; then blot dry.

8. Use felt markers on narrow lines of letters that you can cover with one stroke. Start and end the band of color in the black area, so there is no buildup. Be sure to use markers that adhere to the film, such as those made for use on overhead-projection transparencies.

Colored Acetate. Sandwiching colored acetate with the litho film is another good way to color it.

1. Cut a rectangle of acetate the same size as the film.

2. Clean the film and the acetate well with an antistatic brush.

3. Place the acetate against the base side of the film and mount the pair in a slide mount.

With 4 x 5-inch and larger sheets of litho film that you will be rephotographing onto slide film, separately color each of several areas. To do this, cut pieces of colored acetate roughly to size, and use transparent tape to attach them to the back of the litho film.

Transparent Tapes. Transparent tapes, made for overhead-projection transparencies, come in many different colors, ranging in width from 1/32-inch to 1 inch. You can roll the tape onto the base side of the litho film to cover a line of lettering. This is a quick and easy method to add color just where you want it.

Diazochrome Film. Diazochrome film, or diazo, as it's more commonly known, is an easy way to convert the black areas of a litho image to color. It's a matter of pressing the litho film into tight contact, emulsion-to-emulsion, with a piece of diazo film, exposing it to a light rich in ultraviolet, and developing it. Handle it in subdued room light.

One way to expose the diazo film it to put the litho image on top of it, flattened with a sheet of glass or a contact-printing frame; then expose it to photoflood or quartz lamps for about four minutes. You'll have to do some testing to determine the correct exposure times for your particular setup. For 35mm-size pieces, sandwich the diazo and litho together in a hinged glass slide mount, such as those made by Wess Plastics, and place the slide mount in a projector with the litho closest to the lamp. The exposure time then runs about 30 seconds.

Give the film sufficient exposure to obtain clear areas. If underexposed, the areas will be colored instead of clear. But this property can produce several shades of color on one slide. Mask the clear area of the litho to be subdued: one line of printing, for example. On the diazo, this area will be underexposed, and thus have only a slight amount of color. For masking, use a piece of colored acetate or film, or anything that will partially block the light.

Diazo film develops in the fumes of ammonia. Although you can use ordinary household ammonia, concentrated 26 percent ammonium hydroxide from the drugstore does the job efficiently.

1. Work in a well-ventilated room. Your developing tank can be a widemouthed jar with a lid that has a cardboard insert, such as a peanut butter jar.

2. Put a sponge in the bottom of the jar and pour a little ammonia over it.

3. Suspend the diazo over the sponge so it doesn't come in contact with the liquid. To do this, remove the lid's cardboard insert, punch a hole in the center, put a short string through the hole, and knot it on one end. Then tie a film clip or spring-type clothespin to the other end and put the cardboard back into the jar lid.

4. Keep the jar tightly closed until you're ready to clip the film to the holder. Have an extra lid handy so you can keep the jar capped while you're attaching the film: you don't want to inhale the fumes. The processing time will be around four minutes, after which there will be no further deepening of the color.

5. Do not wash the film; this will only make it blotchy.

6. Simply trim it to size and put it in a slide mount.

during the exposure. You will have to arrive at a basic exposure time by trial, but you will probably find you need at least two more stops than you would for a normal exposure.

Multiple-image Filters. These filters come in a variety of patterns and allow you to produce repetitions of an image. They can surround the principal image or parallel it. Some are even variable, allowing you to change the angles between repetitions. All may be rotated, so you can place the images precisely where you want them. One type of filter gives a streaking effect, adding trailing lines to the subject.

Work with a picture that has a relatively small image on a 5 x 7 or 8 x 10 or larger field. If the image is too large, there won't be room for all the clones of the principal image. Stop the camera lens down to f/5.6. If you use a litho negative, put colored acetate underneath it. With toplighted material, try putting tiny bits of colored acetate on the filter, coloring each of the sections differently.

Neon Glow Effect. Television commercials and magazine advertisements frequently use pictures that glow like neon signs. They look spectacular, but are quite easy to do with a litho negative and a double-exposure technique. First, you need something to diffuse the light. This spills the light into the dark areas and produces the glow. I like to use a number 3 fog filter on the lens, but I've also used some type of diffusing material di-

In this bas relief slide, a black-and-white film positive was made from the original slide, and the two pictures were sandwiched slightly out of register.

rectly over the litho film. Frosted acetate, lens tissue, or even tissue paper work. Hold these fairly close to the litho film or the light will diffuse too much. The effect is easy to control because you can see it through the camera viewfinder.

Diffusing the light decreases its intensity, so your exposure will be anywhere from 1 1/2 to 3 stops more than normal. If you add color with acetate, you will need an additional 1/2 stop more exposure. The diffusion may also make words or pictures unrecognizable; therefore, you must add definition by making a second exposure without the diffuser. You can do this with the colored acetate, without it, or with a different color acetate. Be sure the litho film is anchored with tape, so you don't move it the least bit when you remove the diffuser and acetate. The second exposure will be the normal one, or 1/2 stop less if you use white light.

Bas Relief Effect. Bas relief is especially effective for titles. One way to do this is to take a white-on-black image and make your first exposure. Then shift its position slightly north-south and east-west, and make a second exposure on the same frame of film. For each exposure, use a different

color filter when using toplights or a different color acetate when using backlit litho film. Be aware of how the colors combine photographically.

Another method requires positive and negative litho images of the title. Place the negative over the backlight, with a colored acetate underneath, and make the first part of a double exposure. Remove the negative and replace it with the corresponding positive, slightly out of register in both directions. Next, use a different color acetate—or the same one for a subtle effect—and make the second exposure. The title will now have a black edging where no color came through and a light edging on the other sides where the two colors combined. This can be quite striking.

Multicolor, Multiple-image Filters. To achieve this effect, photograph one black-and-white image several times. For each exposure, move the image a small amount and use a different color filtration. A variation of this technique is to change the height of the camera with each exposure. You can also use a zoom lens and change the image size. The image doesn't have to move, just the lens.

I like to do these techniques

A bit of diffusion can create a neon-like glow around a litho image.

© Tony Gezrijian

with litho images colored with acetate, but you can also use black-and-white artwork, toplights, and over-the-lens filters. The images can be either positive or negative. By now, you can probably figure out the color changes that will take place.

Zoom Effect. A zoom effect is so called because it usually is done with a zoom lens, but you can do it with an ordinary lens, too. The feathery streaking as the image expands upon itself is quite dynamic.

You need a 5 x 7 or larger litho negative of words or an outlined subject. (It doesn't work well with toplit subjects.) Moving the lens takes at least five seconds, so you need to stop down the lens about three or four stops from your normal setting. The best exposure recommendations I can make are that you make a number of trials and keep notes.

With a zoom lens, you need a supplementary closeup lens, probably about a +5. Set the lens at its longest focal length. Focus and compose the picture, adding the desired color acetate. Practice zooming from the longest to the shortest focal length, so you have the feel of how quickly you must do it. You can move the lens in one smooth motion, or you can do it with a series of hesitations. Because the effects are different, try them both. When using a continuous movement, start zooming before you press the shutter release.

If you are now envying the person with a zoom lens, don't. You can do a focus zoom, which is also attractive. Start with the image in focus, and then rotate the lens until the image is completely out of focus. A macro lens has a much longer focusing range than a conventional lens does, so it works better. Extend the lens to its closest focusing distance and adjust the camera height accordingly. To make the unfocusing operation smooth, try wrapping a long strip of masking tape around the lens barrel. If you wrap it correctly, the lens rotates when you pull the tape. It's a nice trick.

Nice, too, is to change colors midway during the zoom. This requires a double exposure. Make the first exposure, zooming part of the way. Change the colored acetate, back up the lens a bit, and resume the action for the second exposure. The slight overlap of color is part of the attractiveness of the technique.

Streaks and Trails. The effect of streaks and trails works quite well for titles. You must use a litho negative to create it. During a five-second exposure, rotate the negative or move it down, to the side, or in irregular swoops. This leaves trails behind the words. Do this as a double exposure: one for the words themselves and one for the trails. Rehearse the movement, checking to see that there are no light leaks around the litho while you move it. Tape black paper around it to mask off such areas.

Perspective Distortion. There are several ways to make lettering seem to recede into space, curve around, or assume unusual forms. One way is simply to tilt the copyboard at an angle, either horizontally or vertically, so it is not parallel to the lens. The part closest to the lens will be larger than the other. Prop the title, so it remains steady during the exposure. Stop down your lens to *f*/8 or *f*/16, and check with your depth-of-field preview to be sure everything is in focus from front to back.

You can create curves and distortions by sticking pressure-sensitive vinyl letters onto black velvet. Then bend, fold, or drape the cloth any way you want. The letters cling no matter how you twist them. The black velvet resists picking up highlights from lamps and seems to disappear.

Other methods include making a negative on 35mm litho film, projecting this onto an interestingly shaped surface, and rephotographing it. You can also try using a fisheye-lens attachment on the front of your lens. It makes the lettering curve effectively, appearing larger in the center and smaller as it reaches the edges of the field.

These are some of the basic, useful methods for creating titles and graphics for your slide presentations. (You'll find more ideas in Chapter 4.) If you're in a rush, though, many companies can do the job for you. Some have ready-made stock slides, with words that are appropriate to many types of presentations—both personal and professional. Other companies can make titles for you if you send them camera-ready artwork. Others can set type, add illustrations, and do the whole job for you. (Some of these companies are in the list of suppliers.)

Improving Your Slides

The word-slide techniques in Chapter 3 and the pictures in your slide files are just the first of many exciting images you can create for slide presentations. I suggest you look at a book on special effects photography for creative ideas when you're doing live photography. But using the techniques in this chapter will add pizzazz to your titles and alter and embellish images you have already taken. Some of these methods require a copystand. For others, you also need a source of backlight or some darkroom equipment. For the rest, all you need is imagination.

A backlight stage enables you to transilluminate a slide or piece of litho film so you can rephotograph it. You can make one yourself, much as you would construct a slide illuminator. It has to be horizontal, though, and not at an angle: it must rest on the copystand with the camera facing it squarely.

The light source must be appropriate for the film you're using.

Ordinary household lamps, while fine for sorting slides, produce unsatisfactory colors when you photograph them. You need photoflood, quartz, or special photographic fluorescent lamps. Fluorescent lamps require daylight-balanced film; photoflood and quartz lamps require tungsten-balanced film. (You may want to review the section on film, lamps, and filtration in Chapter 3.)

To prevent extraneous light from entering the lens, you'll need pieces of black cardboard to mask off areas surrounding your subject on the backlight stage. Black photographic tape is handy, too.

Special Effects

Slide Duplication. Many effects depend on making duplicates of your slides. Ignore any rumors you may have heard about the difficulty or poor results of slide duplicating. Today's film and equipment make duplicating slides

almost as easy as taking the originals.

The duplication process does tend to increase the contrast in the slide—that is, light areas become lighter and dark areas become darker, with a consequent loss of detail. Fortunately, slide duplicating films are specially made for duplicating slides and do a remarkable job of maintaining the original contrast. Ektachrome 50 or Ektachrome 64, although not as good as slide duplicating film, can give fairly satisfactory results. Because Kodachrome is a high contrast film, I don't recommend it for making duplicates. Incidentally, if the original slides are made on Ektachrome, the film's relatively low contrast makes them duplicate better.

There are several slide duplication methods. For each, I'll suggest the way to determine the correct exposure. But make it easy for yourself: find the standard exposure before you do any work. Be-

gin with a slide of average contrast and brightness, without large amounts of very dark or light areas, and take a meter reading from it. Then make a series of exposures, in 1/2-stop increments, from two stops less than the meter reading to two stops over it. For example, if your meter indicates 1/2 sec. at $f/5.6$, try the following settings:

• $f/2.8$
• between $f/2.8$ and $f/4$
• $f/4$
• between $f/4$ and $f/5.6$
• $f/5.6$
• between $f/5.6$ and $f/8$
• $f/8$
• between $f/8$ and $f/11$
• $f/11$

Project these slides and compare them with the original to find the best exposure. Be sure to write down all the critical information, including f-stop, shutter speed, and distance of the lamps. You will then be able to standardize the optimum setting for all your slide duplication work. It's always a good idea, though, to bracket your exposures by shooting extra slides that are 1/2 stop over and under your standard exposure. If the slide you are duplicating is too dark or too light, you can compensate for it with the exposure. Whenever you change any of the variables, you have to make new tests.

Always start with an immaculately clean slide. Blast it with compressed air or wipe it with an antistatic brush. Hold the slide by its mount or edges, so your fingers never touch the film itself. If you do accidentally touch it, clean the slide immediately with a swab moistened with a tiny bit of film-cleaning liquid. You can also use rubbing alcohol on the base side. *Film and Filtration.* As noted in Chapter 3, film is specifically made to be used with a certain type of light. When you correctly pair the film and the light source, the colors in the duplicate slide should be fairly close to those in

the original. If the colors are slightly off when you project the duplicate, make adjustments with filters. For over-the-lens use, you need optically clear color compensating (CC) filters. Most likely, though, you can place the filter between the light source and the slide. In this case, you can use less expensive color printing (CP) filters. These acetate squares come in sets of yellow, magenta, and cyan, all in various densities. You can estimate the amount of correction needed by placing the original and duplicate slides next to each other over a backlight. Next, place a filter over the duplicate until its color more closely approximates the original. Whatever color is in excess, use the complementary color filter, as shown in the chart below. For example, if the slide is too green, try adding a bit of magenta.

Use this color filter to make a series of test slides, varying the density of the filters. For each 0.10 density of filtration, you need approximately 1/3-stop more exposure to compensate for the loss of light. Make bracketed exposures until you find the best one.

Your exposure and filtration tests are reliable standards for all your slide duplication work as long as you use film from the same emulsion batch. (See Chapter 2.) It may not be critical, but different emulsion batches frequently require a change of filtration. Buy a quantity of film with the same emulsion number and store it in your refrigerator. Let it warm up in its sealed canister for at least three hours before you use it.

Slide duplicating films always need filtration. You must be sure to do a careful series of tests to arrive at the best combination of exposure and filtration. Duplicating film 5071 requires a long exposure; one second is optimum. If your light source is an electronic flash, you must use duplicating film SO-366, which is made for exposure during the short duration of the flash.

Begin your trial exposures with the following filters: 40 cyan plus 60 yellow for 3200K tungsten light, 20 cyan plus 65 yellow for daylight, and 15 cyan plus 90 yellow for flash. Set your exposure meter to ISO 12 and set your shutter speed to one second if you are using 5071 film. Make a series of exposures, changing the aperture rather than the shutter speed. Judge the exposure and filtration by projecting the finished slides; then decide if you must make changes in the color or exposure. The chart at the bottom of the page is based on a filter pack of cyan and yellow, and you can use it to determine what filter pack adjustments to make. For more detailed—and current—information, get Kodak's booklet E-38, *Kodak Ektachrome Duplicating Films.*

Special films can give you special effects when you duplicate slides. Infrared film changes the colors in rather unpredictable ways. Use it with an orange, yellow, or other colored filter for unusual color renditions. Base your exposure setting on ISO 100 and bracket your exposures in 1/2 stops, because this film has very little latitude for exposure error. It

COLOR CORRECTION WHEN MAKING SLIDE DUPLICATES

If duplicate is too	Add this filter	Or subtract
Yellow	Cyan + magenta	Yellow
Magenta	Yellow + cyan	Magenta
Cyan	Yellow + magenta	Cyan
Red	Cyan	Yellow + magenta
Green	Magenta	Yellow + cyan
Blue	Yellow	Cyan + magenta

is important that you filter out infrared radiation when copying slides onto it; otherwise, the slides will all be rather orange-colored. An infrared-blocking filter, such as the HA11 or HA28 from Fish Schurman Corporation, will do the job.

Another film that's fun to use is Vericolor slide film, (see Chapter 3). The only colored filter you need is a number 85, which gives better colors. As before, tell the lab to process only, and your new transparencies will have negative colors: magenta instead of green, blue instead of yellow, and so on. Very interesting.

Flashing. Slide duplicating film reproduces slides with almost negligible buildup of contrast, but there may be times when you use ordinary camera film. I've found I can control the contrast quite well by giving the film a flashing exposure, either before or after photographing the slide. This is simply an overall exposure to a very small amount of light.

One way to do this is to use your chosen slide duplicating setup without the slide in place but with any necessary color correction filtration. Place a 2.0 (not 0.2) neutral-density filter over the lens and use the standard exposure setting you already have determined for duplicating a slide. As an alternative to using the neutral-density

filter, you can make your flashing exposure seven stops less than the one you'll use for photographing the slide. Either way, you'll make a double exposure, one for flashing and one for the slide.

Duplicating by Front Projection. An easy method of duplicating a slide is to project it onto a white matte screen or a wall painted with white flat paint, and take a picture of it. You won't need any special closeup equipment to do this.
1. Put the camera on a tripod and use a cable release to be sure the camera doesn't move during the exposure.
2. Be sure to place the camera as close as possible to the projector lens. Otherwise, you will distort the shape of the image. (You may be able to place the projector between the tripod legs.)
3. Next, move the camera back and forth until the image fills the viewfinder, getting as close as possible for the brightest image.

4. To determine the exposure, turn off the room lights and take a reading with the camera's built-in meter or with a handheld exposure meter, making sure you don't cast a shadow on the screen.
5. To rephotograph only a portion of the slide, move the camera closer to the screen or use a longer focal-length lens.
6. Finally, be sure that you crop off a little of the image in the viewfinder. This allows for the camera recording more than the area seen in the viewfinder although this is generally masked by the slide mount.

Duplicating by Rear Projection. Instead of projecting the slide onto an opaque screen, you can use a translucent one. In such a rear-projection setup, the projector and camera are on opposite sides of the screen. The advantage is that you can align the camera on the same lens-to-screen axis as the projected image. The disadvantage is that

One way to create a surrealistic slide is to copy the original on Vericolor slide film.

ADDITIVE COLOR COMBINATIONS

	RED	BLUE	GREEN	YELLOW	MAGENTA	CYAN
RED	—	magenta	yellow	orange	reddish magenta	white
BLUE	magenta	—	cyan	white	bluish magenta	bluish cyan
GREEN	yellow	cyan	—	yellowish green	white	greenish cyan
YELLOW	orange	white	yellowish green	—	red	green
MAGENTA	reddish magenta	bluish magenta	white	red	—	blue
CYAN	white	bluish cyan	greenish cyan	green	blue	—

the center of the image is brighter than the edges. To counteract this hot spot, use as long a focal length lens as possible in both the camera and projector.

White or gray rear-projection screens are the best for copying. You can also try substituting a sheet of matte acetate or frosted glass. A couple of blocks of wood can support rigid material; flexible material can be tacked to a wooden frame. Small, tabletop units, such as Prima's Groupshow, and units made for transferring to videotape are also convenient to use. These units include a mirror, so you don't have to put the slide in backward to correct the left-to-right orientation.

Turn off the room lights to prevent reflections from the screen; then take an exposure-meter reading from the side of the screen facing the camera.

Slide Duplicating Attachment. Instead of copying the projected image of the slide, it's more common to photograph the slide directly. You have to transilluminate it with a backlight. You also need a closeup attachment that enables you to fill the viewfinder with the entire slide or crop the image even closer. One answer is a tubelike device that attaches to an SLR camera body the way a lens does. It contains everything you need: slide holder, diffuser to create uniform illumination, and closeup lens. All you have to provide is a light source. Use your camera's built-in meter to take your meter reading directly from the slide.

Extension Devices. To use your camera lens to fill the viewfinder with the image of a slide, you need a spacing device between the lens and the camera body. Many macro lenses, which are the best lenses for closeup work, must be extended. The devices to look for are bellows, extension tubes (sometimes called extension rings), or the special "one-to-one" extender for a macro lens. "One-to-one" refers to the reproduction ratio in

The Bowens Copytran (on the left) and the Beseler Dual-Mode Slide Duplicator (on the right) are two slide-duplicating devices that provide lighting and color correction for duplicating slides with your own camera.

which the image on the film is the same size as the subject being copied—which is what slide duplication is all about. The longer the extension, the greater the magnification. But magnification also depends on the focal length of your lens, and a shorter lens gives greater magnification. To cover the area of a slide, you need about 36mm of extension with a 50mm lens.

Bellows are accordian-pleated units that allow you to vary the amount of extension. Tubes have a fixed length, but come in sets so you can choose the length you want or couple several of them together. Neither contains glass elements. They couple to your camera body and lens, so be sure to buy those with the correct fittings.

When using such an extension, attach the camera to a tripod or a copystand so it faces a backlight. Mask off the area surrounding the slide, using black paper or cardboard. Turn off the room lights. If your extension device couples to the camera's metering system, you can take your reading directly from the slide. Otherwise, hold a hand exposure meter close to the slide and increase the exposure by two stops over the meter reading. It's necessary to use additional ex-

posure to compensate for the light lost through the device. Bracket extensively—perhaps plus and minus 2 1/2 stops, in 1/2-stop increments—to establish your standard exposure.

If your light source is an electronic flash, you have to run a more extensive set of trials. Put the flash on manual, not automatic, and set the shutter speed to the one required for flash. Beginning at the largest *f*-stop, make an exposure at every *f*-stop, closing down the lens 1/2 stop each time.

Slide Duplicators. These handy devices, such as the Testrite or Bowens Copytran, are good investments if you are going to do a lot of slide duplicating. They have a holder for the slide, a built-in light source, and a holder for correction filters. You provide the camera and lens.

The ultimate duplicator is electronic; it includes the camera as well as light source, meter, and everything else needed for high-quality, high-quantity slide duplication, including a flashing device. These are principally used by film laboratories and slide-production companies.

Supplementary Closeup Lenses. Although a + 20 closeup lens attachment on a 50mm lens gives

you life-size reproduction, there is too much distortion and poor resolution at the edges to be useful. Don't use them.

Special Effect Filters. A diffraction-grating filter spreads rainbows of color throughout the slide if there are bright highlights in the picture. You can subdue an image with a misty glow by using a fog or diffusion filter. A star filter also adds a bit of diffusion, but don't expect it to make pointed stars out of bright points of light. Color filters of all shades and hues can change day into night, noontime into sunset, and Earth into Mars. This is an area in which you can let yourself go wild.

Slide Sandwiches. One of the easiest special effect techniques is sometimes the most effective. All you need are two slides out of their mounts. When you sandwich them and remount them in a new slide mount, you have an entirely new picture.

Title Slides. Sandwiching is an excellent way to eliminate glaring white backgrounds from title slides, as well as a great way to utilize slightly overexposed picture slides that you hate to throw away. For the title, use black letters on a white background. Next, choose a picture that's appropriate for the slide show. Make sure the background picture provides sufficient contrast to the lettering and is not cluttered in the area where the words will fall. A slightly overexposed slide frequently works out better than a correctly exposed one, and you can sometimes use slides that are slightly out of focus.

Place the two pieces of film together emulsion to emulsion to keep the images in the same plane of focus. Although this reverses the background slide, it shouldn't make any difference. Of course, it would look strange if there were writing on the background slide (and because writing would conflict with the message of the title slide, you would not want to use it

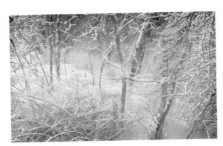

A *diffraction-grating filter added color and multiple images to this duplication.*

This shot is the result of using a diffraction-grating filter.

An effective title slide has good contrast.

Big, chunky letters can make strong titles on sandwiched litho slides.

In this shot, a slide of a fish was sandwiched with a picture of a seascape.

For interesting effects, sandwich a picture slide with a picture of a textured surface. On the left is an image of frost; on the right is a picture of crystals.

anyway). Next, clean them well with an air syringe or an antistatic brush. Now, remount the slides. I've found a glass slide mount presses the two pieces of film close together, so they stay in focus.

You may also want to shoot pictures especially for this technique. You can do this, for example, if you want to leave a specific area for the words. Another good idea is to shoot pictures of abstract or geometric patterns. Wood grain, textured carpeting, clouds, water, fabric, wallpaper, and crystals make fine backgrounds if they are not allowed to be overpowering.

You can do some clever things with litho slides that have clear letters on a black background. Make the lettering bold; that is, use broad strokes. Then sandwich this with a normally exposed slide of a picture or a pattern. The result is a group of colorful, patterned letters or a scene shaped like the letters. *Picture Slides.* Two picture slides sandwiched together can be a more interesting image than either slide alone. You may be able to salvage many pictures from your box of discarded slides and use them to your advantage. The best way to find attractive combinations is to experiment. Generally, look for two overexposed slides, each having detail in different areas. A silhouetted subject sandwiched with a normally exposed slide works well. For example, sunsets are almost always more splendid with something silhouetted in the foreground. You might want to shoot a collection of litho images to combine with other pictures.

Photograph patterns and textured surfaces, too. These combine exceptionally well with many pictures. You can shoot them directly onto color film. You can also shoot them on litho film and convert it to color with dyes, diazo film, or by rephotographing it and making a double exposure on a sheet of colored paper, as described on page 61. The textures can be almost anything. Try tree bark, cement, burlap, window screen, or sand. To emphasize the texture, be sure the light glances across the surface from the side. If it's in front of the object, it will smooth out rather than show surface irregularities. Sometimes you may want to make an out-of-focus photo of a pattern; this is especially nice with colored lights.

When you've decided on the slides you want to combine, clean and remount them, emulsion-to-emulsion, in new slide mounts. By rephotographing slide sandwiches, I can use the slides in other combinations, but more important, I can maintain sharp focus in each image. Another advantage of slide duplication is that it's not necessary to use a glass slide mount. Rephotographing two slides together requires additional exposure of about one or two stops.

Shaped Masks. Not all your slides have to be rectangular. You can put the image inside a circle, an oval, an elongated rectangle, a map of the United States, or almost any simple shape. It's a clever way to introduce variety. It also lets you eliminate an unim-

portant part of the picture while highlighting another, or cover distracting elements or imperfections in a picture.

One way to do this is to sandwich the picture with a specially shaped litho mask. You can buy these from such companies as Visual Horizons or Porter's Camera Store. You can also make them yourself by exposing and developing litho film (as described earlier in Chapter 3). It's easy to trace circles, squares, stars, and other geometric shapes using a stencil. Fill in the areas with black ink and photograph them. You might want to buy self-adhesive red stickers (litho film is blind to red), place them on white paper, and take their picture. You can silhouette any object—a leaf, flower, toy airplane—against a backlight. Take your meter reading from the lighted area. You can also buy self-adhesive shaped masks. These are circles, ovals, squares, and other geometric shapes that you simply press into place directly on the base side of the slide. Another way is to remount the slide into a shaped slide mount.

Multiple-image Slides. As you can guess from the name, multiple-image slides put more than one image onto a slide. You can use several arrangements of pictures, words, or pictures and words, but you can also devise other groups of two, three, or four images. *Slide Mounts and Masks.* Wess Plastics Corporation and other manufacturers make slide mounts with multiple openings. Cut out

For a change of pace, put the slides in different shaped masks.

Pieces of several slides within one mount create a multi-image slide.

Masks that hold several images in various configurations are available.

It's easier to work with full-size film frames than with snippets to make multi-image slides. Join several with black tape and rephotograph them.

areas from slides in your collection. Make these fragments large enough to extend into the borders of the multiple-slide mount, and attach them with a drop of rubber cement or a sliver of transparent tape. I find it's easier to handle these small bits of film with a pair of tweezers than with my fingers. I also like to use glass slide mounts because they keep the fragments flat and ensure that the adhesive doesn't ooze. This is important: it prevents me from having to rephotograph the composite.

Custom-designed Multiple-opening Masks. With a little darkroom time, you can make your own masks by photographing them onto litho film. Your art supply store can furnish you with charting tape in a variety of widths. Put this on a sheet of white paper—layout bristol, with its network of nonreproducible blue lines, is particularly convenient—and photograph it onto litho film. Of course, the result will be clear lines with solid black areas. To convert this to black lines and clear openings, put it onto a contact-printing frame with a fresh sheet of litho film and expose it to a strong light. If you use a darkroom enlarger, you will need about four seconds at $f/8$. Now, develop the litho film.

Another method is to make multiple-image masks with openings the full size of a slide. Then, instead of cutting your slides and working with tiny pieces, you can put an entire piece of slide film behind each of these windows. But you have to rephotograph the assemblage. If you don't want to use litho masks, you can take strips of 3/16-inch charting tape and join several slides before rephotographing them. Similarly, you might want to work with prints instead of transparencies. Join these with black tape and rephotograph them.

If you are duplicating your slides by projecting the image, use a second projector to show two images side by side. Then rephotograph them as a multiple-image slide.

Insert Slides. You can insert one picture within the area of another picture, without using a window for each image. The insert can be round, square, or some other simple shape. One way to do this is with a pair of positive and negative masks that fit into a filter holder, such as those made by Cokin, or a matte box, such as those made by Ambico. Make a double exposure, one with the positive mask in

place and the other with the matched negative mask. The black areas of the mask will prevent any image from forming in those places.

You may prefer to make insert pictures by duplicating two existing slides onto one frame of film. Get a pair of positive and negative litho masks made on 35mm film. Sandwich each mask with a slide. One way to do this is to make a double exposure, first of one sandwich and then the other. But it's tricky. You must be able to keep both slide/mask sandwiches in exactly the same place, and you must be sure the film in the camera remains equally steady. It's better to use two projectors, with one slide sandwich in each. Focus the images so they fall in the right place on the screen and rephotograph them. This is easier because you make one exposure—not two—and can see when the images are in register.

Another approach is to make a collage of many printed images. Attach them to a firm surface with rubber cement and rephotograph them. Magazines, brochures, maps, and your own photographs are sources for pictures.

Derivations with Litho Film. As mentioned in Chapter 3, litho film can help you produce some unique slides. Here are a few ideas to get you started.

High Contrast Images. Because litho film has exceptionally high contrast, it produces pictures that are black and white, with no intermediate gray tones. This is strikingly dramatic on the screen. You can put this film in your camera, and expose and develop it (as described on page 48), or you can contact-print any negative or slide you already have onto it. Negatives, naturally, give you positive images, and slides give interesting negative images. To change a negative litho image into a positive one, contact-print it onto a new sheet of film. Then add color to

litho slides using one of the techniques described earlier.

I continually refer to litho negatives and litho positives. Litho negatives have black backgrounds with clear images; litho positives have black images on clear backgrounds.

Highlight Masking. An interesting way to transform a slide is to contact-print it onto litho film. Anything clear or light-toned on the slide will be a black image on the litho. Sandwich together this litho image and the original slide and put them into a new slide mount. You and your audiences will be intrigued by the black skies and other dark accents. (I have found, though, that pictures of fruit and

For this slide, the picture of the yellow flowers was inserted.

A dramatic example of highlight masking.

Contact-print diazo film with a slide to create a monochromatic image.

vegetables look decidedly unappetizing when treated this way.)

Shadow Masking. The opposite approach to highlight masking is to make all of the dark colors and tones on the slide appear black. First, contact the slide onto litho film, making a litho negative. Then contact this negative onto another piece of litho film, for a litho positive. Sandwich the positive with the original slide.

Derivations with Diazo Film. Diazo film, with its several different colors, can also make some unusual slides. (Directions for exposing and developing it are on page 49). Try making a shadow litho mask, contact-printing it onto diazo film, and sandwiching the diazo with the original slide. Instead of changing areas to black, the diazo will give them color. Experiment with other combinations, too: a highlight litho mask with a shadow diazo, a shadow litho mask with a highlight diazo, or a shadow diazo with highlight mask of a different color diazo.

I like to make monochromatic slides with diazo film by contact-printing the slides directly onto diazo. All the shades of tonality of the original slide will be reproduced on the diazo, but they will be shades of one color instead of multicolored.

Bas Relief Effect. A picture with a bas relief effect has a three-dimensional appearance and looks like a piece of sculpture. Take a litho highlight mask and sandwich it with the slide, but put the two pieces of film together slightly out of register. You'll also create this effect when you sandwich a diazo film image out of register with the original slide (see page 50).

Another handsome way to do this is to sandwich the slide with a continuous-tone black-and-white negative image of itself. To make the black-and-white image, contact-print the slide onto a piece of black-and-white film. A good film

to use is Bubble film, which develops via heat instead of chemicals.

Transforming Black-and-white Pictures to Color. All of your slides can be color, even if you are taking pictures of black-and-white photographs of drawings. Remember the slide show I did for my parents' golden wedding anniversary party? I found black-and-white prints in their photograph albums and wanted to give them a nostalgic sepia tone. I used daylight-balanced color film in the camera and tungsten lights on the copystand when I rephotographed the pictures. This film/light mismatch made both the black and white areas corresponding shades of sepia brown. Nothing could have been easier. Similarly, you can create a slide with blue tones if you load the camera with tungsten-balanced film and use an electronic flash or sunlight.

Filters. You can also alter colors with filters. Look through your collection of colored filters—black-and-white photography filters, intense-color filters for special effects, graduated-color filters, and multicolor filters. You can preview the color you'll get through your viewfinder. First, match the film to the light source. Next, take your exposure reading with the camera's meter, basing your reading as always on a neutral gray card. If you wish, lighten or darken the image by adjusting the indicated exposure.

You can also add color to your picture by putting filters over your lights. Tape a piece of colored acetate or cellophane over an electronic flash. With flood lamps, be sure to use heat-resistant acetate especially made for this purpose, and place it at least eight inches from the lamp.

Overlays. Use a sheet of acetate or self-adhesive acetate on top of your copy. You can put color over the entire area, or in specific areas, by cutting the acetate. Razor

art knives with interchangeable blades make the best cutting tools. I like numbers 11 and 16 and swivel blades.

Optical Coloration. One of the best methods of converting black and white to color is the double-exposure technique described in the section on optical effects (see below).

Color Xerox. If you have access to a Color Xerox machine, you can create some weird and wonderful effects by duplicating black-and-white pictures and varying the machine's color controls. Then photograph the copies onto slide film.

Distortion. The abstract quality of a distorted image is sometimes appropriate. Textured glass and plastic are excellent distortion devices, and they work when duplicating a slide as well as when photographing flat copy. Place the material directly on top of the picture or slide or raise it slightly. The farther the distorting material is from the picture, the greater the distortion is.

Slide Mutilation. Slide mutilation sounds terrible, doesn't it? But it's fun to do with slides you otherwise wouldn't show. Remove the film from the mount and grasp it with a pair of tongs. Then hold a burning match near the emulsion side until the emulsion bubbles and turns into interesting abstract shapes. The film no longer lies flat, so you'll have to rephotograph it. Scribble on the film with felt markers. Scratch the emulsion with a pin or any sharp instrument. Bleach each part of the emulsion with a swab dampened in liquid household bleach. Use one or more of these crazy ideas on the same piece of film. You may create something fantastic. If not, at least it will be fun.

Correcting Overall Balance. When the slide's color is slightly off—too red from being shot late in the day or too blue from being photographed in the shade—you

This distorted image can be made with a piece of patterned plastic or glass.

Changing black areas into color.

Converting black to color.

can compensate. Sandwich the slide with a complementary-color piece of acetate or color-printing filter material and remount it. Place the acetate next to the base side of the slide.

In-camera Optical Effects. So far I've described combining images mainly by sandwiching two pieces of film. There's another way, which produces quite different and exciting effects. You can do this in the camera by double-exposing the frame of film. Once you under-

stand the principles, you can change black areas to color, combine colors to produce new colors, and superimpose white titles on a picture. Most, but not all, of these techniques require using images on litho film and transilluminating them with backlight.

Changing Black Areas into Color. Begin with a high contrast, black-and-white image on the copystand. When you rephotograph it onto slide film, the white areas completely expose the film. But because no light comes from the

Coloring with different acetates.

black areas, the film is not affected one bit in the corresponding areas. This leaves unexposed areas that can acquire an image when you make a second exposure.

Remove the black-and-white image and substitute a sheet of colored paper. Prepare the camera for a double exposure, and take a picture of the colored paper. Throw it slightly out of focus to eliminate any imperfections in its surface. The processed slide will now have clear areas corresponding to the white areas of the original image and will have color where it was black.

Instead of a solid color for the second exposure, you can also use textured material, abstract pattern, or a full-color picture. But you'll get even better results if you use a black-and-white litho image on a backlight stage for the first exposure and a sheet of colored acetate for the second. This is one of the best ways to create a slide with white lettering or graphics burned into a colored or pictorial background.

Changing Clear and Black Areas to Color. You can go one step further and transform both the black and the white areas. Make the first exposure with a colored filter over the lens. Remove the black-and-white image and filter, and place a sheet of colored paper on the copystand. Make the second exposure. The slide will now have two colors, but not the same two colors as the filter and the colored paper. The first exposure will put color in the areas corresponding to the white areas of the picture. The second exposure will put color into the black areas, but it will also add this color to the other areas because they were not totally exposed. Only white light or extreme overexposure can expose the film 100 percent. As a result, areas that correspond to the white in the picture will be the color that results from the mixture of the other two colors. When you make a double exposure in the camera,

colors combine as shown on the chart of additive colors on page 54. The exact hue depends on the colors and exposures you use.

To know exactly what colors you will get, make some test exposures of the various combinations. Bracket the exposures plus and minus 1/2 stop to give yourself more choices. This test will be helpful if you take exact notes and later transfer the information to the slide mounts. Keep them in a slide-file page for easy reference. *Three Colors from Two Exposures.* Let's suppose you have a picture of a black mountain against a white background, which you re-photograph with a red filter. On the film, a black mountain silhouetted against a red sky is recorded. Substitute a picture of a black bird against a white background and take its picture with a blue filter. On the film, nothing is recorded in the area of the mountain during the first exposure (Figure 1), so that area acquires a blue color. Also in the first exposure, the entire sky was exposed to red, including the area where the bird would be. On the second exposure (Figure 2), blue was added to the sky, except where the bird was. Figure 3 is the result: the bird is left red, the mountain is blue, and the sky becomes a mixture of red and blue—magenta. (If you prefer a blue bird as in Figure 4, use a blue filter first and red second.)

With all of these optical effects, you get the best results if your black-and-white images are on litho film, illuminated by a backlight. Transilluminating litho film produces the deepest blacks and clearest whites. Color it by slipping a piece of colored acetate between the litho and the light source. This gives purer colors than does using a filter over the camera lens. To determine the exposure, take your reading from the backlight stage *without* the litho in place; then increase the exposure by two stops. Bracket the exposures to be sure. (If you don't have

facilities for the processing of litho film, you can always have it done at a film or graphics laboratory.) This is not to say you can't use opaque artwork illuminated with toplights and colored with over-the-lens filters. You can, indeed, get perfectly satisfactory results this way.

Monochromatic Slides. Though you may not have realized it, a monochromatic slide is an extension of the first in-camera optical effect. By double-exposing a black-and-white, continuous-tone photograph with a solid color, you can convert the photograph to a colored one with a full range of tones.

Optical Effects by Projection. If you have two projectors, you can produce effects similar to those of double-exposing in the camera. The colors of light combine in exactly the same way. So if it's difficult for you to double-expose with your camera or if you want to preview the effect before you commit it to film, try this method.

Put the projectors as close together as possible so the images coincide. When a projector lens is not perfectly parallel to the screen, the image is larger on one side than the other; this effect is called keystoning. It's easier to control if the projectors are stacked one on top of the other rather than placed side by side. There are special projector stands for this. Your camera also has to be lined up squarely to the screen.

When you project a slide from each projector, the resulting image is a double-exposure effect. Put a litho negative title in one projector and a pictorial slide in the other; white letters will burn into the picture because they completely overexpose that area of the screen. Next, try sandwiching a litho negative with colored acetate and put that in one projector. Then place a mounted piece of colored acetate in the other and the colors will combine. For example, red-on-black letters in one projector and a green slide in the other yields yellow letters on a green field.

Improving Slides

You can improve your slides by correcting their minor faults. If you've ever looked at a slide and felt it would be great if only the color were richer, or the horizon weren't tilted, or the composition were more pleasing, be reassured. There are simple, corrective measures you can take.

Retouching. You may be surprised to learn that you can tone down distractingly bright highlights, increase color saturation, or change the colors in specific areas of a slide. With a little practice, you can make great slides out of ordinary ones. This is a useful technique for scratched slides, too. The best colorants are those made especially for retouching color transparencies, such as Berg Retouching Colors or Kodak Transparency Dyes, although the transparent watercolors that work on litho film also do the job. A bit of diluted spotting color used for black-and-white prints (Spotone) is fine for subduing overexposed areas.

1. Get a white saucer, which will act as an artist's palette; a magnifying glass; and two sable watercolor brushes, a number 0 and a number 2.
2. Test the brushes to be sure they come to a point when moistened, with no hairs sticking out.
3. Leave the slide in its mount if you have only a small area to retouch. If not, remove the slide from the mount so the colors don't pool at the edges.
4. Clean the slide well with film cleaner or distilled water.
5. Be sure to work over a diffused backlight with some top light so you can see where you are placing your brush.
6. To get a truer idea of color if your backlight is daylight, place a sheet of white paper on your worktable and elevate the slide on a piece of glass or plastic. This lets the light reflect off the paper and through the slide.
7. Next, tape the slide to the glass, emulsion side up.
8. If you have only yellow, magenta, and cyan dyes, put a small amount of each in a triangle on the palette.
9. Now spread the dyes slightly, so they blend together at the edges and in the center. This gives you red, green, blue, and black.
10. Moisten the slide slightly (many people do this with a bit of saliva).
11. Then dab your brush with some color and twirl it across a piece of tissue, so just the least bit of color is left on the brush.
12. Test the density of the color on a scrap of film.
13. Apply the color carefully to the slide, and blot the excess with a cotton swab.
14. Continue adding color until it is the right density. Adding color is easy, but it's hard to remove if you put on too much. Practice retouching on discarded pieces of film before you tackle the important ones.) Keep your brush moving continuously, so the color goes on evenly.
15. Don't attempt to retouch scratches on the original slide; the color won't adhere if the emulsion has been removed. Make a duplicate slide and work on that. Apply the color by dotting, rather than brushing it on.
16. Let the retouching colors dry on the palette. When you're ready to use them again, moisten your brush with some distilled water and pick up a bit of the color.

Prevent possible damage to your slide by doing the retouching on a piece of clear litho film and sandwiching that with the slide. Develop the litho without exposing it. After it's dry, tape a one-frame piece to one edge of the transparency and do your retouching on it. If you're not satisfied, start over with another piece of clear film. This way, you can try

CORRECTING POOR SLIDES

SLIDE DEFECT	REMEDY
Low contrast	Duplicate onto high contrast film, such as Kodachrome
Overall poor color	1. Sandwich slide with complementary color acetate and remount 2. Duplicate slide, filtering with complementary color
Overall unexciting color	1. Sandwich slide with acetate of desired color and remount 2. Duplicate slide, filtering with desired color
Dull or overexposed sky Poor color in part of scene	Duplicate slide using graduated color filter
Scratches	1. Duplicate slide and retouch with transparency retouching colors 2. Mask scratches with special slide mask or mount
Small areas of poor color Bright, distracting highlights	Retouch with transparency retouching colors
Poor composition Tilted horizon Background distracts from center of interest	1. Crop with slide tape 2. Mask with litho or self-adhesive mask 3. Remount in specially shaped slide mount 4. Duplicate slide, cropping and positioning correctly
Overexposed	1. Duplicate, underexposing ½ or 1 stop 2. Sandwich slide with neutral-density acetate and remount
Underexposed	Treat in transparency reducer

The colors on the left are bland. In the shot on the right, a graduated-color filter was used to add color to the sky and rock.

different degrees of color change and still leave the original intact.

Changing Color. For an exotic color change, sandwich a slide with a strongly colored acetate or rephotograph it with filtration. This lets you do such things as add drama to sunsets with red or change day into night with blue.

Correcting Color in a Large Area. We all have slides with bald white skies instead of pretty blue ones. Duplicate the poor slides and put in what nature forgot. Some filters are graduated; that is, half the slide is a color that gradually fades to clear. If you position the filter over the camera so the graduated areas fall over the horizon, you can put blue—or gray, or red—only into the sky area. Use the filter for other scenes, too, such as deepening the green of parched grass.

You can also use a piece of acetate underneath the slide if you place it far enough away so the edge is out of focus. Because the line of demarcation between colored and clear areas should be subtle, use a slide duplication technique instead of sandwiching the slide with a piece of acetate.

Improving Overexposed Slides. A piece of gray or neutral-density acetate sandwiched with a slide darkens it. Although it won't bring missing detail into the washed-out areas, it can make the overall impression more pleasing. Another approach is to duplicate the slide, underexposing it by 1/2 or 1 stop. Yet another method is to make two identical duplicates, and then sandwich them. Tape them before mounting so they stay in register.

Correcting Underexposed Slides. For slides that aren't underexposed more than one stop, use a transparency reducer, such as Correct-a-Chrome for Kodachrome and Colorbrite for all others. Another approach is to make a duplicate of the slide, overexposing it one or two stops when you do.

Cropping. Sometimes you will find that a slide needs a bit of cropping to improve its composition. You can do this when you duplicate it. In projection methods, simply move the camera closer to the screen or use a longer focal-length lens. Adjust the image until it's pleasing. When using a bellows or extension tube, add additional tubes or extend the bellows; this increases the magnification. You have to increase your exposure 1/3 or 2/3 stops, depending upon the amount of magnification.

But you don't have to make a duplicate. You can crop your original slide with a slide mount or mask. Some manufacturers of geometrically shaped masks and mounts make them in rectangles of varying proportions. If the commercially available products aren't exactly right (or even if they are), you may prefer to apply a strip or two of tape and crop the slide yourself. Use Scotch number 850 tape. This has sharp, clean edges that project neatly on the screen. Use two layers of tape to ensure complete opacity.

Mounts and Mounting. First, be sure to wear editing gloves. Otherwise, an accidental fingerprint will probably make itself a permanent part of the image.

To remove the film from a cardboard mount, cut it along the long end, about 1/4-inch from the windowed opening. Pry the two pieces of cardboard apart with your fingers or the point of your scissors. I use straight—not curved—manicure scissors for many of these slide-making projects. But there's an even easier, neater way to remove slides from their cardboard mounts. Wess Plastics Corporation makes an inexpensive device called the Paper Mount Opener that slits the cardboard quickly and neatly.

Several kinds of slide mounts are available in photo stores. Some are cardboard, in two pieces or in one foldover piece, and you can seal these with a warm household iron. Plastic mounts are faster. Some are two-piece arrangements: you lay the film down on one part and lock it in place with another. Others have the front and back already attached, and you push the film between them with your fingers or a special mounting device. I prefer plastic mounts to cardboard ones. Cardboard mounts are susceptible to damage, which often prevents them from dropping into the projector gate. Plastic mounts are more durable.

You can also buy glass mounts, which have certain advantages. They hold the film perfectly flat and keep it that way. Film in an open mount is slightly bowed, and the heat of the projector lamp can cause an open-mounted slide to "pop" and go out of focus. The pressure of the two pieces of glass is especially useful when you make slide sandwiches, keeping the pieces of film in contact. They also protect slides from dirt.

The disadvantages of glass mounts are that they are more expensive and are too thick to be used in 140-slide Carousel trays. You also have four glass surfaces, as well as the film, to clean. There is a tendency for the formation of Newton's rings (irregular dark areas where the film touches the cover glass). Alleviate this problem by using mounts with anti-Newton's ring glass or slides that have metal liners, which prevent the film from touching the glass.

MULTIPLE EXPOSURES

If your camera doesn't have multiple-exposure capability, there are other ways to achieve the same results. One is to make a series of exposures, wind the film back to the beginning of the roll, and shoot a second series precisely with the frames of the first.

The secret is loading the film properly. In a manually loading camera, insert the leader into the take-up spool and crease the film so it will stay attached to the take-up spool when you rewind the film. Take the slack out by rotating the rewind knob slightly.

With a marking pen, draw a line on the film next to the lip of the cartridge. This is your reference point for the second series of shots.

Close the camera back and advance the film until the exposure counter indicates "1." Make the first series of exposures. Slowly rewind the film, and stop winding when you feel a tug. Open the camera back and adjust the film so the line you drew is against the lip of the film cartridge. Close the camera back. You're now ready for the next series of exposures.

Mounts with tiny openings let the edges of the slide be masked.

The Wess Paper Mount Opener slits open cardboard mounts easily.

5

Scriptwriting

Do you need a script? Do you even need to deliver a narration? You may think the answer to both questions is "no." But how many times have you shown your slides of a trip or family celebration and said absolutely nothing during the entire presentation? It's highly unlikely that you sat there silently, the only sound the rhythmic clunking of the slides.

Most of us like to comment on the activities on the screen. So, back to my first question: do you need a script to deliver these comments, even if they are very casual remarks to family and intimate friends? The answer is an emphatic "yes." Not that every slide show must have a detailed and meticulously written script. Although I will discuss that, too, there are times when a less formal approach will do.

Writing Informal Notes
Unless you have a superb memory, you'll need some help in the form of written words. Jot down key words on 3 x 5 index cards to jog your memory. These will be of inestimable help—at the first show and months and years later, when you will have forgotten the vital facts.

Do not state the obvious. Such comments as "this is the Eiffel Tower" or "here we are feeding sea gulls" are boring and generally unnecessary. Your friends can recognize the familiar iron structure, and they can see the birds grabbing morsels of bread. Nevertheless, what is self-evident to one group of people may not be to another. You'll want to identify the Eiffel Tower for young children, but you'll hold their attention longer if you give fascinating bits of information.

If you take the note card approach, use one card for every slide. Number the cards, put them in order, and secure them with a rubber band. Some visuals need little or no comment, so a card is

unnecessary. This can create a problem, though. If you don't have a card for each picture, you might deliver the right words at the wrong time. To avoid this, simply jot down a three- or four-word description of the slide or make a sketch of it on the card.

I prefer note cards because they make it easy for me to keep my place, but I've also used sheets of lined paper. Put the slide number and its description or sketch on the left, and your commentary notes on the right. I want to stress *notes*. All you want are words and

Omit redundant comments, such as "This is my father feeding sea gulls."

© Carolyn Livingston

Instructional slides need narration.

phrases, and perhaps a reminder of an occasional anecdote. Make your notes as you look at your slides on the slide sorter. (Earlier, I suggested editing your slides with planning cards and jotting words on the cards to help with your commentary. If you do this, transfer those words to your commentary cards or the sheet of paper. If they are legible, you can use the original planning cards.)

Using informal notes is easy, and yet it has another decided advantage: it makes your presentation casual and pleasant. As you do for reading a speech, you need a certain amount of skill to read words from a page and have them sound natural. But having only notes to work from, instead of complete sentences, can almost ensure your sounding relaxed and friendly. Certainly, this is the impression you want to create when showing slides to your family and close friends. And, of course, having something written down eliminates stumbling comments.

Store your notes in the box with the slide tray. Following this basic bit of advice can save hours of frantic searching. And it's even better than having a file folder full of slide-show scripts.

Scriptwriting

When you have more time and the need to do a terrific presentation, you'll want a formal script. Scripting a slide presentation does not only mean writing the narrator's words. This script is your visualization—your plan—for the entire show, which may or may not include spoken words. It is the detailed description of the visuals and their organization, together with the words and indications of any music or sound effects you intend to use. It represents an organized and creative approach. It's what will make your slide show outstanding.

I discussed some of the preliminaries for scriptwriting in Chapter 2, in which I gave information on planning and organizing your ideas. You may want to look at those sections again. They include some points that are crucial to a successful slide show. Basically, you must define your purpose, analyze your audience, and research your subject before you do anything further.

Planning and Visualization. A slide show is primarily a visual experience. This should be reassuring if you are more comfortable taking pictures than writing. In planning the presentation, *think visually:* plan images that will get your ideas across. The best way to plan these pictures and words is to do it simultaneously. Close your eyes and let your mind's eye become the screen for your intended slide show. You'll soon find it quite easy to imagine seeing the pictures you want. This is the process of visualization. In addition, you may even "hear" the music you want to accompany them.

Notice, the pictures are first and foremost. The words are there to explain, emphasize, and supplement whatever additional information is needed. Sometimes none is necessary. Strong visuals often can get an idea across themselves.

With your purpose firmly understood, relax and let your imagination take over completely. Then get all your ideas down on paper. Make some quick sketches—nothing elaborate, just enough to indicate the elements you'll want in the picture. If you can't sketch your idea at all, you'll know it cannot be visualized in a slide show. Now, next to your sketch—on the planning card or whatever you're using—jot down the words you'll want to accompany it. As with the pictures, the words are only rough ideas at this stage, not polished and perfected.

The process of formulating a slide show progresses from this visualization stage to organizing the pictures into sequences, as described in Chapter 2. But now you

are also thinking about the accompanying words. Take each idea you want to communicate and develop it, and illustrate it through into a sequence of slides. All of the pictures must be concrete and specific. For example, a summer camp might want a slide show to stress that it has activities to promote physical fitness among the campers. Rather than show a picture of a healthy camper, take pictures of volleyball, racing, calisthenics, and other activities. If you want to say that a certain area is enjoying unprecedented prosperity, you can convey the idea with pictures of a Mercedes or Rolls Royce in the driveway, hands bedecked with diamonds, and people dining in luxurious restaurants.

These examples require slides to illustrate the idea, which is part of writing a script: do it in sequences. Make lots of sketches—doodles if you like—of what you think might work. Later, you can choose those that flow together well and help develop the idea fully. What's fundamental, though, is your ability to recognize a story-telling image when you see it and to be able to imagine something similar when you need to.

Getting Words on Paper. After your imagination has dictated its ideas to your hand and you have them on note cards, arrange the cards in the order that will make your slide ideas come alive. Your organization should include an introduction, a middle, and a conclusion. (Again, see the section on editing in Chapter 2.)

Now you can get down to writing the actual script. Because the words and pictures go hand in hand, scriptwriters use a two-column format that keeps them aware of both elements. In a typical slide-show script, the left side of the standard sheets of typing paper is reserved for what will be on the screen and is labeled "visuals." The right side of the paper is for the audio: words, music, and sound effects. After numbering the slides sequentially, list them, with a brief description of each picture,

Some slides don't need a narration.

A SECTION OF A TYPICAL SLIDE-SHOW SCRIPT

VISUALS	AUDIO
6. Jan on ground, touching toes	Stretching, limbering up, or doing whatever runners do to get their muscles warmed up—
7. Jan doing backbend	seemed to be the order of the day. And the runners sure took . . .
8. Stretching leg over another racer	some strange positions.
9. Racers standing around	The atmosphere was one of excitement.
10. Jan and other racers	The racers and their families chatted and milled around . . .
11. Person tying shoe	as they waited for the event to begin.
12. Superman with megaphone	There was no question as to who was in charge. "Superman" was a highly visible personality . . .
13. People behind curtain	who requested the spectators to stand back of the red curtain . . . and the race to begin!
14. Racers starting	
15. Similar to 14, but closer	
16. Similar, but still closer	

In a typical working script, the description of the visuals is on the left, and the narration and description of the sound effects are on the right.

SPEAKER-SUPPORT SLIDES

Many of us first use an organized presentation of slides when we give a speech. Words alone are frequently inadequate. For example, statistical information is difficult to remember when a speaker mentions it, but figures shown on a chart or graph or added to an illustration or photograph make the points more tangible. When the audience sees and hears the information, they remember it. As the saying goes, "the ear hears, but the eye remembers."

This type of slide presentation is different from others because the speech—the words—tends to be thought of before the pictures. The visuals are now supportive: they help explain the words or emphasize them. This is why they're frequently called *speaker-support slides*.

As a photographer, you might be asked to supply the slides to go with a speech your boss or co-worker has written. Your task, then, is to come up with the right pictures to support the words. You'll need a visualization for every idea, and the words and the slides must fulfill the speaker's objective. If you think hard enough, you will be able to brainstorm a way of visualizing every point. Of course, the more concrete the words, the easier it is. For example, if the speech is about a product, you can show the product, people making it, people using it, and the results of it being used.

If you must illustrate such abstractions as "inspiration," "knowledge," or "business," you can use symbols. A head with a bright light superimposed on it can indicate "inspiration," a lamp symbolic of learning can convey "knowledge," and the stock market page undeniably suggests "business." Often, you may find it difficult to illustrate an abstraction, such as "insight," but you would have no trouble showing "a flash of insight." You can fre-

quently use graphics in these situations rather than live photographs. And several slide-production companies specialize in making illustrated slides for use in business speeches. (See the list of suppliers at the end of the book.)

Some other points: include pictures of people whenever you can. The audience relates to people on the screen. Use pictures of local happenings to further help the audience identify with the subject. And, whenever you can, try to use pictures that arouse

people's senses and emotions.

Speaker-support slides can present charts and graphs or can be word slides. Word slides are excellent for emphasizing important points, introducing a new topic, and summarizing the speech. Use as few words as possible. Pick up only *key words* from the speech. Remember that you shouldn't paraphrase the speech on the word slides. This can confuse the audience if they see and hear different words.

Words that introduce topics are

This picture makes this man seem evil.

This shot can suggest love, tenderness, or motherhood.

© Visual Horizons

Word slides can introduce topics.

like chapter titles in a book: they indicate what's to come. They're also good transitional devices. They can appear on the screen during a pause and remain there during the speaker's next sentence. You may even want to use numbers to alert the audience that there are several points of information.

Summarizing a topic firmly plants it in the audience's mind. An oral summary combined with a visual one is more than doubly effective. You can summarize at the end of each major topic during the speech and again at the end—or just at the end. Use a *short* list of words or fragmented sentences containing two or three words each.

When you have several points to spell out on the screen, don't show them all at once. If you do, the audience may be reading the fourth point while the speaker is still talking about the first. But you may want to have all the points on the screen when you finish the topic.

To do this, try a technique called progressive-disclosure, build-up slides, or reveal slides. This is done by using a set of slides, each having one more line of information than the preceding one. You can also use it with diagrams, charts, graphs, or other graphics when you want to lead the audience from something simple to something more complex.

With a similar technique, which I call progressive emphasis, you present all the information at the same time, but you make a particular line a brighter color than the rest; it then stands out. A slightly less emphatic method is to accent the desired word with a bullet or asterisk.

You can use any of a number of lettering methods to make progressive-disclosure and progressive-emphasis slides, and can shoot them on a copystand. Make the complete list of words on one sheet of litho film. The film should have clear lettering on black. Place it on top of a lightbox. For progressive disclosure slides, mask all but the top line by placing a sheet of black litho film underneath it. Photograph the first line, and then move the mask down to expose the next line. Continue this process until you have recorded the complete series. You might find it convenient, instead, to cover all the lines with black tape and remove the strips of tape one by one.

For progressive-emphasis slides, put the words on litho film and use strips of colored acetate under the appropriate lines. For example, use yellow acetate or no acetate under the principal line and blue acetate under the others. Another approach is to leave the principal line of lettering clear and to de-emphasize the others with gray acetate. If you photograph this with a colored filter over the camera lens, the principal line of lettering will be bright and the others will be a subdued shade of that color. Diazochrome film is well suited for making progressive-emphasis slides.

You can combine the two methods to give build-up plus color emphasis. Let the first slide display one item in white or in a bright color. Let the second slide show two items, but with the first one subdued and the next in the brighter color. The third slide will show the preceding points in the subdued tone and emphasize the new one.

Here is a series of slides called progressive-disclosure, build, or reveal slides.

in the left column. Give as much information as necessary to help you visualize the scene, transferring the description from your planning cards. Include camera angle, subject, and location, and specify if you need artwork or other types of graphics.

With the clues to the visuals in front of you, you're ready to tackle writing the narration. The visuals side of the page should reveal that your slides are organized into sequences; your narration will reflect this. This makes writing a script different from any other writing you have done and helps to make watching a narrated slide show more exciting than merely reading about a subject.

Finally, as you start writing, regard your work as the preliminary stage in the scriptwriting process. You'll have a good idea of what the completed slide show will look and sound like, but it shouldn't be unchangeable. Get the rough version on paper, and then go out and shoot your pictures. You'll most likely bring back additional exciting images and sequences you'll want to include. You may also find you couldn't get some pictures or they did not work out as well as you planned. You'll have to make deletions and substitute something. When you know exactly what images you have to work with, you'll be able to polish the script by correlating words and images.

Prose Versus Scriptwriting

Most writing is intended to be read silently. A letter, a brochure, a magazine article, a book—all give readers the luxury of time. They can control their own reading rate, varying it to adjust to the complexity of the material. If it's difficult, they can go back and read it again and again. If a word is unfamiliar, they can look it up in the dictionary. If the conditions aren't conducive to seeing the words easily, they can take a moment and find a different reading lamp. But

when they receive verbal information by listening, the parameters are different. A narrator delivers words at about 125 words per minute, and if listeners don't pay attention, don't understand, or can't hear because someone else in the audience coughs, those words are gone. No chance for instant replay, no dictionary to consult, no slowing down the message.

The differences between words we read and words we listen to don't have to be obstacles to understanding. It just takes awareness on the part of the scriptwriters that there are differences and knowledge of what changes they must make in their writing style.

One major difference concerns the sequences of slides you assemble to form a show. These are different from the sentences assembled into paragraphs meant to be read. As an illustration, analyze the paragraphs you've been reading on these pages. Almost always, the paragraph begins with a general statement, such as "Most writing is intended . . ." and is followed by specifics to support the general statement: "They can control . . . ," "they can go back and read it again," "they can check it out. . . ." This progression from general to specific is common to all prose writing. But in writing a slide-show script, general and specific ideas are presented simultaneously. Most often, the narration presents the more general ideas, while the slide images provide the specifics. The two are continuously interacting, rather than one coming before the other. Look again at the sample script on page 67 to see what I mean.

Conversational Sentences. When you write the script, use short sentences. Even fragmented ones. The idea is to be conversational. Lengthy sentences with involved clauses are not easy to understand, and listeners can easily get lost in the maze of phrases. This is another big difference between writ-

ing words people read silently and words they listen to. The more difficult the subject matter is—technical or instructional material, for example—the more important it is to use shorter sentences. If you're talking about something inherently complex, take extra care to simplify it.

Consider this sentence: "Awakening at 6:30, we dressed, located the tour office where we purchased our tickets, and then we meandered to the coffee shop for a breakfast of juice, coffee, and waffles, finishing just in time to board the bus for the sightseeing tours of Los Angeles and Hollywood—with all the celebrities' homes—and the make-believe world of Universal Studios." These 58 words are a little confusing, but you can reread it and figure out the meaning. It's not a good sentence even for written material, and it would be a complete disaster in a slide-show script. You want listeners to grasp the meaning easily because they are going to hear the description only once. This example contains too many different ideas, which gets in the way of understanding. Another reason for rewriting that sentence is that it is difficult to read aloud. Try it; you'll find yourself straining to finish the sentence. It's certainly not conversational.

To avoid falling into the trap of writing lengthy, complex, difficult sentences, *say* what you want to say. Say it aloud, and then write those words down. *Talk, and then write.* When you've finished the script, read it aloud again. It's even better if you record it on tape and play it back. As you listen, you'll hear if the script is conversational and easy to follow.

I have rewritten that awkward sentence and related it to just one slide: a medium closeup of two people eating breakfast in a restaurant, with a tour brochure spread in front of them. I changed it to: "We had just enough time to grab breakfast. It was a meal of juice,

**A SECTION OF AN
EFFECTIVE SCRIPT**

Clouds form as air rises. When the
air rises, it expands and cools.
And as it cools, some of the air's
moisture condenses into tiny
droplets of water or ice crystals.
Every condition on the earth's
surface affects the air that blows
over it—the surface temperature,
wetness—how hilly it is, how
rough. These conditions all play
a role in how clouds develop.

If the script is instructional or contains complex material, simplify it.

waffles, and excited comments about what we'd see in Los Angeles and Hollywood." I cut the horrendous sentence into two because two short sentences are almost inevitably easier to follow than one long one. I also deleted some of the extraneous information. I could have left just the first short sentence, saving comments about the anticipation to use with a picture of passengers boarding the tour bus. Maybe you'd want to introduce the story of the trip with a picture of an alarm clock or buying tickets (although you probably wouldn't want to devote much time to that relatively uninteresting part of the trip).

The amount of narration and the time a slide will be on the screen are interdependent. If the message in the picture comes across in 5 seconds, don't bore your audience by giving them 20 seconds of verbal information. Either add an additional slide, or cut the narration—preferably the latter, as most scripts are too wordy anyway. If the slide is detailed or so wonderful that people will want to linger over it, you don't necessarily have to have words to fill up each moment. Plan the script so you say what you have to; then keep quiet and let the slides make the impact.

Actually, you should plan the visuals and narration so you don't comment continuously. Allow the information to settle in people's minds with silent pauses, music, or sound effects. An introductory sentence might well be all you need for a succession of several slides. For example, you might say, "The Botanical Gardens were at their most splendid," and show a sequence of four or five slides without additional narration. If the narration is split to allow music or sound effects to predominate, do not start a sentence with a connector, such as "but" or "however."

There's another picture that does not need to be talked about: the subject that cannot be seen. If the narrator says, "The chief of the tribe is standing behind the woman in the purple hat," it's frustrating if all the viewers can see is the overpowering woman. Like making a promise that can't be fulfilled, it's best left unsaid.

Avoiding Redundancy. Just as in planning informal comments aided by notes, you should avoid repetition. If a picture clearly shows tourists eating waffles, do not repeat that fact in words. Your comments might be, "We had just enough time to grab breakfast." Even though we usually think of repetition as a replication of something in the same medium—words being said or written more than one time, pictures duplicating pictures—in a slide show, we have to be aware that the information in pictures can repeat itself in words. Avoid this. Otherwise, the audience thinks you are talking down to them or grows bored.

Effective Words. A few guidelines can help you choose the words that are most effective when writing a script.

- Above all, strive for natural-sounding, conversational words. Even if you're sure the words are part of your audience's vocabulary, higher-level words tend to make a script sound pompous and pedantic.
- Include contractions. "You're, he's, they've," and others can ensure a large degree of casualness.

- Do not contract the word "not." The negation often is not heard, and you're apt to leave the opposite impression. If you want to emphasize the negative, use the whole word.
- Generally, it's best to avoid slang. Colloquialisms, if you're sure they're familiar to members of your audience, can sometimes express an idea better than more traditional language. And, as for clichés, unless your narrator's tone of voice conveys the impression that he or she knows the expression is a cliché, it's best to avoid them, too.
- Incorporate the terminology that's part of the everyday language of members of a certain group or profession. If you think some audience members will not be familiar with the words, use the terms, but explain them by paraphrasing.
- Choose words that are easy to pronounce. Single words are not apt to give too much trouble to the narrator, unless he or she always bumbles over "statistics" or "nuclear."
- Avoid word combinations that often cause problems, such as tongue-twisters. While you may not be able to do anything about a particular name, you can usually rewrite combinations of words. Certain phrases can be easy for one person to say but not for another. So, if you are not doing the narration, be flexible and make changes later on.
- Finally, include action words and descriptive nouns, which can strengthen a script. (Many adjectives are unnecessary because they repeat what's obvious in the picture.)

Entertaining Scripts. All the suggestions about sentence structure and word choices are lost if they produce a dull script. Use your creative ability and ingenuity to turn the information into a script that intrigues, excites, and entertains your audience. That's the

© Tony Gagliano

These slides lend themselves to one narrator.

most challenging part of writing a script. A recitation of facts can be lifeless. Put drama into your narration: include some facts to tease the viewers' curiosity, and then bring your comments to a satisfying conclusion. Somehow, you've got to surprise the audience and add punch. Inject humor, suspense, color—whatever will make the show entertaining. You can also pose a challenging question, such as, "Would you like to cook dinner for the greatest chefs in the world?" Try making a startling or absurd statement: "There's murder in your mailbox!" Even if the program is instructive, it must entertain if it's to succeed.

Narrative Approaches. You can write a narration from one of several points of view:

- The narrative voice can be that of an observer, someone who presents the information impartially and impersonally. Write the script in third person, or second and third person. Never show the narrator's picture on the screen.

- The narrator can be one of the subjects pictured in the presentation and does not necessarily have to be a person. You can give a voice to an animal or an inanimate object. Write the words in first person, or first and second person.

- The narrators can be two people speaking in third person.

- The narrators can be several people (or things), each a character in the presentation who sees things a little differently.

- There can be a combination of two of these approaches. For example, the narrator states pertinent facts, and character voices provide a dramatic interchange.

The one-person, documentary-type narration—either in first person or third person—is a basic method. It's probably the easiest to write. But using two voices can be more interesting, and the change helps keep the presentation lively. Plan to use distinctly

© Michael Fowler and Jan Perrin

These work well with two narrators.

different voices, so the listeners are sure two people are speaking. A male and female voice work well together.

When you write words for two or more characters actually seen in the slides, you are getting away from straight narration. There are other methods you can try.

Dialogue and Dramatization. One of the most effective scriptwriting approaches is a dramatic technique: a story line with dialogue. Writing dialogue is not as straightforward as writing narration. It must sound completely natural and real. Decide on the idea you want to get across and say it aloud. It helps if you use a tape recorder to evaluate the flow of words. "Flow" may not be the right term. Conversational speech has hesitancies, pauses, and interjections, many of which you will want to include. Keep the characters' speeches short, letting them acknowledge and react to what the other one has said. If you've never written dialogue, I suggest you look at a book on film or radio scriptwriting for some additional pointers before you give it a try.

Actualities and Ad Libs. Your portable tape recorder can do more than record the obvious. Take it with you when you research your subject with an authority or when you talk to people you are photographing. Later, you may be able to edit out your voice and use the others as part of the sound accompanying your slides. The trick is to ask questions that will elicit a well-developed answer, not just a "yes," "no," or grunt. And be careful that when you talk, you do not speak at the same time the other person is talking. You may be able to use pieces of conversations among several people. (Chapter 6 discusses sound editing.) You may find, however, that you want to retain the voices of both interviewer and interviewee, which is another scriptwriting technique. Most of your effort will go to planning: writing down questions to ask.

Poetry. Classic poetry or modern free verse can be teamed with slides effectively. If you have a speaker who can do justice to the words, you might like to explore this method, using your own works or those borrowed from the masters.

Improving and Finishing the Script. *Rewriting and Refining.* You must plan on making changes through rewriting, revising, refining, and revising some more. It's part of the writing process.

Pacing. Read the script aloud as you project your slides in order to perfect the pacing of show. Sometimes all you have to do is add or subtract a few slides—or words—to make the program move along the way you envisioned it would. And whether your show proceeds sprightly or leisurely, make sure there's variety in the pacing of the scripted words.

Balance. Another element to look and listen for is balance. The more important the idea, the more time you'll want to devote to it to give it appropriate emphasis. Also, a show that begins with a clever, attention-getting opening will disappoint the audience if other parts of it do not come up to this level.

Transitions. The basic element of a slide show is a sequence of images and words. A script must help make the transition from one sequence to the next, particularly when there is no visual transition. You'll want to find words and phrases that can tie the sequences together.

Typing. I recommend typing the script, double-spacing the lines and using upper- and lowercase. Capitals are harder to read than lowercase letters, as is single- or triple-spacing. Although you'll do your preliminary writing in the two-column format, to coordinate the visuals and the words, you (or the narrator) will find it easier to read if only the narration is typed on the page. Leave wide margins.

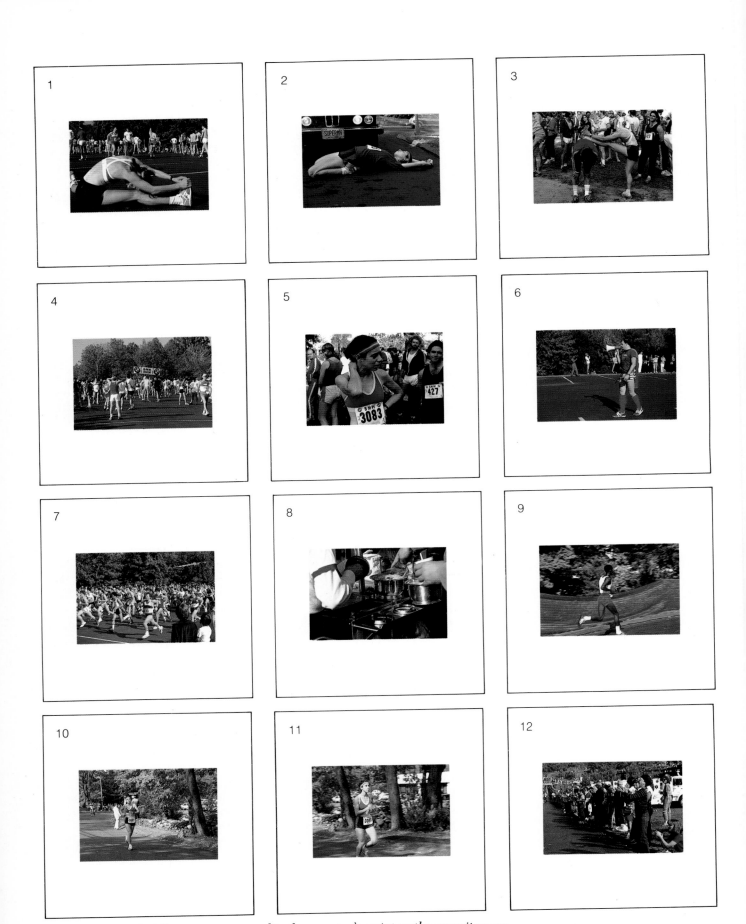

These pictures of a 15km race correspond to the narrator's script on the opposite page.

```
Stretching, limbering up--or whatever runners do to
get their muscles warmed up--seemed to be the order
of the day. And they sure took some strange positions. /

The atmosphere was one of quiet excitement. The racers
and their families chatted and milled around as they        quietly
waited for the event to begin.

There was no question as to who was in charge.
"Superman" was a highly visible personality, who
requested the spectators to stand back of the red
curtain--/and the race to begin! //                         expectedly

For less than an hour, we nonrunners enjoyed the
sunny day . . .

and hot dogs helped pass the time pleasantly. /

The first racers approached the finish line in less
than 45 minutes.

Jan did not do quite that well, but she did finish in
one hour, seven minutes . . .

to our admiring applause.
```

A narrator's script that is easy to read.

Use the eraser end of a new pencil to stamp dots that indicate slide changes.

Do not break a paragraph at the bottom of a page. And be sure to number the pages. If you are delivering a narration while both showing the slides and operating the projector, have a one- or two-word description of the slides on the left side of the page.

Next, indicate words you want to stress by underlining them. If you want to indicate a short pause, do so with three dots. For a longer pause, during which several slides will be projected, jot down the number of seconds that pause should last. Remember to spell out numbers, and spell difficult names phonetically.

Marking Cues. There's one more thing as a scriptwriter/show designer you have to do: mark the script to indicate where you want slide changes to occur. These cues should not be left to memory. Put a big dot over the word that indicates when you will push the slide-advance button. You can use a felt pen or a rubber stamp, or you might want to try inking the eraser end of a pencil on a red stamp pad.

Remember that it takes a little more than a second for a projector to lift one slide and drop the next, so if timing is critical, you may want to mark the script *slightly before* you want the new slide to appear. Finally, be sure to leave a breather between cues. They must not follow each other so closely that there isn't enough time for the slides to change. Practicing will show you how much time you must allow.

The script can be read aloud—live—while you project the slides. This same script can be used with a recorded sound track, creating a slide/tape show. (I'll discuss putting that script in front of the microphone in Chapter 6.)

Delivery

Both the visualized speech and the narrated slide presentation require rehearsing—as much as is practical. Emphasis, pauses, and pacing are critical. As you practice, continue to underline and mark your script with helpful cues.

One objective of the rehearsal is to coordinate the words with the slide changes. If someone other than yourself will act as projectionist, give your helper a copy of the script and a chance to get involved in the rehearsal. If this is impossible, be sure the projectionist has a copy of the marked script well ahead of time. And have an extra copy available at presentation time—just in case!

Of course, if you intend to speak extemporaneously from abbreviated notes, you'll have to press the slide-advance button yourself. Be sure to put a description or a sketch of the slide on each note-card or on a separate list, whichever way will best remind you of what slide is next in the tray.

(I haven't forgotten that part of the scriptwriting process is planning the music and sound effects; my discussion of them comes in the next chapter.)

6

Recorded Sound

A slide show isn't complete until you add sound. I have already discussed one type of sound: voice. But you should also consider using music and sound effects. All three, either alone or combined, add substance to your program.

You can deliver the narration live, as I suggested earlier. You might even be fortunate enough to have someone play a musical instrument while you show your slides. More likely, though, you'll use recorded music. If you put all the sound on tape, you'll be assured that it will be the same every time you make your presentation. Although the focus of this book is creating slides for an effective presentation, this chapter is about sound. Putting sound with the pictures gives you an audiovisual presentation, which is an exciting means of communicating.

Choosing Music

You don't need elaborate techniques to combine your slides and music into an effective show. You can do this as casually as playing a record while you project the slides. This is reminiscent of the days of silent movies, when distributors sent along musical scores for a live pianist or full orchestra to play when the pictures were shown.

Music is the most important element in setting the mood for your show. It is a powerful controller of emotions. It creates atmosphere. It sets the pace. It enhances what is on the screen.

The right music is the appropriate music—whatever reinforces and complements the mood, tempo, and character of your show. Music can be playful or

Shots of children, city streets, and placid landscapes call for music of different moods.

foreboding, tranquil or exciting, or
romantic or angry. Some composi-
tions express all of the gradations
between these extremes.

Look at your visuals and decide
on the mood you want to convey.
Pictures of children playing in a
park probably need a light, cheer-
ful sound; pictures of factory work-
ers, busy music. But if you play
sad music with the children or
slow music with the workers, you
will convey different messages
than you intended.

The effects of music and picture
combinations are hard to describe
in words, so I suggest a little ex-
periment. Project your slide show
several times, playing a different
type of music with it each time.
You can even select some composi-
tions that seem inappropriate.
Note how different compositions
change the mood and feeling of
your show. You may be sur-
prised—sometimes pleasantly—
by the effects of adding music that
is in contrast to the visuals.

With a travelog, you may want
to use music that is typical of the
region. Many people buy record-
ings while they're traveling, but
you can also get them in your local
stores. The music doesn't neces-
sarily have to be authentic to be ef-
fective; composers often write mu-
sic that represents music of
another land.

The music's rhythm and tempo
are critical, too. They must relate
to the way you intend to edit and
project your slides. If there is a
pronounced beat, you can often let
the rhythm of the music be your
cue to change the slides.

Different parts of your show
may require different types of mu-
sic. It's a good idea to go through
the script, or the slides, and write
down a description of the mood
and pace of each major section.
You also need to know approxi-
mately how long each section
takes. If the music is on a record,
you have to find one that can work
throughout the entire presenta-
tion. But if you use a tape, you can

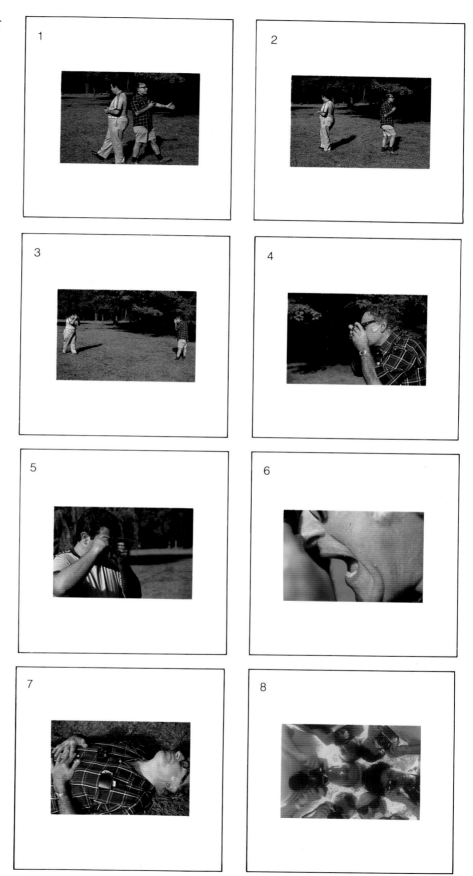

The "1812 Overture" worked well with this staged squirt-camera duel.

COPYRIGHT

There is a somewhat discordant note about using recorded music to accompany your slides: the matter of copyright. Recordings are protected by copyright and may not be used during a public performance unless you have secured written permission and, in most cases, paid a fee. This can be complicated and expensive. No one is going to fine you for using copyrighted music in the privacy of your home, or even to a PTA, garden club, or other local group. But when you show your work to larger audiences—whether or not they pay an admission fee—it's prudent to stay within the boundaries of legality and morality. And, perhaps, the show you make for your own enjoyment might be so good that you'll be asked to present it to large groups or on cable television.

There are several solutions to the problem. One is to use music that is not copyrighted. Music written before 1907 can safely be thought of as in the public do-

main, and the composer or any heirs no longer own the copyright.

Stop. Don't rush to a Vivaldi recording because the composition is in the public domain. The recording of it is still copyrighted by the recording company. But if you have friends who are musicians, you can record them playing the music as long as the arrangement is not copyrighted.

Many music students are composers as well as performers, and they might be willing to assume both roles for your production. Get written permission from them to use the music, and give them credit on a title slide. Another solution is to use music from a production music library. These companies sell recordings of music specially composed for use in films and slide shows, and they grant you the right to use it. The licensing fee is quite reasonable and certainly worth it if there's any possibility your show will be going public.

edit any number of selections together that fit the mood.

Familiarize yourself with lots of music. As you play different selections, imagine what kinds of picture sequences go with them. The power of music is so strong that you don't need a musical education to know what works and what doesn't.

You need to know about your audience before you choose the music they will hear. You can antagonize or bore them if you don't consider their tastes. Certainly, some selections are "safe" for everyone, but it's unwise to play hard rock when making a presentation to a group of older executives or baroque canons at a meeting of boy scouts.

Selecting music is, of course, a subjective process. It's natural to choose music we prefer and are fa-

miliar with. The difficulty is that your musical tastes may not agree with those of the audience. It's also hard to make blanket statements about the kinds of music an audience prefers. Age, education, and region of the country are fair indicators, but even so, you're likely to find 10-year-old lovers of Bach and 60-year-old lovers of rock. The safe course is to plan so you do not offend. If you think that the majority of viewers will not like a certain type of music, don't use it.

Don't select music that is too familiar, either. Melodies with well-known themes are distracting, causing the audience to pay more attention to the music than the pictures. It's even worse when a viewer recognizes the music but can't remember what it is—and spends the rest of the slide show trying to recall its name.

Background Music. If you're using music as background for the narration, it must be subdued and not call attention to itself. Fairly uniform, somewhat monotonous pieces are best. Music that has sudden, loud passages can interfere with the narration. Try to avoid solo violins, clarinets, and flutes as they, too, can make spoken words hard to understand. Music played by a large orchestra is apt to compete with the narration. Vocals should also be avoided unless the words are in a foreign language the audience won't understand. A song that alternates with the narration can, however, be effective.

The best way to be sure the music doesn't obscure the narration is to test it by actually reading the narration aloud while playing the music.

Choosing a Narrator
The right voice can make a difference in the effect the narration has on the listener. Tune in documentaries on television and you hear friendly, person-next-door voices; erudite British voices; and authoritative, "voice-of-God" voices. Because the voice can set the tone of your presentation as much as the music does, you have to decide what you want to convey and use a voice to match.

You may not have too much choice among yourself, your family, and your friends. No matter how beautiful a speaking voice a person has, it takes considerable practice to deliver a natural-sounding narration. Most people cannot read a script aloud without sounding as if they are reading.

Choose your narrator carefully, and try to be objective. You or your friends will do well if you or they have done some acting or are accustomed to public speaking. Your best bet may be to ask someone in a local drama group or a college theater workshop. If you are putting together a slide show for a business or commercial presenta-

tion, get a professional narrator. You can find their names in classified telephone directories under such headings as "Recording Service" and "Audiovisual Producers." You may also be able to find narrators by contacting radio stations; many announcers do freelance work. Don't compromise.

Recording Taped Music

Recording your music onto tape allows you to edit the music: shortening it, lengthening it, and combining different selections. Having music on tape also will enable you to cue your slide changes precisely to the music (more about that later). If you expect to edit the tape, use an open-reel rather than a cassette recorder.

The technique of transferring from record player to tape recorder is simple.

1. First, here's what *not* to do. Don't set the microphone in front of the speaker of your record player. You would be able to transfer the sound, but the quality would not be very good.

2. Do, however, use your record player's output sockets to bypass the microphone and go directly from one machine to the other. This produces excellent sound quality.

3. Buy patch cords at any audio supply store. The plugs must be the correct size to fit into the sockets of the equipment. Connectors come in many types, so consult your instruction manuals to find out which to use and how to use them.

4. Manually set the volume level if your tape recorder has an automatic level control (ALC) or automatic gain control (AGC) with a defeat switch. This preserves the nuances of loudness and softness the composer intended.

5. Before you make the transfer to tape, depress the "record" button on the tape recorder while you play the record.

6. Now observe the volume indicator on the tape recorder, and ad-

CONNECTING AUDIO EQUIPMENT

When connecting audio equipment—whether microphones, speakers, headphones, recorders, or mixers—be sure that the pieces have similar impedance and voltage ratings. Impedance is measured in ohms, but it may be listed as high or low impedance.

Do not connect a unit rated for high impedance to a unit rated for low impedance. This will result in inferior sound and, possibly, damaged equipment. Consult your instruction manual for the specifications at the output and input of the various devices.

To transfer sound from one piece of equipment to another, patch cords with the appropriate connectors at each end are necessary.

In this shot, the patch cord is connected so sound can be transferred from the cassette recorder onto the reel-to-reel recorder.

Outlets on a tape recorder.

Audio equipment usually accepts (from left to right) phone plugs, mini plugs, submini plugs, and RCA plugs.

just the volume control until the indicator shows a level just below the 0 dB mark most of the time.

7. Do a test recording at different levels to find the maximum volume the machine can tolerate before the sound becomes distorted. Occasional loud accents that send the indicator momentarily into the red danger area are all right. If the recording level is too low, you must compensate later by setting the playback volume very high, which makes tape hiss obvious and gives less than ideal sound.

8. Use good-quality recording tape. Very inexpensive tape is usu-

ally inferior, and can cause momentary loss of sound, give poor sound, and even wear away the recording heads.

9. Use a new tape or erase the sound on the tape with a device called a bulk eraser (a degausser). A tape at least 1mil thick is less apt to stretch or break than a 0.75mil or thinner tape.

10. Record on just one side of the tape, using a tape speed of 7 1/2 inches per second (ips) rather than 3 1/4 ips. The faster speed produces better quality and gives you leeway for errors when you edit the tape.

Recording Live Sound

Recording sound onto tape requires attention to a few important details. You have to arrange for and take care of the following.

Equipment. One of the most important pieces of equipment is a microphone. Some tape recorders have built-in mikes, but they do not produce high-quality sound. The separate microphones supplied with recorders are somewhat better, but you'll be more satisfied if you get a good microphone.

One useful type in almost all recording situations is a condenser mike with a cardioid pickup pattern. "Cardioid" refers to the direction of the mike's sensitivity. This heart-shaped pattern rejects sounds coming from behind; it is ideal because, in general, you will be concentrating on just one sound source. An omnidirectional microphone responds equally well to sounds in front, back, and at the sides. It usually is not desirable because the mike picks up unwanted background sounds along with the sounds you want to record. A mike with bidirectional response records sounds from the front and rear, but not from the sides. This makes it a good mike for recording two people in a conversation or interview situation. You can also buy such microphones as the shotgun and the parabolic, which have highly directional pickup patterns. These microphones record sounds within a very narrow angle directly in front of them; they are advantageous when you're trying to capture sounds from a distance.

When shopping for a microphone, find those compatible with the impedance of the recorder (the opposition in an electrical circuit to the flow of an alternating current), which may be high or low. Check the specifications to be sure. You should also consider buying a microphone stand, which is a useful accessory. Those little plastic supports often supplied with tape recorders are too small

to be very satisfactory. It's better to improvise by taping the microphone to a support or to buy a relatively inexpensive stand that sits on a table.

The Recording Studio. Unless you're doing a very important presentation, you won't need a full-fledged recording studio to record your narration. But you will have to find a suitable place to do your work. By the time you've moved furniture around and asked people to keep out, you will feel that your temporary setup deserves to be called a studio. The arrangements may be makeshift, but they can give excellent results.

- Choose a room that isn't filled with many hard, reflecting surfaces, such as tiled walls and bare floors. These cause unwanted excessive reverberation—a sort of echoing effect. Kitchens, bathrooms, and hallways are inappropriate. Find a room with carpeting, draperies, and upholstered furniture.
- Close the windows, draw the drapes, and clear off a table for your microphone stand and script.
- Cover the table with a piece of foam rubber or a towel, so it won't bounce sounds back into the microphone.
- Direct the microphone away from a window to prevent picking up any sounds from outside. Position it so the narrator does not face a nearby wall or, worse, into a corner.
- Be sure to arrange the microphone-to-speaker distance carefully. If too great, the sound is quite hollow and booming; too close, and distortion results. The best position for the mike is about 12 inches from the speaker's mouth and level with it.
- Minimize speech problems—popping "p" and "b" sounds or hissing "s" and "z" sounds—by placing the microphone so the narrator does not speak directly into it. Instead, have the narrator talk slightly to the side of or

even at a right angle to the microphone.
- Improve these troublesome speech sounds by muffling high frequencies a bit with a windscreen.
- To determine exactly where to place the microphone, use the ultimate evaluators, your ears.
- Monitor a trial recording with a good pair of headphones, positioning and repositioning the microphone while you listen to the narrator.
- Whether or not you monitor with headphones, record a few minutes of the narration. Listen to it critically, and then make any necessary changes.
- If no room in your house seems ideal, improvise with all sorts of sound-deadening materials. The

This microphone stand sits on a table and allows the microphone to be positioned at the desired angle.

Improvise a floor stand by taping a mike to a lightstand or a tripod.

room may not look beautiful, but it will be effective.

- Tape blankets to the walls or drape them over chairs opposite the narrator. Even a few heavy coats or sweaters can do the job adequately.
- Staple empty, paper egg cartons to a large board to make an efficient, portable acoustic wall.

Eliminating Unwanted Noises. While you listen to the narrator's voice, listen for ordinary house sounds that our ears disregard but the microphone does not. The squeaking chair, the chatter in the next room, and the clock ticking are sounds we ignore, but they are recorded. Eliminate these noises from your "recording studio" if possible. Turn off the air conditioner, unplug the clock, and make sure your cat can't enter the room. Fluorescent lights may also be a problem: they can introduce a hum or static into the recording that is otherwise inaudible.

There are other undetectable—until they're on tape—sources of noise. Sometimes noise comes from an electrical plug; turning it around in the socket may be all you need to do. Noise may also come from the refrigerator or other equipment that has periodic power surges; plug the recording equipment into a different line. Make sure that the microphone line does not run parallel to a nearby power cable from the tape recorder. But if they must be near

each other, arrange them so they run perpendicular to each other. This is also true of patch cords, which should run at right angles to the power cable. In fact, all of these precautions against undetectable sounds apply to rerecording as well as recording setups.

Another source of unwanted sound comes from the projector. It's best to record the narration without showing the slides. Your script provides the timing cues, and you can edit the tape afterward if it isn't exact. If you find it necessary to project the slides while doing the narration, make sure the microphone doesn't pick up the projector's clunking noises. The farther the projector is from the microphone, the better. Place the projector on sound-absorbing padding, and put some sound-absorbing material between the microphone and the projector—soft items, such as a blanket, a quilt, or that clever egg-carton acoustical wall. You can construct a housing for the projector out of acoustical tile, but be sure the projector has sufficient ventilation.

Paper noise from the script itself is also a potential troublemaker. The slightest shake sounds like the crackle of a fire. The solution is simple. Type the narration onto heavyweight paper. Slip each page into a plastic page protector or staple the sheets to cardboard or blotting paper. The pages should be numbered, of course, but not encumbered with paper clips or sta-

ples. It also helps if you bend up a corner of each sheet so the narrator can change the pages easily.

The narrator, without knowing it, is often a source of noise. Pencil tapping, fidgeting with jewelry, and beard scratching make almost imperceptible sounds that are amplified when recorded. Become aware of noises the narrator makes and suggest that he or she do whatever is necessary to maintain quiet.

The worst offender is the person who touches the microphone, mike stand, or cord during the recording session. Did you ever hear what that sounds like? It's thunderous on the sound track even though you can't hear it in the room. Try it: you'll see why this is the most serious noise problem.

With thought, you can eliminate all but airplane noise. I know at least one person who records sound tracks well after midnight when the planes don't circle overhead and the rest of the household contributes only distant snores.

Improving Narrative Technique. Generally, the quality of a person's voice is better when he stands rather than sits. But most people feel more comfortable if they can sit while narrating. Sitting or standing, the narrator should be erect, not slouched. If seated, he should have a chair that's firm and straight and sit toward its edge with both feet touching the floor.

The narrator can hold the script

In the shot on the left, the narrator is doing everything wrong: not talking into the mike, touching the mike, wearing clunky jewelry, and not standing correctly for the best voice quality. In the center shot, the improvements made promise a good-quality recording. In the shot on the right, the narrator is speaking at a 90° angle to the mike to eliminate the hiss of "s" and "z" sounds.

at an angle, making sure the script doesn't come between his mouth and the microphone. A supporting rack makes this more convenient and lessens the chance of paper noise. You can use a book rack, a music stand, a typewriting easel, or a pile of books to hold the script slanted at about a 45° angle.

Make sure the speaker directs his voice toward the microphone, not the script or the table. Also, make certain he doesn't lower his head as he approaches the bottom of the page or turn his head from side to side. Even slight changes in head position can cause noticeable differences in the volume of the recorded voice.

Make a trial recording and listen to it critically. Does it sound casual and friendly? It helps if the narrator pretends to be telling the story to a friend. The narrator can also smile and make gestures. Even though these physical movements won't be seen, they will help make the narrator's voice sound natural.

Directing the Nonprofessional Narrator. If you coach someone who has consented to narrate for you, strive for a conversational tone. Ultimately, you want the audience to feel that the narrator is talking *to* them, not *at* them.

Explain the concept of the show to the narrator, tell him what words and phrases to emphasize, and show him the slides. Give him the script so he can practice; he gets the original, but you keep a copy. Let him make suggestions and changes. Although he may be good, he may be unable to master the pronunciation of certain words. Be flexible: let your narrator change words if necessary.

In trying to coax a good performance out of a nonprofessional, you'll find that tact is most important. After the first run-through, praise some aspect of his work before you make any suggestions—even if he did a less than adequate job. Then make a couple of positive suggestions, such as, "We

have lots of time in the sequence, so I think you could slow down a bit," not, "You read too fast." After the next run-through, comment on how well he got the idea and how good the narration is starting to sound.

"Swallowing" the final words of a sentence so they are almost inaudible, taking an audible breath before speaking, or using a monotonous pattern of inflection are some of the most common problems in reading aloud. If you listen for them, you may be able to help your narrator change his speaking pattern. (If you do the narrating, listen to your voice critically on the tape recorder.)

When the time comes for the actual recording, electronics can help. Some novice narrators benefit from recording in sections: recording the narration for one sequence, stopping to rehearse the next section, and then recording that one. This lets you provide a little extra handholding.

Putting It on Tape. Mike placement, rehearsals, and all the other preliminaries are the hard part; after that, you only have to make a few adjustments of the tape recorder controls. As when rerecording music, use a tape speed of 7 1/2 ips and put the recorder on "manual" volume control. Record for a minute or so to make sure the volume level is just below the red danger area. You can now start recording the narration.

Let's assume you are the director/recorder and another person is the narrator. Follow along with your script, making marginal notes when the narrator flubs, there is accidental paper noise, or some other mishap occurs. If you are aware of a problem, you can record the section a second time. Mark your script to indicate a rerecorded passage. If the fourth recording is the good one, note this so that later you will be able to edit quickly.

If you decide to do all the re-

takes at the end, it's very important for the narrator to maintain the same position in relation to the microphone. Even a slight tilt of the head can make the recordings sound different.

You have two more things to do before you break for a cup of coffee. Play back the tape to be sure it really does sound good. Many problems that go unnoticed during the recording session can be heard on playback and corrected. After the narration is finished, with the recording levels unchanged, keep very still, and record three or four minutes of silence. Not absolute silence—room tone. Every environment sounds a little different, even though it seems completely silent. As you'll see a little later, you'll need this room tone when you edit the tape.

Recording Music
Finding the best place to put the microphone while recording live music is done by trial and error. Each musical instrument requires a special location for the mike, and the acoustics of the room need a little more reverberation—to be more "live"—than those of a room for voice recording. For example, when recording a guitarist, place the microphone in front of and above the player. You may pick up noises from the fingering, but these are characteristic of the instrument; they'll be less pronounced if you move the microphone back a bit. Similarly, for woodwinds, placing the microphone somewhat in front of and above the musician should also prove satisfactory. For an upright piano, lift the lid and try the microphone somewhere on a line diagonally across from the pianist's right shoulder. (If you will be doing a great deal of music recording, consult *The Use of Microphones* by Alec Nisbett (Focal Press, 1974). This book has many helpful and specific instructions on microphone placement and room acoustics.

Recording Sound Effects

Recording actual sounds seems the logical way to capture most common, everyday noises. A door slamming, a telephone ringing, and a faucet dripping are easily recorded with a microphone placed near the source. When recording outdoors, put a foam rubber

A directional mike made by cutting the bottom out of a styrofoam cup and taping it around an ordinary mike.

windscreen or a wool sock over the mike to reduce wind noise. For distant sounds, you may need a highly directional microphone, such as a shotgun. You can improvise by cutting the bottom out of a paper cup and taping it around the microphone.

Frequently, it's not practical or possible to record the actual sound. You don't want to smash up your car to record the sound of a car crash. And how are you going to record the sound of crunching, dry leaves during the summer? Furthermore, live recordings often do not produce the effect you think you are capturing. One reason is that the ear is selective but a microphone is not. If you are listening to the surf, for example,

you will be aware only of the sound of the surf and will tune out everything else. A microphone, on the other hand, will also pick up the sound of an airplane taking off, highway traffic zipping by, a dog barking, people laughing, and other irrelevant sounds.

Another reason recordings sometimes fail is that actual sounds are not what we expect them to be. Not all sounds need to be technically accurate. An effect that is closer to what you imagine may be more convincing than one that is real.

You'll discover that crumpling a ball of cellophane in your hands simulates the sound of fire. By blowing through a straw into a pan of water, you can imitate the

CREATING YOUR OWN SOUND EFFECTS

Automobile brakes: Slide the top edge of a drinking glass against a pane of window glass.

Automobile tires: Push erasers against a pane of window glass.

Automobile tires screeching: Scrape a screwdriver across a piece of metal.

Babbling brook: Blow water through a straw.

Body falling into water: Drop a block of wood into a tub of water.

Body falling to ground: Drop a melon from the top of a ladder onto concrete, or drop your elbows and then your forearms onto a table.

Broken glass: Drop several small, thin metal plates.

Crash: Fill a wooden box with broken glass and lightweight pieces of metal and nail on the cover. Turn the box upside down to make a crashing sound.

Creaking floor: Twist an old, dry desk drawer.

Elevator: Record a vacuum cleaner or sewing machine in use.

Elevator door: Construct a plank of wood about 2 1/2 feet long,

with a metal plate at one end and several nails at the other. Roll a roller skate along the plank, and let the skate hit the metal plate for the sound of the elevator closing; let it hit the nails for the sound of it opening.

Fire: Crumple a sheet of cellophane close to the microphone.

Fist fight: Slap yourself lightly close to the microphone.

Footsteps: Fill a shallow cardboard box with a layer of gravel. With your hands inside a pair of shoes, "walk" the shoes over the gravel.

Footsteps in dead leaves: Stir cornflakes at the top of the cereal box, or stir potato chips in a bowl.

Footsteps in snow: Fill two small cloth bags with cornstarch and knead them with your hands.

Gunshot: Hit a large corrugated box with a curtain rod, or hit a table with the handle of a hammer.

Hail: Drop rice onto glass, wood, or metal.

Heavy machinery: Record the noise a dishwasher or washing machine makes while in use, and

play the tape back at half-speed.

Horses' hooves: Hold rubber plungers by their handles and hit them against each other in the appropriate rhythm. Otherwise, use two halves of a coconut shell.

Rain: Pour birdseed in a continuous stream over an inflated paper bag. Pour salt through a paper tube, with the microphone close to the opening.

Ray gun: Rattle a tambourine. Record it at one speed and play it back at double the speed.

Telephone voice: Talk into a plastic cup, or have someone call from an actual telephone and record his or her voice.

Thunder: Rattle a thin sheet of metal.

Water: Record water running from a tap. Different microphone distances and volume levels will give different effects.

Waves: Sweep two wire brushes over a metal surface in opposite directions.

Wind: Pull a piece of silk over several wooden boards, 6 to 12 inches wide.

sound of a babbling brook. The most unusual device I have ever seen is a diagram of a rain machine, which I found in an old textbook on radio broadcasting. Here's how it works. First, birdseed is poured into a large funnel. When the seeds come out the spout, they hit a ping pong ball, which scatters them. Some of the birdseed then bounces off an inflated paper bag and falls into a wastepaper basket filled with crumpled paper!

Sometimes you may want completely unreal, mysterious sounds. You can, for example, create electronic effects by putting rubber erasers between the strings of a piano, and then plucking the strings or rubbing them with your fingers. You can produce "electronic" sounds other ways, too. For example, you can record at one speed and play the tape back at half or double speed. Try a toy music box. Drip water into a large, empty

Birdseed

Wastebasket

A variety of the rain machine. (Reprinted from Handbook of Broadcasting *by Abbott and Rider, 1941. Used with the permission of McGraw-Hill Book Company.)*

tub, and record it at a loud level. You can also slide your fingers up and down the strings of a guitar or record tiny wind chimes or several types of wind instruments played out of tune. Try playing back two effects at different speeds simultaneously. If you can play your tapes backward, you can create really weird electronic effects. To play a tape backward, record it on a stereo or quarter-track recorder, turn it over without rewinding it, and play it back on a half-track, monaural machine. If you experiment by manipulating your tapes, you can create some unusual and fantastic effects.

You can also manipulate commercially recorded sound effects to achieve exactly what you want. Consider wind. You can buy recordings of a slight breeze, a blizzard, wind and rain, and moderate wind. But what if you want an eerie, whistling wind? Create it by recording a moderate wind sound at a normal volume level. Then play it back at half speed, varying the volume level. You'll end up with the "woo" sound of a spooky, cold winter wind gusting. You can alter the sound of the surf in a similar manner.

Theater and radio sound technicians are adapt at devising artificial means to produce all kinds of sound effects. You, too, may want to consult books on radio and play production, which often describe how such sounds are made.

Editing and Splicing

If you edit your tapes, you can eliminate portions and rearrange sections by cutting and splicing the recording tape. Being able to edit your tapes gives you marvelous freedom and creative control.

Determining the Cutting Point. First, determine where you want to cut the tape. It helps if you made the recording at 7 1/2 ips. This gives you much more area in which to cut than if you recorded at 3 3/4 ips. When you try to make precise cuts, you will appreciate

this leeway. Your first experience in editing tape will be splicing large sections of speech or music, but as your confidence builds and your sense of adventure increases, you will find yourself cutting out musical phrases, single words, or even single sounds.

You must be able to control your tape recorder—to move the tape very slowly by hand in order to stop and mark it exactly. Removing the protective head-assembly shield allows you to see and have access to the recording heads. You need to be able to free the tape from between the capstan and pinch roller in order to move it slowly back and forth across the playback head. Your owner's manual may provide you with more specific information.

Of course, when the tape moves slowly, the sound becomes lower in pitch, and the words and music sound quite unusual. You must practice listening, but you will soon learn to identify the sounds you want. With your hands, move the tape backward as well as forward; this frequently helps with sounds that are difficult to identify. Turning up the volume or using headphones while you work also helps.

Because you hear the sounds as they pass over the recorder's playback head, you must know where that is. Your recorder has two or three heads, and the playback head is on the right as you look at the front of the recorder. The center of the head has a tiny gap that does the actual work. Your job is to mark the tape at the point where the desired sound passes in front of this gap. But putting pressure on the tape in order to mark it can damage that very delicate head. It's better to put a reference point on the tape recorder, about 1 inch to the right of the gap.

Put a similar reference mark on your splicing block, at exactly the same distance, to the right of the grooves where you will cut the tape. When editing, stop the tape

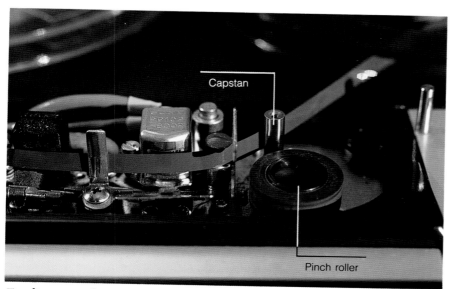

To edit tape easily, you must be able to move it freely backward and forward with your fingers. To do so, thread the tape so it does not travel between the capstan and pinch roller.

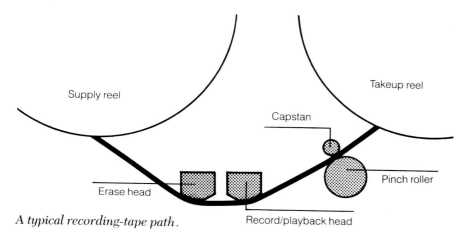

A typical recording-tape path.

when you hear the sound you want to cut. Mark the tape opposite the reference line. Put the tape in the editing block, aligning the mark on the tape with the reference mark on the splicing block. Then, you will be able to make the cut exactly where you want it.

For marking the tape, you can use a yellow china-marker pencil or a felt pen that writes on acetate. Be sure to mark only on the base side of the tape (the side away from the recording head).

Splicing. There are all-in-one splicing units available that hold and cut the tape. These do not let you do as clean a job as an editing block, such as one made by Editall, and a single-edge razor blade that has been demagnetized. These can produce a join that is undetectable and easy to do.

Let's get started. With clean hands and a clean work surface—that means no coffee cups or cookie crumbs around—lay the two pieces of tape, base side up, on the editing block. On most tapes, this will be the shiny side, although some low-noise tapes are shiny on the oxide side and dull on the backing side. Check the tape-box label or look at the tape on the reel. When wound, the base side is outermost.

EDITING MUSIC

- When cutting into the middle of a piece of music, do so where there is a natural pause; otherwise, fade into a sustained chord or cross-fade it with another piece of music.
- When ending a piece of music, retain a bit of the dying out of the last note.
- When shortening a section by eliminating part of a strong, rhythmic passage, preserve the basic beat. In complex rhythmic passages, you can make the cut almost anywhere.

- When joining two pieces of music, either the same or different selections, use one of these techniques:
A. Select an incoming piece that has a strong beginning: a heavy chord, percussion beat, or musical effect, such as a trill or drum roll.
B. Begin at the start of a well-defined musical phrase.
C. Cut the outgoing piece at the end of a phrase. This is not always necessary, especially if the cut is on a strong beat.

D. Be sure the accent (beat) of the incoming piece sounds natural. The slower the rhythm of the outgoing piece, the less careful you have to be. If there is a sharp change in character between the two pieces, don't be concerned.
E. Go from soft to loud, non-rhythmic to rhythmic, slow tempo to fast—never the opposite.
F. Do not leave a pause between pieces, especially if the incoming piece has a strong beat.

To splice two pieces of tape, place them, with a slight overlap at the diagonal cutting slot, in the groove of the editing block. If using reference marks, line up the mark on the tape with the mark on the splicing block, as shown here.

Next, pull the point of the razor blade toward you, cutting both pieces of tape at once.

Flick off the loose piece of tape with a fingernail, and nudge the tapes together if they slip apart.

Join the tapes with about one inch of audio splicing tape, smoothing it with a fingernail.

Once you push the tape into the groove of the editing block, it will be held firmly. The block has a 45°-angle cut to guide the razor blade. Overlap the incoming and outgoing pieces of tape over this guide. With the point of the razor blade, cut the tapes at the same time, carefully pulling the blade toward you. Flick off the loose piece of tape with a fingernail.

The two pieces of tape are butted. If they slip apart, nudge them back together. Join them with splicing tape made specifically for recording tape; it holds securely and does not ooze adhesive. You can buy it in rolls or in precut tabs. Cut off about 1 inch of splicing tape. Push it down with your finger, parallel to the edges of the recording tape and over the join, and smooth it with your fingernail. Hold one end of the recording tape in each hand and snap it out of the editing block. There. It's a very fast procedure.

During the process, be sure you don't cut into the middle of the sound. To avoid this, cut ahead of the sound. At 7 1/2 ips, 1 inch of tape takes about 1/8 second. If you left too much time, go back and trim the tape a little at a time. If you cut off too much, you actually can splice the bits of tape back together—if you saved the ends of your tape. Until you're finished with the editing, do not throw any ends away.

Editing Narration. Assemble the good narration takes consecutively on a new reel. Remove the bad ones. If you didn't do so when recording, space the sections according to the timing notes on your script. You may want to use a stopwatch or a clock with a second hand. If you find places where the narrator didn't pause long enough, insert blank pieces of tape. Not blank actually—these would be conspicuous silences, quite different from the rest of the tape. What you need is a bit of room tone, recorded earlier. Splice it in, and the

recording will sound natural. When you finish, listen as you project the slides to make sure the pictures and the narration really work together. Make final adjustments by lengthening the time between passages, stretching it out with room tone. You can also speed up the delivery by cutting out bits of sound between sentences or words. But be sure to preserve the speaker's natural rhythm. If you abbreviate the pauses too much, it will be obvious that you made a cut.

As you become expert, you will learn many tricks to do when editing words and sounds. But I'll let you discover them. Take a look at *Tape Editing*, a helpful book by Joel Tall (Editall Corp., 1978).

Editing Music. Editing music is a little harder than editing voice. Some music doesn't combine well with other music. But this type of editing is a great experience that makes you feel as of you are a composer.

Music is made of phrases: short, thematic progressions of notes separated by slight or definite pauses. These pauses usually make logical cutting points. If you listen closely, you hear that the final note of a phrase does not end abruptly but fades. Don't cut off all of this sound; if you do, the effect sounds unnatural.

Shortening Music. Some compositions start with a very definite introductory passage, which you may want to eliminate. To find a new beginning that sounds natural, choose a place that has a natural pause ahead of it, and cut within this pause.

At the end of a composition, you usually find a concluding passage known as a coda. It may be just a few notes or it may last for several minutes. Because it would seem out of place anywhere but at the very end of your show, the coda should end as the show does, giving a sense of conclusion.

Most likely the music you re-

corded is a little too long, or a little too short. If it is too long, you can cut out some parts, and the altered composition can sound as good as the original. Also, you may hear sections that repeat an entire earlier passage. If you locate the beginning and end of the section, you can remove it. Many times, the easiest way to shorten music is to take a chunk out of the beginning, so the piece ends when the slide show ends. You can also take parts out of the middle of the music to shorten it or to omit a section that doesn't fit with the visuals.

I urge you to save all strands of tape you cut out; you may find them useful. And, because you can't see what it is, label each piece on the base side, indicating which is the head—the beginning—of the sound.

Production music—copyright-free music that is composed and recorded specifically for use in audiovisual productions and is designed to be edited—has introductions and endings that are desirable, but not dominating. To shorten such a piece, leave the introduction and ending intact, and remove tape from the middle of the piece.

Lengthening Music. Being able to edit the tape also gives you the ability to lengthen it. If your show is 10 minutes long and the music is 9 1/2 minutes long, you don't have a problem—as long as you have additional music on hand. When you record the music, do it twice. Then you can take a portion of one recording and insert it into the other one. Just make sure it doesn't sound too repetitious. A little practice and careful listening can help you determine what works.

Uniting Different Music. You can make a more interesting sound track, though, if you splice together different musical compositions rather than extend the same one. This lets you tailor your sound track to the different parts of the slide show, providing differ-

ent emotional effects and tempos. You have to be aware of the tonality, loudness, and rhythm of the different pieces of music. For instance, you can cut from a quiet piece to a louder one without much trouble. A shift from a slow passage to a faster one also works well. Music that has an obvious rhythmic pattern should be cut to preserve the rhythmic beat.

Other suggestions for joining different types of music can be found in the section on editing music, but no matter how many rules and suggestions you're aware of, the best guide to editing is this: if it *sounds* right, it *is* right.

Editing Sound Effects. There are fewer technicalities to be concerned with when editing sound effects. One special problem, though, is extending the length of a sound. Of course, you can record and splice together 5, 10, or endless lengths of tape. There's another method, called looping, in which you join the head and tail of the tape. This lets you prolong a continuous effect, such as a rainstorm or city traffic noise, for as long as you wish. But you must guard against a conspicuous sound

emerging out of a nondescript background—a bird chirping, a horn blowing. When the tape goes around in the loop, the bird chirps and the horn blows at unnaturally regular intervals. Cut the effect to eliminate the extraneous sound.

You should also listen for a sound that has a regular, rhythmic beat, which can be either a background or the principal sound. It can be, for example, the beat of a heart or the ticking of a clock. Make sure the interval at the join corresponds to the intervals in the rest of the tape. This is a little trickier to do and will probably take more than one cut-and-join operation to get it right. The last step: play the looped sound back and rerecord it onto the final sound track.

Composite Sound Track
Narration provides the information for, music sets the mood of, and sound effects add realism to your presentation. You can use just one of the elements, but a combination of two or three makes a more effective sound track. Take advantage of the fact that strategically placed music or sound effects can add emphasis.

To make a loop, begin by taking about 2½ feet of tape. Join the head and the tail in an endless loop, and thread the loop through the tape recorder. This will prolong a sound effect indefinitely.

Assembly Method. It's good to have music at both the opening and closing of the show, and if there are significant pauses in the narration, you may want to use music at those points. Otherwise, you may want to set the scene with sound effects. But you don't have to fill every instant with sound. A distinct period of silence is pleasing. If the silence comes at breaks in the narration, make sure it isn't complete silence; use a length of room tone for these pauses.

From your script, devise a cue sheet with the exact timing of each piece of sound. Follow the sheet and, using a stopwatch, splice together the various lengths of tape. Begin this master reel with a 2-foot length of leader, which is a piece of unrecorded tape.

To make sure each section lasts the correct length of time, rewind the tape to a point a few seconds before the start of the section you want to time. This gives the tape recorder the chance to come up to speed before you time the edited portion. When you are finished with the entire sound track, play it back along with the slides, make notes to yourself, and refine the timings if necessary.

Mixed Track Method. The ultimate way of putting together a sound track gives you the flexibility of superimposing and fading one sound over another. When you do this, you can, for example, establish the music, fade it down underneath the narration, and then fade up again during a pause. You can also create an atmosphere with a sound effect, and after establishing it in the audience's minds, you can fade it down, so it will be in the background. The effect of music behind a voice is quite pleasing, and music combined with sound effects can be dynamic.

When combining two pieces of music, you should join them directly, at the same loudness level. But if your cutting points do not meet the criteria for good music editing, you can disguise the error by fading down the volume of the ending piece of music and simultaneously fading up the volume of the new music. In musical terms, this cross-fading is termed as a *segue*. If possible, hide this under the narration.

When using several sounds at the same time, try to let only one dominate. Any narration, for example, must be dominant, and music and sound effects should be subordinate, low in volume, simple in orchestration—if not fairly monotonous, so they don't attract attention. Don't let the music drop so low in volume, however, that the audience strains to hear it. This can be annoying. You can add interest and make the narration command attention if you leave pauses between segments of narration, during which you fade up the music or effect, and then fade it back down. This takes planning or reediting the voice to create pauses at least five seconds long, in which you can establish the music or effects.

A radical change in the character of the music or a sharp accent of music or sound effects is a potent way to add emphasis. Strategically placed, either can highlight a visual or punctuate a point. Another effective use of a fade is to fade music down as a sound effect enters. Do this only if the sound effect lasts for a period of time. Finally, don't think you have to use music continuously through the entire show. If the narration makes its point clearly and deliberately, you may well want to fade out the music completely.

When they are the only sounds on the track, it is strange to hear occasional, isolated sound effects. They, too, should emerge from background noises. For example, the sound of traffic can be a background for a horn, or office chatter can surround the clatter of typewriter keys. Effects can also be placed against background music. In this case, let the effect occur in a breathing space between musical phrases, over a held chord, or pre-

ASSEMBLING A COMPOSITE SOUND TRACK

- Music, especially musical punches and changes, should enter at key points in the visuals or at pauses in the narration.
- Start and end the music with cuts, not fading it in and out.
- Music does not have to be continuous throughout. If the narration clearly and deliberately says what it has to say, leave the background silent.
- Short periods of silence are effective—you don't need a wall-to-wall carpet of sound.
- Space the narration to create pauses of several seconds to fade up music or effects.
- Only one element—music, voice, or effects—should dominate at any time. Whenever there is narration, it must be dominant.

- No two elements of the sound track should start simultaneously. Stagger them by 1/4 or 1/2 second, always letting the music lead the narration.
- Choose music that complements the sound effects, not duplicates them.
- Disguise problems in editing music by cross-fading the outgoing and incoming pieces and/or hiding them under narration or sound effects.
- One long piece of music used throughout a show of more than four minutes is boring. Edit together sections of several compositions.
- Too many choppy changes are unpleasant. Each piece must be long enough to establish itself—at least 30 or 60 seconds.

ceding or following a sharp musical sound. Some music is written to deliberately mimic the character of a realistic sound. If you use this type, it is unwise to add a sound effect. Choose music that complements the sound effect, not duplicates it.

Creating a Mixed Sound Track. Having two sounds occur simultaneously on recording tape requires somewhat more sophisticated editing techniques and editing equipment. But the flexibility it gives you in controlling the relationship of one element to another makes it satisfying and worthwhile. Your approach will depend on what equipment you have or can borrow to do the project.

With three tape recorders and a mixer, you can do a professional-sounding mixing job. Yes, three recorders—or even more. One recorder feeds the music into the mixer, another feeds the narration, and the third receives the mixed track from the output of the mixer. A mixer is a clever little machine that you plug all the tape recorders into. It combines the sounds onto the recorder connected to its output and lets you have complete control over the relative volume levels. Let's begin.

1. Find out the impedance of your tape recorders' outputs and auxiliary input, and be sure the impedances of the recorders and mixer match. Some mixers are variable and can be set to correspond to the equipment.
2. Get connecting patch cords with the appropriate plugs.
3. Check that the music and narration are on separate reels of tape, that each reel is edited and timed, and that each has several feet of leader.
4. Prepare a cue sheet that indicates when the music fades in and out during the mix. One type of cue sheet can be seen on the right. The left column has the footage-counter numbers, reel A is the narration track, and reel B is music and effects (frequently termed

M&E). The inverted V-shaped marks mean the music will be faded in and the V-shaped marks mean it will be faded out. (Some people simply write "fade.")
5. Indicate when the sound will be faded all the way out and when it will be faded to a lower, predetermined volume level.
6. Write down what the sound effect is. A straight line means the sound will be started or ended at a normal volume level, without fading. (I've often used a horizontal chart on which I wrote the opening words of each segment of narration, made three dots, and wrote the closing words. Opposite this, I put the corresponding footage-counter numbers.)
7. Next, with a bit of tape, label the recorders A, B, and C, as well as the corresponding reels of tape—to prevent putting tape on the wrong recorder. If you do, you discover that footage counters vary from machine to machine, and that recorders don't run at precisely the same speed. (In normal record/playback situations, this is no problem, but it is critical in precise sound mixing.)
8. Let the footage-counter numbers for your cue sheet correspond to the numbers on recorder A, the narration.
9. Put the narration tape on recorder A.
10. Then line up the juncture of the leader and the tape at the playback head and set the counter to "000."
11. Now play the narration, noting the numbers where you want music to fade in and out.
12. *Do not* rewind the tape to check the numbers if you're not sure of certain spots. Do this later. When the recorder rewinds, the footage numbers may not correspond to the same spot on the tape as they did before. They won't be off much, but the cumulative differences can throw off the entire mix.
13. After you have listened to the complete tape and made notations

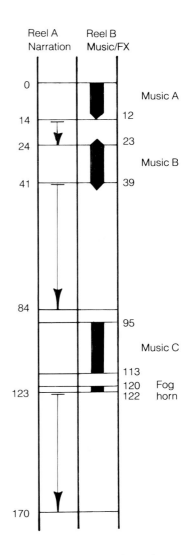

A sound cue sheet shows where the sound occurs on the narration, and if the music starts or stops at a normal volume level, or fades in and out.

A SIMPLE CUE SHEET	
CUT IN MUSIC; FADE OUT	0–12
The day . . . so much easier	14–24
FADE IN MUSIC; FADE OUT	23–39
On her boat . . . gathered around	41–84
CUT IN MUSIC; CUT OUT	95–113
FOG HORN	120–122
Vote of confidence . . . the impossible	123–170

on the cue sheet, rewind the tape and check it again.

14. Return to your cue sheet and mark where you want the music to fade. If the narration starts at "015," start fading the music out at "014." The time interval differs for the numbers at the beginning and the end of the reel because most tape recorder counters are based on the number of revolutions made by the tape reel and not the length of tape. Take this into consideration.

15. When you've noted all your cues, adjust the volume level of the mixer for each recorder; mark the settings on the cue sheet.

16. Make a few minutes of test recording to decide how much to fade down the music. Test by starting all three recorders, A and B set for playback and C for recording.

17. When you get to a segment with speech, fade down the music 1, 1 1/2, 2, and 2 1/2 units.

18. Listen to the newly recorded tape and decide which test level is most satisfactory.

19. Next, at the appropriate places on your cue sheet, write the levels you wish to fade down to.

20. Rewind the tapes, and you're now ready to begin the actual mix.

21. One at a time, start the playback recorders.

22. When the end of the leader reaches the playback head, stop the recorder with the pause control and set the counter on recorder A to "000."

23. When all three machines are in the proper recording or playback mode and the volume levels are set, sit where you can read the cue sheet and manipulate the volume control.

24. Start the recording machine at the beginning of the leader.

25. At the instant the end of the leader crosses the recording head, release the pause controls on recorders A and B.

26. Keeping one hand on the volume control for recorder B, carefully follow the cue sheet and watch the counter numbers on recorder A. Smoothly lower and raise the volume to the desired levels at the appropriate times for the entire length of the track. You're done.

27. Rewind the mixed track and listen to it critically. If it doesn't meet your expectations, make notations on your cue sheet and try again.

If you have a stereo tape recorder that allows you to record monophonically on each channel, you can do your mix with less equipment. You need the stereo recorder to record on, another tape recorder to play back from, but no mixer. Compile a cue sheet as before. Record the narration onto one channel of the tape; rewind it. Then transfer the music to the other channel, fading it down and up as indicated on the sheet. If you wish, you can combine the output of both stereo channels onto a new tape.

It's sometimes possible to combine your sound tracks directly onto a monaural tape recorder without a mixer. The sound may not be excellent, but the technique is worth experimenting with. Attach a "Y" connector to the recorder's input jack, and feed the output of the other two recorders into it.

The most versatile units are multitrack recorders. One piece of equipment can take the place of three stereo recorders and a mixer for less than $500. These, such as the Fostex X-15 Multitracker or the Tascam Porta One, are cassette recorders with four stereo tracks and internal mixing. You can record music on one track, narration on another, and then combine them onto another track—all on the same machine.

Creating a mixed sound track takes concentration, but it can be rewarding. To explore the nuances of sound editing, read the booklet *The Soundtrack in Nontheatrical Motion Pictures* by Frank Lewin (Society of Motion Picture and Television Engineers, 1959). Most of what he says is as applicable to slide-show sound tracks as to film tracks.

7

Putting It All Together

Pictures taken, slides in order, narration recorded—these are the major parts of putting together a slide show. But you'll also want to make plans for the actual presentation. The "big moment" requires some preparation and knowledge of projection equipment to ensure that it comes off smoothly.

More and more equipment seems necessary for every aspect of photography. Slide shows, of course, call for a projector, something to project them on, and, perhaps, a tape recorder, loudspeakers, and a few accessories. The information here will help you plan your purchases wisely, prevent problems, and remedy them when they do crop up.

When you give your slide show at home, you have the advantage of knowing the room and being able to set it up well ahead of time. But if you take the slides to another location, you should get there early so you can set up,

check everything, and relax. Use the checklist on page 92 to ensure a flawless presentation.

The Room

Some rooms are better than others for a slide show, but most of us have little choice. We're limited to the rooms in our homes or the meeting room in which we'll make the presentation. The room itself dictates the kind of screen and the seating arrangement to use.

The main requirement of a screening room is that it be dark. When you show your slides at night, this isn't much of a problem. But always close your drapes or pull down the window shades. Although it may be nighttime, street lights and passing cars—even a bright moon—can throw light and shadows onto the screen. Any such light can lower the contrast of the image and make details disappear. To completely cover ordinary windows, you can drape

lengths of fabric or prop up large pieces of cardboard. If you will use one room repeatedly, consider buying blackout shades or lining draperies with blackout material.

Choosing a Screen

A wall painted matte white makes a satisfactory screen—if it's clean, if it hasn't yellowed, and if it has no protruding nails or seams. This is an inexpensive way to get started, and it's easier than carrying a screen to a friend's house. You can also use a large sheet of white cardboard, or you can paint a lightweight board with flat white (not off-white) paint. Another economical substitute for a real screen is a white bedsheet. But it only works well if you hang it so it doesn't wrinkle. Even a small bulge as it drapes over a mantle or window curtain can cause image distortion. But with lots of tape, tacks, and care, it can serve in an emergency.

SLIDE-PRESENTATION CHECKLIST

Ahead of time, be sure:
- You have labeled each slide tray and the accompanying audio-tape with the name of the show. Store them together, with the script, in a labeled box.
- All the slides are numbered.
- The slides are clean and inserted correctly.
- There is an opaque slide after the last slide, if your projector does not have a dark-screen shutter latch.
- The slide-lock ring is secure on the tray.

- To take the slide tray with you in your carry-on luggage if you are flying.
- The room has electrical outlets in convenient places that are live when you turn off the room lights. Bring extension cords and three-prong adapters, if needed.
- There are sufficient chairs, placed properly for good viewing; stands for the projector and recorder; a screen of proper size and type; a way to darken the room; a properly placed loud-

speaker; and a small reading lamp, if necessary.
- You and the projectionist have copies of the script, marked to indicate slide changes, and that the script has all revisions marked on it.
- You have a list of slides and their tray positions if you anticipate a question-and-answer period.
- You know where the light switches are and have appointed someone to take care of the lights before and after the show.

SETTING UP

Before the show, be sure to:
- Set up the projector, making sure people cannot trip over the cord. Tie the cord around the leg of the projector stand so the projector won't fall if someone does trip on it. In a small room, if the cord is in the line of traffic, coil it under the projector stand until everyone is seated. In a large room, plug in the cord, but protect it by covering it

with 2-inch-wide duct tape or carpet tape.
- Adjust the image size and focus the projector. If you have both horizontal and vertical slides, be sure both types will fit onto the screen area.
- Verify that the speed selector is set correctly on a reel-to-reel tape recorder.
- Set the volume and tone controls of the recorder.

- Know how to turn on the microphone and work any controls from the podium.
- Rehearse the show to see that all the equipment is in working order and that you have not forgotten anything.
- Reposition the slide tray so that the first slide is in place and is ready to be shown.
- Rewind the audiotape so it is at the beginning of the show.

SCREEN SELECTION CHART

SCREEN CHARACTERISTICS	Matte	Beaded	Metallic lenticular	Nonmetallic lenticular	High-gain aluminum
Best viewing area	Unlimited	25°	35°	45°	30°
Room illumination	Quite dark	Completely dark	Somewhat dark	Partially dark	Only slightly dark
Brilliance in main viewing area (compared to matte screen)	—	Up to 4 times	2 to 4 times	2 times	12 times
Can be wall or ceiling hung	Yes	Yes	With added tension	With added tension	On rigid support
Can be rolled for storage	Yes	Yes	Yes	Yes	No

A screen is a good investment because it enhances the images. The wrong way to pick out a screen is to buy it because of its low price; it may not be the best one for the room where you'll be showing your slides. You have a few choices to make.

This is the right way. First, you should think about the several types of screens; each has different characteristics, but their prices are not substantially different. If you are buying a screen for a particular room, choose the one most appropriate for it. You also need to consider the size and shape of the room, the angle at which the audience will see the screen, and the amount of stray light creeping into the room. If you already have a screen, it will determine how far to the side of it the audience can sit and how much effort you must expend to block out light.

There are four major types of screen surfaces, and most screens reflect nearly all of the light the projector throws onto them. From that, it would seem that any screen will do. But the various screen surfaces distribute the light differently. One type reflects the light within a narrow cone; another spreads it over a wide angle. Because there is a finite amount of light, the wider the angle over which the light is spread, the dimmer the image is. You will want to have the brightest possible image, but you may have to sacrifice brightness if the room is wide and some viewers must sit to the side.

Another factor is that screens reflect stray light equally as well as they do light from the projector. Sunlight coming through drapes or light flashing across the screen as someone opens the kitchen door washes out the image. But stray light may or may not be a problem. Some screen surfaces reflect this light directly back into the viewing area, while others successfully deflect significant amounts of stray light away from the audience.

Matte Screens. A matte screen produces the least bright picture of all, but the brightness is the same for all viewers; the image can be seen equally well by a person off to the side as by a person in the middle of the room. This makes it the best screen to choose when people will be spread out in a wide room. The color fidelity of a matte screen is excellent, and the image on a matte screen is sharper than that on any other surface.

Lenticular Screens. A lenticular screen has a more directional light pattern than a matte screen, but a brighter image. This screen is a good choice if your viewers will not be seated at extreme angles to the projector-to-screen axis. These screens are embossed with a pattern of rectangles, stripes, diamonds, or ribs. This acts like thousands of small mirrors or lenses to reflect the light, hence the name "lenticular" (lenslike).

Because the manufacturer can control the shape of these lenticles, there is considerable variation in both the allowable angle of view and the brightness among the various makes of screens. Some lenticular screens are metallic: the pattern is embossed on an aluminum coating. These have a narrower angle of view than nonmetallic lenticular screens and so are a little more brilliant. Nonmetallic lenticular screens show an image that's about twice as bright as matte screens do; metallic lenticulars are about four times as bright. Although there are differences among manufacturers, metallic screens, in general, have the brightest viewing area within 25° of the projection-to-screen axis, while nonmetallic screens have the best visibility within 35°.

Beaded Screens. A beaded screen is a good choice for a long, narrow room. This screen contains little clear glass beads bonded to a white fabric. It reflects almost all the light back to the source. Within 5° of the projector-to-screen axis, the image is extremely bright, about

four times as bright as that on a matte screen. But the brightness falls off quickly at wider and wider angles. Anyone seated beyond 25° of the projection axis will think that the image is too dim.

So far, I've discussed screen types only in relation to the seating arrangement, but how dark you can make your room also affects your choice of screen. With a matte screen, the room must be almost totally dark because any stray light in the room will degrade the image. The screen does not discriminate; it reflects stray light as well as the projected image, equally and in all directions. A lenticular screen is better in this respect. Some of the stray light that originates outside the viewing area is reflected back there, so the screen can be used in a room that is only partially dark. But a beaded screen reflects much of the stray light originating outside the viewing area. The farther to the side a person is sitting, the more troublesome this stray light is.

High-gain Screens. If you must project your slides in a lighted room, try a high-gain aluminum screen. These screens are made of thin sheets of specially processed aluminum foil, permanently laminated to lightweight frames. The screen reflects an image that is about 12 times as bright as a matte screen does, within 30° of the projection-to-screen axis. But outside this area, no image can be seen.

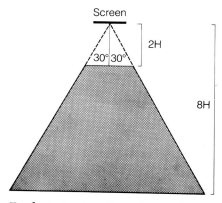

For best viewing, the audience should be seated within the shaded area.

Any light not originating from the projector is reflected totally outside the viewing area. These screens may solve your problem, but they are relatively expensive and can't be rolled.

A final factor to consider when selecting a screen is its shape. Screens come horizontal, vertical, and square. If all of your slides are horizontal shots, this is the only dimension you'd have to consider. But chances are, many of your slides are vertical, so make sure the screen is adequate in this dimension. Square screens are a good compromise.

Mounting, Transporting, and Storing the Screen. How to mount, transport, and store your screen is a practical problem. All but high-gain screens are made

The most popular home projection screen is one that's tripod-mounted.

A screen mounted on the ceiling is always ready.

with tripod mounts that allow you to roll them up for storage and carry them in your car. Screen cases are available, too.

For convenience, a wall- or ceiling-mounted screen is best. I put two hooks in my living room ceiling and hung a screen from them. Now it's always handy and fairly unobtrusive. You can completely conceal such a screen by hanging it behind a drapery cornice. Many matte and beaded screens can be mounted this way. Lenticular screens must be stretched to eliminate all wrinkles and waves, which can produce dark and light areas in the image. A tripod mount does this automatically, but you have to increase the tension when hanging lenticular screens.

If you are installing a permanent screen in an office or a meeting room, you may be interested in the Eberhard Faber-Board Visual Aid Panel. This is a self-adhesive panel with a nonmetallic lenticular surface, and it can be pressed onto any smooth surface. You can also write on it with special felt markers. Some models hold magnetic letters and objects; some have built-in loudspeakers.

Caring for the Screen. With reasonable care, your screen should last a lifetime. Matte screens are quite tough: if, for example, your children put their fingers on the surface, you can usually wash the screen with a mild detergent. Lenticular screens are fragile, and it's easy to damage their ridges with your fingernails or a pointer. You will then see dark and light streaks on the images. You have to be careful with beaded screens, too, as you can knock off the beads, and they can't be replaced. Beads that do last have a tendency to yellow with age. The only way to clean this type of screen, should it be necessary, is to wipe it off gently with a feather duster.

At one time, my large, tripod-mounted screen wouldn't retract into the metal tube at the top. If

you should have a similar problem, remove the end caps with a screwdriver and wind the screen on its roller, just as you would a window shade—but use a pair of pliers rather than your fingers.

Screen Position and Seating Arrangements

You want your audience to see the pictures easily, which means you must consider the picture size and the placement of the chairs. Here are some rules of thumb about how far people should sit from the screen for the best view.

- Sitting too close is not good. The perspective seems distorted, and the picture is too large for audience members to see without moving their heads.
- Sitting far away is even worse because they can't make out details and the relatively small image loses its impact.
- When an image is projected horizontally, don't seat anyone at a distance closer than two times the height of the image or farther away than eight times the height of the image. This is the 2H/8H rule. Suppose the projected image is 30 inches high. Everyone will have a good view if the chairs are no closer than 5 feet and no farther than 20 feet from the screen.

Following the 2H/8H rule—seating the audience within an area from two to eight times the height of the projected image—will ensure that the image is a good size for comfortable viewing.

No rule, however, says the screen has to be parallel to a wall. Try putting it at an angle in the corner of the room; you may be able to increase the seating space.

Although a matte screen may give an acceptably bright image for people seated at the side, they are going to be bothered by the distortion of the image. For example, circles will look like ellipses. For the most accurate image possible, have the viewers sit within a 30° area of the projection-to-screen axis.

The bottom of the screen should be high enough for everyone to see the picture. In a home-viewing situation, put the screen a little above the eye level of the audience—about four feet off the floor. If you are setting up a slide show for a large meeting, you'll want to be sure that the projected image is high enough so everyone has an unobstructed view, but not so high that it puts a strain on their necks. Most people can comfortably tolerate looking up, or down, 15° from the middle of the screen.

Choosing a Projector

Although many types and makes of projectors allow you to do simple slide shows, you have fewer options when you want to make more elaborate shows, as described in the next few chapters. When you want to synchronize the images with the sound on a tape recorder or when you want to use two or more projectors, the projectors must be able to accept the accessory controls. Most controllable projectors are based on Kodak's circular tray. Kodak Carousel and Ektagraphic, Telex Caramate, Elmo Omnigraphic, and Leitz Pradolux are the best known, but there are others. In general, look for projectors with a remote-control receptacle and a "fan" position for the lamp.

A few projectors take a straight magazine or a vertically oriented circular slide tray, which also gives you some versatility. Another advantage of the circular-tray projector is its popularity. You can visit a friend, speak at a meeting, or travel across the country and take only your slide tray with you.

If you are going to buy a new projector, consider the following. Some features, in my opinion, are essential; others are nice but unnecessary. You will be working with the projector for a long time, so make sure it does exactly what you want it to.

Autofocus. When you use ordinary, glassless slide mounts, auto-focusing is essential. You focus the first slide, and after that the mechanism keeps all the other slides in focus. If you are using glass-mounted slides, autofocus is unnecessary. If you have both glass and glassless slide mounts in your trays, choose a projector with autofocusing that works with mixed mounts; otherwise, be sure it has an autofocus defeat switch.

Quick Lamp Change. A quick lamp change feature is essential. One of the greatest fears a projectionist has is of the lamp blowing while a roomful of people is gathered in front of the screen. A projector that must be turned upside down is aggravating. Some projectors have a spare lamp that slides into place easily when the other burns out.

Dark-screen Shutter Latch. A dark-screen shutter latch is becoming standard. It irritates an audience when white light is blasted onto the screen because there is no slide in the projector gate. Until now, the solution has been to put an opaque slide or piece of cardboard in the tray. But the dark shutter latch solves the problem automatically. It also works when a slide fails to drop from the tray into the gate.

Reading Light. If you will read a script or notes while projecting the pictures, a reading light is a convenient feature; however, you must stand near the projector rather than in front of the room.

Preview Screen. A preview screen is nice, but far from necessary. For a quick run-through of the slides when they come back from the processor or when editing them, I find it just as easy to project them on a nearby wall or a piece of white cardboard.

Room-light Outlet. A room-light outlet seems like a good idea. I've had this feature on projectors for many years, but I find it easier to let someone turn on a room lamp rather than bothering to run the lamp cord to the projector. Also,

this makes one more cord for someone to trip over.

Automatic Timer. An automatic timer changes the slides automatically—at whatever rate you set it for. This is fine for a presentation that runs unattended, but the lack of variety in pacing adversely affects a slide show.

Slide Tray Removal Without Power. A slide tray that can be removed without using power is very nice to have. Some projectors don't allow you to rotate the slide tray or remove it without switching the power on.

Ektagraphic Versus Carousel. Two types of Kodak projectors, the Ektagraphic and the Carousel, have many features in common, but the Ektagraphic was designed for hard use, such as a continuously running point-of-purchase display, or for multi-image presentations, for which accurate registration of every slide is critical. Unless you need these features, don't spend the additional money.

Choosing Projector Lenses. When you buy a projector, buy the lens you want to go into it. How do you

Use a reading light if a script or notes will be read during the show.

Various special purpose lenses provide better resolution, color, and contrast.

know what you want? The room you will use will tell you. Just as different photographic situations require certain lenses for your camera, different viewing conditions necessitate certain projector lenses. But projector lenses are one of the most neglected items on a photographer's shopping list.

The projector manufacturer's lens may not give you the sharpest image with the best contrast; however, it may be perfectly satisfactory. Let the number of shows you expect to give and the size of your wallet determine whether you need to spend $30 or several hundred dollars.

If you decide you want a high-resolution lens, make comparison tests. Use two identical test slides and compare the images projected side by side by two similar projectors fitted with lenses of the same focal length. (Choose a test slide that has many objects with sharp boundaries and is detailed throughout. A row of trees with bare branches makes a good subject.) Mount the slides in glass. Focus the slides carefully and note if the image is uniformly sharp from edge to center. See which lens gives better contrast and truer colors. Make sure no fringe of colors surrounds the black lines.

Focal Length. You need a lens of the proper focal length for the projection situation. This focal length, like camera lens focal length, is the characteristic that affects the image size. If you require a large image and the projector is a short distance from the screen, you need a lens with a short focal length; if you will project from a long distance, you need a long focal-length lens. Zoom lenses are actually variable focal-length lenses. They may be slightly less sharp than prime lenses, but they certainly are convenient if you will be showing your slides in different places. I'm very fond of zoom lenses because they make setting up a show much faster.

The most popular focal length for a slide projector lens is 5 inches; a useful range for a zoom lens is 4 to 6 inches. Because users' needs vary, you'll find lenses with focal lengths from 1 inch to 14 inches and beyond.

Special Purpose Lenses. There are some interesting special purpose lenses. One is an anamorphic lens, which produces a wide-screen effect. When you put the lens on the camera, it compresses the width of the image. Then, when it's placed on the projector, it expands the image 1 1/2 times. Another unusual lens is a motorized zoom lens that keeps the image in focus while it automatically zooms to make the image larger or smaller. And if keystoning is a problem, you can get a keystone-correction lens. Expect to pay considerably more for these special purpose lenses than for ordinary ones.

If you hold a cardboard-mounted slide in your hand and look at it, you will see that the film curves slightly. This is why, when you project the slide, you'll find you can focus the center of the image, or the corners and the edges, but you can't focus everything at the same time—with a flat-field lens, that is. A curved-field lens corresponds to the curvature of the film and corrects this focusing problem. It is the best lens to buy if you will be showing slides in open mounts. If, however, you mount your slides in glass, the film will be held flat and you will need a flat-field lens; otherwise, you will still have a problem.

Some special purpose lens accessories may also interest you. Bifocal converters shorten the focal length of a lens, and Barlow attachment lenses extend the focal length. Super-Vision is an optical system that magnifies the image up to five times when placed in front of the projector lens.

Projector Placement. To raise the projector enough so the image can

be seen comfortably, you'll need a sturdy support. Tables usually are not high enough, but a block of wood or a wooden box can raise the projector and keep it steady. You can also use several books of the same height, one for the front and one for the back. Most convenient is a projector stand. Although you can tilt the projector up on its elevating foot or raise the front of it on an ashtray or wedge-shaped rubber doorstop, it's much better to keep the projector level.

Optimally, the projector should face the screen squarely. When the beam of light from the projector is perpendicular to the screen, the sides of the image will be parallel to each other and the top will be parallel to the bottom. If the

The Da-Lite/Welt projector stand.

The keystone effect.

DETERMINING APPROXIMATE PROJECTION DISTANCES (ft./*m*)										
	NOMINAL LENS FOCAL LENGTH (in./*mm*)									
SCREEN IMAGE DIMENSIONS (in./*m*)	1.4 *35*	2 *50*	2½ *65*	3 *75*	4 *102*	5 *127*	6 *152*	7 *180*	9 *230*	11 *280*
13½ × 20	2	3	3½	4	5½	7	8½	10	12½	15½
20 × 30	3	4	5	6	8	10	12	14	18	22½
27 × 40	3½	5½	6½	8	10½	13	16	18½	24	29
33½ × 50	4½	6½	8	10	13	16½	19½	23	29½	36
40 × 60	5½	8	9½	11½	15½	19½	23½	27	35	42½
48 × 72	6½	9½	11½	14	18½	23	28	32½	41½	51
56 × 84	7½	10½	13½	16	21½	27	32	37½	48½	59
80 × 120	10½	15	19	23	30½	38	45½	53	68½	83½
96 × 144	12½	18	22½	27	36½	45½	54½	63½	81½	100
0.67 × 1.0	*1.1*	*1.6*	*2.0*	*2.3*	*3.1*	*3.9*	*4.7*	*5.6*	*7.2*	*8.8*
1.0 × 1.5	*1.6*	*2.3*	*3.0*	*3.4*	*4.6*	*5.7*	*6.9*	*8.3*	*10.6*	*12.8*
1.33 × 2.0	*2.1*	*3.0*	*3.9*	*4.5*	*6.0*	*7.6*	*9.1*	*10.9*	*13.9*	*16.9*

beam isn't perpendicular, you'll see the trapezoidal shape known as the keystone effect or keystoning. If the front of the projector is tilted up, as is often done to elevate the picture, the top of the image is farther away from the lens and is, therefore, slightly larger than the bottom. Tilting the projector slightly usually doesn't bother the audience—as long as the angle doesn't exceed 12°. If you must angle the projector more than that, try tilting the screen so its angle matches that of the projector. Some screen manufacturers make a keystone adjuster that allows you to tilt the top of the screen forward, making the lens and screen parallel.

It may bother the audience to have the projector in their midst. As a viewer, I have often been annoyed by the noise and the breeze of warm air coming from the projector. If you can, put the projector in the back of the room so it doesn't distract the people sitting close to it. Small considerations like this can mean a great deal.

Determining Focal Length, Distance, or Image Size

The three factors of focal length, distance, and image size are inter-related. You can make the image on the screen larger by moving the projector farther away from the screen or by using a lens with a shorter focal length. With a zoom lens, you can stay wherever you've set up the projector and change the image size by adjusting the focal length of the zoom lens.

Instead of changing the image size by trial and error, it's easier to know what focal-length lens you'll need to project an image of a certain size from a particular distance. You can get this information from the chart above. If you need projection information for other lenses, distances, and image formats, Kodak has a circular projection calculator and Da-Lite Screen Company has a slide-rule-type calculator that can help you.

As you can see above, a 4-inch lens at a distance of 8 feet throws an image that's 20 x 30 inches. If you want to fill a screen that's 27 x 40 inches, you have to move the projector back to 10 1/2 feet or change to a lens with a focal length of 3 inches. To double the dimensions of the image, making it 40 x 60 inches, you can move the projector back twice as far from the screen (16 feet) or use a lens of 1/2 the focal length (2 inches).

Handy screen calculators help determine projection distances.

Increasing Image Brightness

The brighter the image, the better. I mentioned that stray light in the room can dim the image. Look at the screen in the darkened room with the projector off. Make sure the image is significantly brighter than that black screen.

If your presentation consists only of high contrast word slides, graphs, or other graphics, you can make do with a less bright image. But with the continuous-tone photographs you are most likely to use, you'll need as bright an image as possible. To achieve this, choose the most appropriate screen for the situation, darken the room, and control the projector.

Image Size. A simple way to increase the brightness of the image is to make it smaller. The light from the projector will then be more concentrated. By reducing the width of the image by 1/2, the image will be four times as bright. Think of it this way. Begin with an image that's 40 x 60 inches (2,400 square inches). If you reduce its size to 20 x 30 inches, the projector lamp only has to illuminate an area of 600 square inches: 1/4 the area.

It's best to reduce the size of the image by moving the projector closer to the screen rather than by using a lens with a short focal length. Lenses with focal lengths shorter than 4 inches or longer than 7 inches almost always reduce the light output, so try to stay within this range.

Fast Lenses. Reducing the size of the image may not be a way to increase your audience's appreciation. You might prefer to use a "faster" lens. Just as an *f*/2 camera lens transmits twice as much light as an *f*/2.8 lens, a fast projector lens sends more light to the screen, up to a point. A projector has a finite light output, and a lens of *f*/2.8 gives the maximum benefit. Beyond that, you will see little difference in image brightness.

Projector Lamp. One of the best ways to control image brightness is with the projector lamp. Many projectors have a high/low output switch. With the lamp set at high, you get an image of medium brightness. If you change to a high-output lamp, you can increase the image brightness by perhaps 25 percent. There's a trade-off, though. The brighter the lamp output, the shorter the lamp life. Even more seriously, the bright light can prematurely fade your slides. If you use a high-output lamp, leave the picture on the screen for as short a time as possible, or use duplicate slides if they will be projected often. Be very sure not to use a lamp that is too powerful for the projector, even though it fits. It can damage the projector. Consult your instruction manual to see which lamps are safe for use.

Insufficient Voltage. Make sure the projector is receiving the proper amount of voltage from the line. There is about a 3 percent loss of brightness per volt of drop. Voltage frequently is lower during peak-use times. In residential areas, this is usually in the evening when most TVs, air conditioners, and dishwashers are on. In commercial areas, peak loads occur during daytime hours.

You should also check your extension cord. With each 10 feet of number 18 extension cord, you reduce the light output by 1 percent. A cord that's too lightweight to carry the load or one that's frayed can also cause a reduction in light. Consider safety factors, too. If the voltage drop is too great, the projector motor may stall, leading to overheating. If the cord is too light, the projector can overheat. Damaged cords and dirty or defective connectors can also cause trouble in projectors (and any other electrical equipment).

Cleanliness. To ensure maximum image brightness, keep the optics clean, but don't be overzealous. Condensers, lenses, and heat-absorbing glass are delicate; too frequent cleaning can cause microscopic scratches that make the image appear fuzzy as well as less bright. Most likely, all you'll need is a blast from an air syringe or a can of compressed air. If you see fingerprints on the lens, remove the lens and clean the surfaces by blowing on them gently with your breath. Then wipe them carefully with a piece of lens tissue. You can also apply a drop of lens-cleaning liquid to the tissue.

High Intensity Projectors. Several companies modify Ektagraphic projectors to provide 100 percent more light. There are also special, high intensity xenon arc projectors. These are made for situations that require a great deal of light output, such as an auditorium with a long projection distance. These projectors are expensive, but they are available.

IMAGE BRIGHTNESS VERSUS STRAY-LIGHT BRIGHTNESS

TYPE OF SLIDE	ALLOWABLE STRAY LIGHT
Slides with shadow detail and saturated colors	Brightest part of image should be about 100 times as bright as screen with projector off
Slides with no important detail in dark areas; colors not dark or highly saturated, e.g., a high key photograph; artwork with pastel colors	Image needs to be 25 times as bright as screen with projector off
High contrast slides with artwork, charts, words, or other graphics (message, not color, is primary)	Image needs to be 5 times as bright as screen with projector off

Illusion. You can also "produce" a bright image through an illusion. Take a second slide projector with a short focal-length lens, and project a border all around the image area. When the border is a subdued color, the image seems brighter by comparison.

Choosing Slide Trays

For slide/tape presentations, you will most likely use circular trays in the appropriate projectors. Trays that hold 140 slides are convenient, but because they hold so many slides, the compartments are quite narrow; therefore, if anything is even slightly wrong with a slide mount, it's apt to get stuck in the projector and not drop down into the gate. The compartments accept only cardboard or thin plastic mounts, not glass or metal mounts. Don't use these trays for well-developed slide presentations—save them for less important slides and for storage.

It's easier to maintain 80-slide trays than 140-slide trays. They present less power load to the projector mechanism and function well even with slightly damaged mounts or in extremes of humidity.

Preventing Trouble. Following a few hints can assure you of trouble-free slide operation. Repair or remount all damaged slides. Make sure cardboard mounts are not bent or the corners dog-eared. If you find a bad mount, you may be able to straighten it out with your fingers and clip off frayed corners with a nail clipper, but it's really best to place the film in a new mount. Check the 80-slide trays to see if any of the round plastic pegs on the bottom are broken. If so, discard the tray.

Ordinarily, slide trays don't require any special care. You may want to occasionally blow dust out of them with compressed air. Take the tray off the projector and remove the slides when you do this.

Mounts from different manufac-

Make sure that none of the round, plastic pegs have broken off.

turers vary slightly in thickness, and mounts of cardboard, plastic, and glass are apt to be decidedly different. All the slides for a presentation, therefore, should be in the same type of mount; otherwise, the automatic focusing mechanism will continually refocus the slides.

Loading Trays. Before you load a tray, check that the slide-retaining plate on the bottom of the tray is locked in the right place; if not, the slides will drop right through the tray. On the bottom of the Carousel 140 tray is an arrow-shaped index hole. This must be opposite the index notch on the edge of the tray. If it isn't, find the black wire marked "latch." Pull this toward the middle of the tray. Hold it in this position so you can rotate the slide-retaining plate until the index hole and notch line up. On Kodak's 80-slide trays, the slide-retaining plate is in the correct position when the edge of the latch is engaged in the latch notch. Just rotate the retainer plate until the latch slips into place.

Clean each slide, blowing it with compressed air or brushing it with an antistatic brush. For slides with fingerprints, use a drop of film cleaner on a cotton swab. Do this gently: you don't want to scratch the slide. Then load the slides into the tray, making sure they are upside down with the emulsion (dull) side closest to the screen and the base (shiny) side facing the lamp. An easy way to put them in correctly is to hold the slide so it looks correct to you, ro-

Make sure the bottom of the tray is in the proper position.

Make sure the index hole and index notch are aligned.

Next, rotate the slide-retaining plate until the hole and notch align.

The plate is in place when the edge of the latch is engaged in the latch notch.

Load the slides upside down, with the emulsion slide facing the screen.

tate it bottom to top, and put it into the tray as you stand behind the projector. Next, put the slide-lock ring securely on top of the tray. Turn it clockwise until it clicks twice. Project the slides quickly to see that they are inserted correctly, are dust-free, and have not slipped in the mounts.

I've seen a whole tray of slides spill onto the floor moments before a presentation. In case this happens, it won't be disastrous if you can put the slides back into the tray quickly. You'll have no trouble if each slide is numbered and marked with a dot. Some photographers have another aid. They stack all the slides, in order, and draw a diagonal line across the top edge, from the beginning to the end of the pile. This makes it easy to see an out-of-place slide.

Draw a diagonal line across the top of the slides before loading them.

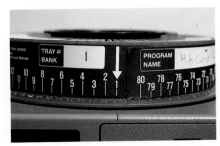

A tray band indicates what slide is being projected.

Troubleshooting. Knowing about the slide-retaining plate on the bottom of the slide tray can help you out in that embarrassing emergency when a slide gets jammed in the projector gate and refuses to pop back into the slide tray. This usually happens because the slide mount is bent, and it's more apt to happen with the 140-slide tray than an 80.

First, try to free the slide by pressing the advance or reverse button. If this doesn't work, remove the tray to get at the slide. Let's suppose you have a Kodak projector. Turn off the projector. On the top, in the middle, is a large tray-removal screw. Using a coin, turn the screw in either direction as far as it will go. This releases the tray, which you can now lift off the projector. Remove the stuck slide with your fingers or a pair of tweezers, or by pushing the advance button. Now rotate the slide-retaining plate on the base of the tray so the slide latch is returned to the zero position, as described earlier. Be sure that the retaining ring on the top of the tray is securely in place when you turn the tray upside down. Put the tray back on the projector, repair and replace the damaged slide, and advance the tray to where the show was interrupted.

Helpful Accessories
Little things contribute a great deal to the ease of the presentation. A remote-control switch to advance the slides lets you sit comfortably while operating the projector. If you want to stand in front of the group, you can use an extension cord, which is available from the projector manufacturer. Wireless remote controls, available through independent manufacturers, allow you to be as far as 150 feet from the projector.

When you give a slide presentation that will be followed by a question-and-answer period, you may want to refer back to a particular slide. Rather than fumble with an entire tray, it's convenient to use a random-access control. Although some of these require a specially modified random-access projector, others work with almost any projector. All you need is a list of the slides and the numbers of their tray slots. Then press that number on the control and the slide tray whirls around, in less than three seconds, to that slide. Of course, you can do this manually, but it takes a bit longer. To be able to see the number of the slide slots easily, wrap a tray band around the circular tray. The large white-on-black numbers make it easier to locate the slides than trying to read the raised same-color numbers on the tray. Bring a pair of opera glasses with you; they'll help you focus the projector.

A pointer often helps a speaker. A flashlight type that projects an arrow or other design at the spot you want to call attention to is best. If you frequently lecture us-

SLIDE-PRESENTATION PREPAREDNESS KIT
(keep with the projector)

- instruction manuals for projector and tape recorder
- spare projection lamp (know how to change it)
- extension cord(s)
- three-wire adapter plugs (if your equipment has grounded plugs)
- coin

- spare slide mounts
- tweezers
- scissors
- small flashlight and new batteries
- lens tissue or blower brush
- transparent or masking tape
- pencil or pen

TRANSFERRING TO VIDEOTAPE

Using a projector, a screen, and a darkened room is not your only option for showing slides. If you have a videocassette recorder, consider transferring some of your shows to videotape. Should you want to show them on the spur of the moment, you can just pop in a cassette without setting up projection equipment. This is also a convenient way to send a slide show to out-of-town relatives. There is another advantage. If you don't have equipment for adding a sound track or controlling two projectors in a "dissolve" presentation (as described in later chapters), a service that does videotape transfers can handle this for you. The disadvantage, though, is that slides shown on a small television screen are not nearly as impressive as when projected on a screen.

Slides to be transferred to video should be horizontal. A video image is a horizontal rectangle four units wide by three units high, while slides are three units wide by two units high. In order to fill the video frame, you lose some image at the sides. It's especially important to remember this when making titles and other word slides. Because video increases the contrast of the image, it's best to use a low contrast film.

The easiest way to turn your slides into a videotape is to take them to a camera store that has a transfer unit, such as the Froelich Foto Video Transfer System. You can also send them to a professional service, such as Slidescan or Aerial Image Transfer. These services can do color correction, exposure correction, and such special effects as fades, dissolves, and wipes.

If you have a video camera, you can do the job yourself. Holders are available for holding the slide in front of the lens; some of these incorporate a closeup lens, which you need if your camera does not have "macro" capability. Simply insert one slide after another into the holder and rephotograph them. Put the recorder on "pause" when changing the slides.

Another method is to set up your camera and projector and shoot the show as your project it. Lock the camera on a sturdy tripod, as close as possible to the projector, and focus both units carefully. Use the "indoor" setting on the color-balance control, and, if you can, use manual rather than automatic exposure. To avoid recording the noise of the projector, dub in your sound track later, or patch the sound directly from the audiotape recorder into the video recorder.

ing a pointer, you may be interested in a laser pointer. These are low-powered enough to be safe, yet high-powered enough to project a brilliant spot of light no matter how far you stand from the screen or how well-lit the room is.

Sound Equipment

I've stressed the importance of using recorded sound—and recording with care. You'll want to take the same care in playing back the sound during your presentation.

Put this book down and clap your hands. If you can hear a definite echo, the room is "live." This happens in rooms that have many hard surfaces. The sound reflecting off the hard walls interferes with the original sound, making speech hard to understand. The opposite of a live room is one that's "dead." Instead of reflecting sound, soft surfaces absorb it. As a result, music doesn't sound as good and you have to turn up the volume level.

When you play back recorded sound, you want a room that's neither too live nor too dead. If it's live, follow the suggestions about carpets, closed drapes, and upholstered furniture that help when you record. Also, a large audience is one of the best sound absorbers you can have. In a very live room, keep the volume level as low as possible for comfortable hearing. If it's too loud, the echo increases. Turn the tone control toward treble to increase the intelligibility of speech.

Loudspeakers. If you show slides in a small room (an ordinary room in a home can be considered small), the speaker built into your tape recorder will probably provide sufficient volume. Some speakers will even work well in larger rooms, although it's more likely that when you turn the volume way up, the sound will become distorted.

Do a test. The sound will be somewhat different when the room is full of people and when it's empty. You'll need more volume with an audience. If you find you must turn up the volume too much to maintain good sound quality, use an external speaker. In small and medium-size rooms, a good hi-fi or bookshelf-type speaker will do.

Many recorders have an output jack marked "external speaker" or "external amplifier," allowing you to run a connecting cord between the recorder and loudspeaker. If the speaker doesn't have a built-in amplifier, you will need that, too. The power capability of the external speaker depends on its efficiency and the acoustics of the room, and the amplifier must be able to handle this. Consult a knowledgeable audio dealer before buying any equipment. If you borrow equipment or adapt units from old hi-fi sets, you will probably get the best results through trial and error.

Placement. It's much more natural and pleasing for the sound to come from the direction of the visuals rather than from the back of the room. But don't put the speaker on the floor next to the screen; raise it onto a table or chair. When it's on the floor, only the people in the front can hear the sound well. If the audience can see the loudspeaker, they will also be able to hear the sound.

Also, keep the loudspeaker several feet from a wall; otherwise, you'll put too much emphasis on the bass tones and decrease the intelligibility of speech. When you move your presentation to a large room or to a very live room, other types of speakers may do a better job than ordinary hi-fi speakers. Sound-reinforcement speakers placed high, but not close to the ceiling, are better for recorded speech. Aim them toward the back of the room so the volume levels will be almost uniform throughout the room. If you give your show in a large hall, get some professional help from an audio equipment rental house, and ask about line-array and horn speakers.

Live Narration

Chances are that you will deliver a live commentary during many, if not all, of your slide presentations. Rehearsal is imperative so you are familiar enough with your notes to be able to frequently look up at the slides and talk conversationally, rather than read the speech. It's best if your voice comes from the front of the room. Sit or stand at a slightly angled position, so you face the audience but can also see the screen. In a darkened room with pictures on the screen, speak a little louder to hold the audience's attention.

You'll need a small lamp or a flashlight, shielded from the audience, so you can see your notes. If you're also changing the slides, be sure your remote-control extension cord is long enough. If the remote control doesn't have a bump that differentiates between the advance and the reverse buttons, put a bit of white tape on the advance button. You'll be able to feel it—and perhaps see it—in the darkened room.

Live Narration with Recorded Music and Effects.

There's something more personal about a live narration. But this doesn't mean you can't use music and/or sound effects. In a way, it's easier because you can have music in the background without using elaborate sound-mixing equipment.

You have a number of options:
- Choose an appropriate disc recording and play it continuously at one low level so it doesn't drown out your voice, or have a friend change the volume level at strategic places.
- Use edited music, or music and sound effects, on recording tape, running it continuously for the entire show.
- Put music for the beginning and end of the program on recording tape, turning it on and off as needed.
- Put music and sound effects of the desired length on tape, recording them consecutively with a three-second pause between each segment. When you come to the end of a passage of sound during the presentation, stop the tape recorder with the pause control. Start it again at the point you indicate in the script. With a detailed script, you or a friend can operate the tape recorder. This results in an extremely effective performance.

You may be delivering your slide-supported speech in front of a large audience, using a microphone. Whoever is in charge of the arrangements should know where to place the microphone in relation to the speakers. The mike must not be in the sound field of the loudspeakers. When sound from the loudspeakers enters the microphone, you get that earsplitting whistle known as feedback. As long as the loudspeakers aren't behind the microphone, this should not happen.

Hand Shadows

Not all presentations are flawless. Sometimes a slide fails to drop into the projector gate and you are faced with a glaring, white screen. Invariably, someone will throw shadows on the screen. I'm one of those people. My repertoire includes a dog and a bird in flight (I'm learning to do an elephant). If you learn to do enough of these, you won't even need slides to do a show! It's an amusing talent, and you might enjoy reading about them in *Hand Shadows to Be Thrown upon the Wall* by Henry Bursill (Dover, 1967).

Synchronized Slide/Tape Presentations

Putting pictures and sounds together by carefully orchestrating slides to match the sound on audiotape is called synchronization, sync for short. There are several ways to synchronize the pictures and sound. Some methods rely on your vigilance and quick reaction time. Others rely on electronics. With the latter, you don't have to wait anxiously for the instant you're to change the slide. The electronic signal ensures that the slide changes take place unerringly when you want them to.

For some slide shows, though, precise synchronization is unnecessary. The coordination of picture and sound can be quite loose and still be completely satisfactory. A series of images with no particular story to tell, such as pictures of flowers or abstractions, is often pleasing only with recorded background music. If the music conveys the right mood and has no conspicuously loud or soft passages or dramatic climaxes, you may not

have to match images to it. Editing the sound track to the correct length may be your only concern.

Synchronization becomes trickier when you want certain musical passages, sound effects, or narration to accentuate a particular picture. It will seem rather strange if pictures of a sailboat race are accompanied by the sound of street traffic. When you put together such shows, you need more sophisticated techniques and equipment. How you do it depends on how accurately the slides and visuals must match up—and, ultimately, what equipment you have.

Manual Synchronization
The most basic and inexpensive method for changing slides is to use only your fingers.
Cued Script. In earlier chapters, I discussed marking the script to show where to change the slides: slightly ahead of where the actual slide change should occur, since projectors take about a second to

cycle from one slide to the next.

If you do a careful job, this system works very well. You can memorize the entire narration, including slide-change cues, but there will be much less chance of error if you use a small lamp or flashlight, or the reading light built into many projectors. Follow the script and push the slide-advance button at the right moment. It's easier to use a remote-control cord rather than the button on the projector, but it's not essential.
Music Passages. Cuing the script works well as long as you have something to cue it to. When you have long passages of music—or only music—your job is not as easy. Play the music over and over while projecting the slides. Familiarize yourself with it, practically memorizing every phrase. After enough rehearsals, you will be able to coordinate the slide changes to the music.

To allow for error, you may want the music to run slightly long, per-

haps 15 or 20 seconds. As you reach the last slides in the tray, you'll be aware of how accurate your timing is. If necessary, you can slow down the rate at which you advance the slides; otherwise, when you reach the last slide, you can fade down the volume of the music until it is off. Don't just stop the music: that's disturbing. (The audience can tolerate a fade and may be completely unaware of a timing problem.) Showing pictures after the music stops can seem rather absurd, especially if the music has a definite closing section. Without a precise system of synchronization, it's better to err with too much music than too many visuals.

A good way to handle passages of music or silence is simply to time everything. Determine the intervals between slides at the editing/rehearsal stage. This may seem mechanical, but it is reliable. Keep your eyes glued to the cue sheet and stopwatch, but glance up occasionally to see that the slides are projecting satisfactorily.

Look at the sample cue sheet on lined paper (above far right). The timing starts at the beginning of the sound track, and there's an indication of the total elapsed time at each slide change. The slide-advance button is pushed when the stopwatch says 10 seconds, 16 seconds, 22 seconds, and so forth. This leaves the title slide on for 10 seconds, the next slide on for 6 seconds, the third on for 6 seconds, and so on.

An alternative to using a stopwatch is to use the counter on the tape recorder. The sound track should start when the counter reads 000. Write down the number that appears when you want to change slides. Although using the counter means you have one less piece of equipment, a stopwatch helps in the planning stage. You may want to time the changes using the stopwatch, and then see what tape-recorder numbers the timings correspond to. Try the var-

One way to mark a cue sheet when there is extended silence or music.

A typical cue sheet.

Another way to indicate slide changes on a cue sheet.

ious methods to see what's most convenient for you. Be sure you use the same tape recorder for both the timing and the show. There is no standard for these counters, which vary from model to model.

It's prudent to write a one- or two-word description of each slide. Without them, if you lose your place, you are in trouble. But with the identifications, a glance at the screen indicates whether or not everything is going well. If you see you've made a mistake, advance to the correct slide or wait for the sound to catch up with the picture on the screen, whichever will put you back in sync.

Cued Script and Stopwatch Timing. If your sound track consists of narration with some extended periods of silence or music, mark the script with dots to show where

slide changes will be. For extended periods of silence or music, write down stopwatch times or counter numbers to help you through these vague periods.

Here are two ways of marking your cue sheet. Both assume that the timing starts at the beginning of the show. When you are 1 minute, 26 seconds into the show—even without a narration to cue you—you know to press the slide-advance button. Do the same at 1 minute, 43 seconds.

Cued Tape. The next step up in synchronization of the audio and visual parts of the show is to put a cue directly onto the audiotape. Although you have to push the slide-advance button, your attention does not have to be riveted as closely and you're not as apt to make a mistake. Do this with either audible or inaudible cues.

Let's discuss audible cues first. You've undoubtedly viewed slide/tape programs or filmstrips that used a beep or clicking noise to signal the projectionist to change the slide. This audible signal seems annoying at first, but, somehow, after the show has been on for a few minutes, the audience forgets about it and concentrates on the more interesting sounds. This method has been used for years and is still satisfactory, especially if you are going to let other people borrow your slide show.

You may want to try a tone generator, which emits a sound of a specific frequency when you push a button. You can improvise with other signals, too, such as the sound of a musical instrument, a door chime, a bell, a spoon clinking on a glass, or a little hand "cricket." Whatever you use, be sure its sound can be differentiated from the other sounds on the track. Otherwise, the projectionist may be confused. The sound should last for about half a second.

One way to put the cue tones onto tape is to record the music and cues simultaneously. Put a tape with the edited sound track onto a recorder. Connect a cable from the output of that recorder to the input jack of a second recorder. If your equipment permits it, connect a microphone into the second recorder. Put the second recorder into the recording mode. Produce your cue tones at the appropriate times into the microphone while playing the sound track. But the problem here is that if you make a mistake when you create a cue sound, you're stuck with it. You can't erase the cue without also erasing the sound track. As a result, if you put a cue in the wrong place, you'll have to start all over again.

Another way is to gather several tape recorders. While listening to the sound on one recorder through a pair of headphones, record your cue tones on another tape on a second recorder. If you

make a mistake, you can erase and change the cue tape. When you're satisfied with the cues, feed both tape recorders into a mixer and put the output of the mixer into a third recorder. The sound track and cues are now on one tape.

An even better method requires a stereo reel-to-reel tape recorder that lets you play back and listen to one track while you record on the other. When working with this

kind of machine, put your music or narration onto one of the tracks. Then listen to the sound as you record the cue tones, using a microphone, onto the other track. On playback, the two tracks will be combined.

Practice the audible cues with your slides and sound track before you actually record the signals. Then review the show to be sure the timings and pacing are right—

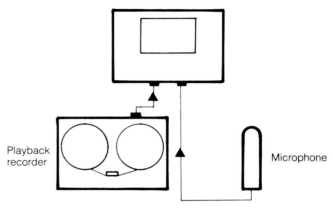

Cue tones can be put onto a tape by recording the music and cues simultaneously onto a second recorder. Connect the recorders and microphone as shown.

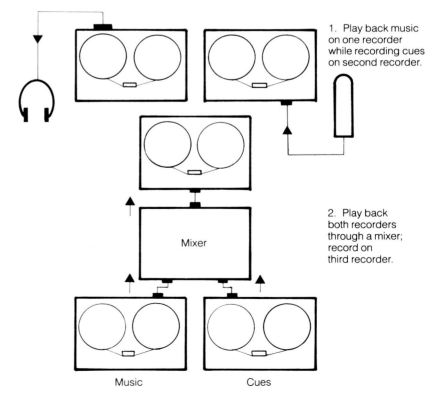

1. Play back music on one recorder while recording cues on second recorder.

2. Play back both recorders through a mixer; record on third recorder.

Cues can be put onto a sound track in two steps, using three tape recorders and a mixer.

and that you've allowed sufficient time for the slides to cycle. Don't expect the cuing to be perfect on the first attempt; plan enough time to do it over. My rule of thumb: everything takes about three times as long as I think it will.

The second way to put a cue onto audiotape is through the use of inaudible cues. A stereo recorder with separate playback and record capabilities for each track allows you to put down cues that are audible only to the projectionist. This will please the viewers. Here, too, first record the sound track. Then listen to it as you put cue tones on the other track. You might prefer to use a verbal signal instead of a tone. Talk into a microphone and say "change," "get ready . . . change," or whatever message you want.

The difference between this and the audible-tone method is on playback. Instead of connecting both tracks to the loudspeaker, connect only the track with the music. Connect the output of the other track to a set of headphones the projectionist will wear. This method works well for everyone. The audience will hear the sound track but be undisturbed by the beeps or clicks signaling a slide change. The projectionist will not have to differentiate between a tone that signals a change and one that is part of the music or is a sound effect.

Electronic Synchronization

Although playing back recorded music and pushing a button to change slides at appropriate times may not be hard, there are easier ways to implement slide changes. But more important, using an electronic system makes the synchronization of the presentation reliable.

A slide synchronizer puts a sync pulse, also called cue tone, onto one track of an audiotape; the music or narration is on a different track. On playback, the pulse automatically triggers the projec-

tor's slide-advance mechanism and silently, without any help from you, moves the show along at the exact pace you want. Obviously, you have to get the information onto the tape, but that's the only work you have to do. Then, once you set up all the equipment and push the recorder's "play" button, you can sit back and be part of the audience.

Equipment. Most of these synchronizers require a projector that has an input for a remote-control device because the sync pulses close the slide-advance switch just as the remote control does.

The Carousel Sound Synchronizer from Kodak and the Pacer II from Impact Communications are two units that connect a projector and a stereo tape recorder. The Carousel works only with reel-to-reel recorders; the Pacer, with both reel-to-reel and stereo cassette recorders. With a monaural cassette recorder, the Pacer puts down audible cues you can use for manual slide advance. Each of these units costs around $100.

For about $200, you can buy a combination synchronizer/tape recorder. These cassette recorders, which allow you to record a mono audiotrack on one part of the tape and a cue track on the other half, are convenient.

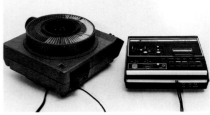

Audiotronics' combination recorder/synchronizer.

Kodak's Sound-Slide Synchronizer.

Impact Communications' Pacer II.

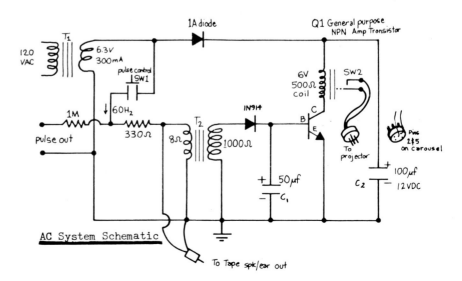

A cuing system you can build, using plans sold by Millers/Sountage.

The international standard for a cue pulse is a 1000Hz tone. Some synchronizers lay down two kinds of pulses: the standard tone and a 150Hz tone. Use the 150Hz signal to program an automatic stop. This is useful for lecturers: you can show slides for a while, allow time for questions or comments, and then resume the slide show by pressing the start button again. You can also use the 150Hz signal more creatively with a synchronizer and two projectors.

Another system, devised by Paul C. Miller of Millers/Sountage, has an oscillator that puts the control pulses on tape. A sound-sensitive relay detects the pulse on playback and trips the projector's slide-change mechanism. As with other pulse systems, the control pulse goes on one track and the audio program on the other.

If you like to build your own electronic equipment, you can construct a slide/tape synchronization system for a fraction of the cost of a commercial unit. A system devised by Terrance Lukas is described in *Producing Slide and Tape Presentations* (Association for Educational Communications and Technology, 1981). He does not use an audio track on the tape recorder for the slide-change cues. Instead, he puts a pencil mark on the audiotape where the slide change is to occur. The graphite triggers the slide-changing mechanism. Thus, with a stereo tape recorder, you can have both stereo sound and synchronization.

Recording Tape. As mentioned earlier, your choice of recording tape can make a difference in the quality of a production. When adding a sync pulse to the tape, it is doubly important. A thicker tape gives better sound than a thin tape; it also prevents the likelihood of print through, which is the transfer of sound from one layer of tape to another while it is coiled up and stored. Although this may not be noticeable on the sound track, it can cause false cuing of

the slide advance when it's on the cue track. For reel-to-reel, use tape that's 1 or 1 1/2mil thick. Cassette tapes should be no longer than necessary to accommodate the program. Long, thin tapes aren't dependable.

Use a new tape. Even though your recorder erases old sounds while putting down new ones, you want to be absolutely sure there will be no surprise signals left on the tape from imprecise head alignment.

If you want to reuse a tape, do the following:
1. Erase all traces of previous sound with a bulk eraser, which takes only a few seconds. Rewind the tape onto one reel or on one cassette hub. Center the tape over the spindle of the eraser, turn it on, and *slowly* rotate the tape two complete turns at a speed of one turn in 10 seconds. Now slowly lift the tape until it is about 2 feet above the eraser, and turn the eraser off. Flip the tape over and repeat the procedure. Be sure to keep the eraser on while you slowly move the tape away from its magnetic field.
2. Check the tape by playing it for a few moments on your recorder. If you hear whooshes of sound, repeat the erasing procedure.
3. Remove your watch before using the tape eraser, which acts like a magnet when it's on.
4. Keep the eraser away from videotape or anything else affected by a magnetic field.

Auto Fade. There's an unusual accessory you can use when you play back a manually or synchronizer-controlled slide show. Called Auto Fade, from Kimchuk, it changes the appearance of a slide change. Instead of the abrupt slide changes, with a momentary dark interval, this unit fades down the projector lamp, changes the slide, and then fades the lamp up. This fade-out/fade-in takes about three seconds and the result can be quite pleasing.

You need a projector that has a remote-control socket and a lamp of no more than 300 watts. To operate Auto Fade manually, plug it into the remote-control socket of the projector. Then plug the remote-control cord into the input of the Auto Fade. Set the projector power switch to "fan" (the effect doesn't work in the lamp-on position) and advance the slides using the remote-control cord.

When using the Auto Fade with a synchronizer/tape recorder, connect the Auto Fade to the projector and plug the cable from the tape recorder into the input of the Auto Fade. Put the projector in the fan position and turn on the tape recorder. The Auto Fade device will fade down the cued slides in response to the pulses. When programming your tape, be sure to allow at least three seconds between slide changes.

The Kimchuk Auto Fade.

The Auto Fade can be used with a tape recorder/synchronizer.

Sound Projection. The most common way to make a synchronized slide/tape presentation is to have the slides in a projector and the sound track on a separate tape recorder. But it's not the only way. Just as there are sound projectors for motion picture film, there are sound projectors for slide presentations. These all-in-one units make it easy to carry a show around. They take up less space when you're setting up and are designed for special needs. Since these needs may be your needs, let's discuss them.

Front Projection. A front projector looks very much like an ordinary projector, but it has a built-in cassette recorder and synchronizer. All the control buttons, therefore, are on the machine. You cue the slide advances in a manner similar to cuing them on a separate recorder/synchronizer.

Several companies make sound/slide presentation systems. With these systems, the projector and synchronizer/recorder are actually separate units mounted together in one compact carrying case. These are most valuable for travelers who take their presentations with them.

Front and Rear Projection. Most front and rear projectors are box-like and resemble a television set with a Carousel tray perched on top. The slides, screen, cassette tape, synchronizer, and amplifier are all neatly housed in the one unit. The average dimensions are 14 x 13 x 13 inches, with a 9 x 9-inch screen; they weigh about 25 pounds. Most allow you to flick a switch and project the image onto a large screen. But their real advantage is that you have just one piece of easily transportable equipment that can be placed on a table or desk when showing the presentation.

Some units are quite sophisticated, such as those with microprocessors that permit you to program your slides in any order, no matter how they are placed in the tray. This, for example, lets you use several different narrations with one tray of slides. To illustrate, you can skip over certain slides that children wouldn't be interested in or you can repeat one image five times in the show, without using five identical slides.

You'll also find units with such features as a "frame filler," which enlarges a portion of the image; remote, push-button, and automatic slide advance; and earphones for listening to the program privately without disturbing other people. These convenient devices are especially useful for sales presentations and teaching. Once you have learned to put together a slide/tape presentation, you will find many opportunities to use your skills beyond entertaining your family and friends, and you will want to know about the various options available to you.

Sound/slide projectors, such as this Telex Caramate, have a built-in cassette recorder and synchronizer and are convenient units to use for slide shows.

Kodak's Ektagraphic AudioViewer Projector can project a synchronized sound/slide show or display it on a self-contained screen.

PREVENTING AND OVERCOMING PROBLEMS

The actual pulsing of a synchronized slide/tape show is almost effortless: all the major work comes before.

When you record the sound track, *use the same equipment you'll use for playback.* Sometimes recorder/playback heads are not aligned identically from one machine to another. This can result in missed cues, or incorrect cues when the recorder reacts to sound on the program track as cues to advance the slide.

Read your recorder/synchronizer's manual carefully. The various synchronizer models don't work exactly the same way. With some recorders, for example, you can break off the tabs on the back of the cassette to prevent accidental erasure of your program track; on other recorders, you can't record cue tones if the tabs are missing.

After marking your script for slide changes, using a stopwatch or the recorder's counter numbers when necessary, run through the program to make sure the cues are where you want them. Connect the cable from the sync output of the synchronizer into the remote-control input of the projector. Turn on the projector and recorder, and play back the recorded sound track. Rehearse the show several times, pressing the "cue" or "pulse" button on the synchronizer to advance the slides. When you're satisfied that the slide changes are where they should be, put the synchronizer into the mode for recording the cue pulses. It may be labeled "program," "sync record," or some similar term.

It's possible to program the show without running the slides—just by following the script and listening to the sound track—but you'll get a better feel for the show if you see and hear things as you proceed.

Breaking off the tabs on the back of an audiocassette prevents accidental erasure of the tape.

One type of volume-control indicator has a needle, which moves into the red area when the volume is too high.

Follow along on your script. With music, keep your eye on a stopwatch or the tape counter. At the right instant, push the pulse button. It will advance the slide each time. You will hear the pulse tone as you record it, but you will not hear the tone when you play back the show. If you detect a mistake, make a note on your script, so you'll be able to find the error later.

If you make several errors, you will probably want to start over. Rewind the tape and return the slide tray to the beginning. Then, when you put the synchronizer into the program mode to rerecord, the machine will erase everything on the cue track, letting you remedy any mistakes.

But what if things are going along smoothly, and suddenly you miss a cue? Stop and rewind the tape a little bit. Make sure the machine is in the program mode because some machines automati-

cally change modes when you rewind the tape. Proceed to pulse the tape correctly.

When you've gone through the entire program and are satisfied, rewind the tape to the beginning and set the projector on the first slide. Take the synchronizer out of the programming mode, put the recorder in the playback mode, and let the show play through automatically. If your mind and fingers were alert, it should run beautifully. If not, make notes on the script to indicate where the problems are.

You may see places where the projector seems to be missing a cue. It could be that you forgot to record the cue or you put two cues too close together. Here's what you need to do to make the necessary corrections:
1. Rewind the tape all the way.
2. Return the slide tray to the first slide.
3. Play back the show until the cue preceding the mistake is reached.
4. Stop the synchronizer.
5. Put the synchronizer into the programming mode.
6. Start the tape again.
7. Pulse the cue at the correct place.
8. Stop the synchronizer when you are safely past the erroneous cue but you are not yet into the next good one.
9. If your problem was that two cues were too close together, you will probably have to replace both of them, spacing them out a little.

Your synchronizer may have a second pulse-tone feature. Use it to signal a pause. The tape will stop at this point so you can design the program for questions or live demonstrations. You can't program the length of the pause, though. Instead, when you play back the program, you will have to manually press the "play" button again to resume the show.

If you use a synchronizer that is not integrated with a tape recorder, the procedure is slightly different. First, record your program onto one track of a stereo reel-to-reel recorder. Next, connect the synchronizer to the slide projector and to the input of the other channel of the tape recorder. Put the tape recorder on "record" for the first channel and "play" for the second. Advance the slides as the instruction manual explains. A sync pulse will be recorded on the first track of the tape.

When you're ready to play back the tape, connect the synchronizer to the recorder and projector according to your unit's instructions. Put both channels of the recorder in playback mode and start the sound. The volume control must be high enough to signal the slide advances, but not too high. If it's too high, it may advance slides when you don't want it to. When you see the show work properly, you'll know you have set the level correctly. Make note of the settings, either on the volume control itself or on the synchronizer instruction manual, for future reference.

If you don't have a stereo reel-to-reel recorder, try this. Make your sound track on any mono recorder, either cassette or reel-to-reel. Then play back on this recorder, feeding the sound into one channel of a stereo cassette. At the same time, connect the synchronizer with the other stereo channel of the cassette recorder. Put the cassette recorder into "record" mode for both channels; then simultaneously cue the slide advances and make the duplicate recording. The disadvantage is that if you make a mistake in advancing the slides, you'll have to go back to the beginning. With a little practice, you should have no trouble.

The Two-projector Slide Show

You may have watched a slide presentation in which the images flowed smoothly rather than clunked from one to another, separated by a moment of darkness on the screen. If you turned to look at the equipment, you would have seen not one, but at least two projectors, probably controlled by an auxiliary device. The device is called a "dissolve control" or "dissolver." Although its function is simple, it adds a polished look to any presentation.

If you become serious about making slide shows and want to do them frequently, you'll most likely abandon single-projector presentations. As fine as a one-projector show can be, two-projector dissolve shows are unquestionably more pleasing.

The Dissolve Control

A dissolve control does nothing more than dim and brighten the projector lamps, and then advances the tray to the next slide when the projector lamp is off. When you activate the slide change, the lamp on one projector gradually dims. At the same time, the lamp on the other projector gradually brightens. An image is always on the screen, and for a brief time, the two images merge: one image appears to dissolve into the other. During the dissolve, two images are superimposed; they combine so the brightness level on the screen is constant. This is similar to making a double exposure with your camera—you add light in both cases. When the outgoing projector is faded down 25 percent, it leaves 75 percent of its light on the screen. At the same point, the incoming projector reaches 25 percent of its total brightness, resulting in 100 percent image light. At the midway point in the dissolve, the two images are equally bright.

The rate of the dissolves can be controlled, so they can be slow or almost instantaneous. Because the next slide is already in position, there is never a momentary blackout on the screen.

Manual Dissolve. Before I discuss dissolve controls, you may be intrigued to know that outstanding projection techniques are possible without special equipment. One of the highlights at a multi-image festival was a program in which the presenter faded the slides in and out, not with a dissolve control, but with his hands. It takes practice to master the technique, but it is possible—and inexpensive. Duffie White, who put on the show as a spoof of the slide-production industry's fascination with sophisticated electronic equipment, advanced the slides by placing remote controls on the floor and pushing the buttons with his toes. Furthermore, he created special effects, such as flashing one lamp on and off and alternating between images. This proves it can be done, but I highly recommend a

An example of a dissolve.

PSEUDO-DISSOLVE EFFECT

One of the reasons dissolve shows are pleasing to watch is that an image is always on the screen. It's possible to achieve this, to an extent, with two projectors changing slides in the traditional manner.

Put word slides with white letters on black backgrounds in one projector, and put pictorial slides in the other. Then superimpose a word slide over a background picture as your project them; the white letters will burn into the background. Now advance the slide tray with the word slides, but leave the picture slide on the screen. Because you've left one projector on during the slide change, the objectionable dark time between slides is eliminated. You can also leave the word slide on the screen and change the pictures. These techniques work well with speaker-support slides, when you want to present attractive word slides that will be responded to enthusiastically.

Two ways to keep an image on the screen continuously.

This scene works with a slow dissolve.

little electronic gadgetry to make it easier.

If you want to try your hands at it (pun intended), experiment and practice. The trick is to gradually block the light from one projector, advancing the slide while the lens is covered. Rather than merely placing your hand in front of the lens, hold your fingers together in a wedge shape (two fingers together and three fingers together), and slightly wiggle them as they go over the lens. This helps to fade out the light rather than making it appear to wipe out from one side to the other. And while fading out the light on that projector, you will be fading in the light on the other.

Manual Dissolve Control. The simplest dissolve controls are manually operated. Although they fade the lamps, they do not put down any cues or pulses—as with a synchronizer—to change the slides. Some of these units have a rotary knob or a sliding lever that lets you change the rate with continuously variable settings. Others give you several discrete settings to choose from.

You can leave the knob at one setting to make all the dissolves the same length, or you can vary the settings during the course of the show to change the pace. The latter is preferable, of course, and with a few practice run-throughs, you'll remember which scenes should go quickly, which slowly. It's a good idea to indicate the dissolve rates on the script, although this may require a helper to turn pages. Your job will be to advance the slides at the desired time, adjusting the dissolve rate before you advance the slides. This is actually quite easy to manage during a performance because you won't be changing the rate for each slide. Most often, you'll show a succession of slides at one dissolve rate before you set it faster or slower.

You can be creative when you decide on the timing of the dissolves. This will depend on the

music, the images, and the effect you want. For example, scenic parts of a vacation will probably look best with slow dissolves blending the scenes, but pictures of the hectic pace of a big city might be better represented by quick cuts.

A cut, as you can surmise, is an instantaneous change from one slide to the next. There is no dark interval because you are not waiting for slide trays to cycle. It gives a hard, staccato effect. You may hear people talk about hard cuts and soft cuts. The former is as fast a change as possible; the latter is just a little slower—perhaps taking 1/4 second. Dissolves last at least 1/2 second and are fluid.

There are two requirements your projectors must meet in order to be controlled this way. They each must have the seven-pin receptacle for remote-control cords, and they must be able to run in the fan position. Ordinarily, if you put the projector on "fan," the lamp is off. With a dissolve control, the device takes over and makes the lamps brighten and dim. If you turn the lamps on (the normal projection position), both

This Audiotronics dissolve control lets you control the rate of the dissolve as you rotate a knob. Other dissolvers work by sliding a lever.

A dissolve control works via a projector's remote-control receptacle.

lamps will be illuminated all the time and no dissolve will be able to take place.

Many people have successfully built their own dissolve controls utilizing a household-lamp dimmer. These sometimes burn out when the projector lamp burns out, and they do not work well with 82-volt projector lamps. But if you want to try it, get Kodak's booklet S-15-30-AP, "How to Build a Dissolve Control for Ektagraphic or Carousel Slide Projectors." Another alternative is to build a mechanical sliding shutter or an arrangement that alternately covers and uncovers the two projector lenses. These are also discussed in the Kodak leaflet.

Automatic Dissolve Control.

Once you've decided on dissolve rates and the timings between slides, you may wish you could put cues on tape and let the show play back automatically—with the dissolves and the intervals between the dissolves exactly where you want them every time.

It is possible. The equipment you need is a dissolve unit and a tape recorder/synchronizer. By

For Programming

Two ways to link a dissolver/programmer, recorder, and two projectors.

connecting the projectors to the dissolve unit and the dissolve unit to the synchronizer, the synchronizer advances the slide trays in accordance with the cues. The rate of the dissolve, though, depends on the rate you set on the dissolve unit. So, even with these electronics, you always have to guide the dissolve control. Nevertheless, it's easy and fun to do. If you make a mistake, only you will know. Most important, the synchronization of the visuals to the sound track is taken care of. You will only have a problem if you set the control for a very long dissolve and have not left enough time for it between cues.

One of my earliest experiences with two projectors, a dissolver, and a tape recorder/synchronizer almost didn't work because I wasn't aware of two necessary pieces of information. To prevent this from happening to you in front of a group of people, be sure of the following:

• The projectors, tape recorder, and dissolve control are all connected to the same electrical outlet. Use a multiple-socket power box or an extension cord of sufficient capacity to carry the current.

• Turn the plugs around in the electrical outlet to reverse the polarity if the dissolves don't work. Do one plug at a time.

Programmer

Before you buy a dissolver and a synchronizer, try out another piece of equipment called a programmer. This incorporates the functions of the dissolver and the synchronizer—which is what you've been waiting to hear about. The simplest programmers advance and dissolve slides at continuously variable rates or, more likely, at several specified rates.

Some manufacturers call their units dissolvers or programmable dissolve controls, reserving the term "programmer" for higher-priced units that control three or

Pacific Micro Systems' Gemini programmer adds incredible effects.

more projectors. If you want a unit that puts the cue signals onto tape, be sure you specify a programmable unit.

Not too long ago, all you could expect to achieve was a cut and a variety of dissolve rates. That's what you still get with programmers selling for less than $300. But the miracle of microcomputers has made all kinds of special effects possible. Programmers can now make your slide shows nothing short of sensational.

Some programmers are tricky and require you to have nimble fingers. Of course, the more sophisticated they get, the more expensive the units are. These programmers cost between $300 and $500, but prices and features seem to change weekly.

(You can create the slide effects manually, following a script and pushing the right buttons when you want them. I've done it, with the aid of a flashlight so I could see what to push and when—but I don't recommend you do it unless you have the equipment to make your show run automatically. If you must present the show manually, keep it simple. You don't want to make a mistake in front of an audience.)

Because the programmers let you do many special effects, you'll want to put cues onto recording tape. You can then create a flawless program that's repeatable. To do so, you need a tape recorder and the proper audio cables. If the instruction manuals do not specify the cable connectors you'll need, ask at your audio store.

PROGRAMMING TECHNIQUES

A programmer lets you do more than simply dissolve or cut between slides. Some effects are possible with a basic dissolve unit, too. Try these ideas.

Action Sequences. A series of action pictures is perfect for a slide show. Here's how you can make one.

Put your camera on a tripod. All you want displaced in these pictures is the moving object; the background should be identical. Photograph these sequences with or without a motor drive on your camera.

Take a series of pictures of a child swimming, boats sailing, or other, preferably slow, action. Action doesn't have to be associated with sports. Any activity lends itself to this technique, such as a child brushing her hair or an enthusiastic public speaker making hand gestures. Slow action is best because of the relatively slow speed at which projectors change slides. With fast-moving action one slide differs greatly from the next, creating a choppy look on the screen. But if you like this, use it.

Keep the camera steady and resist the urge to pan with the moving subject. You want the subject to move to a different part of the frame in each successive picture. Experiment: use a fast shutter speed for one series and a slow speed for another. You may want to blur the subject a bit to add to the feeling of motion.

Alternate. My programmer is marked "alternate"; other units may say "animate," "sway," "flip," "ripple," or "twinkle." All of these terms mean the projector lamps go on and off, alternating between projectors without advancing the slides. At "cut" speed, the effect looks like a shimmer because the lamps don't have time to go completely dark. Don't use a cut time shorter than 1/4 second if you don't want this.

You can do several variations of the effect. Change the lamp brightness at different rates and use different intervals between cuts. You can also try changing

Projecting these slides alternately over and over creates an illusion of movement.

the rate of alternation while the effect is in progress; for example, start slowly, and then progressively speed it up.

Another way to use this feature creatively is to alternate between two similar images that differ in one aspect, such as color, brightness, or size. When photographing these pairs, place the images in the identical spot. For live shooting, use a tripod. For copystand work with either litho film or flat artwork, tape down your artwork or use a registration system, such as the one that follows. Use color conversion methods (see Chapter 4), varying the exposures to create different color densities. You may also want to experiment with something like two identical fields of stars, masking off different stars on each slide. If you alternate between the slides, the stars will appear to twinkle. You can also use this feature to do animation (see the next section). Not all programmers, however, give you these options.

Animation. Animation is the creation of the appearance of motion. To achieve this effect, start by putting your camera on a tripod. Keep the scene in register by positioning everything in it exactly the same way in each picture— except for the one small change in the subject's position. Be sure a person holds still or the artwork is firmly anchored on the copystand. Choose repetitive action. It's best to place your subject against a plain, dark background, so the action is clear. Take two pictures; then project them alternately for as long as you wish. Although this limits the animation to two repetitive images, you can prolong it indefinitely. And because the projectors are not cycling, you can make the action rapid.

With two projectors, another method is possible. It makes the subject appear to move around on the screen. Here, the speed of the action is limited by the time it takes for the projector trays to advance the slides—at least one second between successive images. That's a long time when you consider that in motion-picture animation, you are looking at 24 different images in one second. Nevertheless, although the movement isn't realistic, it can be quite effective with the right images. It works best with your subject against a black background on the copystand. When I photographed a litho image of a bird, I repositioned it slightly between exposures. Then I chose four of the resulting slides and put them in alternate slots in the trays. Images 1 and 3 went into the first projector; 2 and 4, into the second. Dissolving between the projectors made the bird seem to fly across the screen. It would have been even more effective if its wings had been in a different position for each exposure.

Builds. In Chapter 5, I discussed progressive-disclosure word slides, which are often called build or build-up slides. You can use a similar approach with pictorial subjects. You need a tripod so

With two projectors and a sequence of pictures, slow-moving action can be created on the screen. In Figures 1, 2, 3, and 4, the camera was on a tripod while the cat was coaxed to perform.

As shown in Figures 5, 6, 7, and 8, with four images in two projectors, the bird seems to fly from one side of the screen to the other.

Figures 9, 10, 11, and 12 are a series of build slides, in which a little more material is added each time one slide dissolves into the next.

only one element will change between exposures. You can shoot the series either by adding or subtracting elements, whichever is more expedient. Here are some suggestions to stimulate your thinking: placing objects or food on a table, people filling in a grandstand, turning on lights in a building or on a Christmas tree.

A dissolve sequence can create a sense of growth or accumulation when items are added; it suggests reduction or removal when items are subtracted. The rate at which you dissolve or include the information communicates the rate at which the subtraction or addition occurs.

Density Matching. Much of what you do when editing slide presentations applies here, such as using photographs of similar brightness unless you have a transition slide of an intermediate density. But you may want to exploit an interesting effect that occurs in a dissolve sequence. When you dissolve from a very light slide to a very dark one, the rate you set on the programmer will not seem right because bright slides appear on the screen faster. You can make the rate of the dissolve seem to change just by rearranging the order of your slides.

Fade In/Fade Out. You can create a sense of conclusion for a show,

To end a sequence, try a fade out: projecting a series of slides, each photographed with progressively less exposure.

or for a sequence within a show, if your programmer can gradually fade down one projector lamp without brightening the other. If your programmer does not have a specific control for a fade, it's easy enough to do one. In one tray, put the slide you want to fade down. Activating the dissolve will make this projector's lamp dim gradually. To prevent the other projector's light from illuminating the screen, put an opaque slide in the appropriate tray slot, or, if the projector has a dark shutter, just leave the tray slot empty. In both cases, the screen will gradually go dark. The next slide will start with a fade in, which is also pleasing.

Even without a dissolve control, you can simulate a fade. Take a series of pictures ranging from correctly exposed to grossly underexposed. Your camera must, of course, be on a tripod. Then project the slides in succession. The scene will seem to fade out or in, depending on the order of the slides.

Flashing. Flashing is done by turning one projector lamp quickly on and off. Some programmers have a "flash" control; others require you to create the effect by rapidly tapping a control button before the slide advances. An opaque slide in the other projector prevents this from being an "alternate."

You can use this technique various ways.

• You can make a picture with lights flashing on and off.
• You can use the effect to add emphasis with word slides and graphics.
• You can use it in conjunction with another effect, such as a dissolve, to vary the brightness while the flash occurs.
• You can use this feature effectively to superimpose a flashing image over another slide. If your programmer doesn't provide a way to turn the projectors on simultaneously, you can do so manually. Turn the non-flashing projector's lamp to "on." Now you can flash lightning over a landscape, blink some lights in a building, or flash a key word on and off to

add emphasis. With a programmer that lets you adjust the intensity level of superimposed images or by adjusting the exposure of the slides when you make them, you can make the flashing image brighter than the other one. This really will make people notice your message.

Freeze. A freeze or hold feature lets you stop a fade or dissolve that's in progress and keep it at any intensity level. The third image—the new image that results when two images are blended during the course of a dissolve—is often lovely. Prolong the effect by using a very slow dissolve or by freezing it at some point. Start the dissolve; then, at the midway or other desired point, press the "freeze" button. Leave the freeze on the screen as long as you like. To release it, press the freeze button again. The dissolve will then continue in its original direction. With some programmers, you can use different dissolve rates before and after the freeze.

Hold and Titling. A useful effect is sometimes called titling, but is actually a combination of superimposing and hold—one image is held on the screen while the other changes. You can, for example, take a picture of a sunset, hold it on the screen, and fade up the title of the show. Now, change the title to a slide with your name on it, then to one with the name of your co-producer, all the time leaving the picture of the sunset on the screen.

Home. At the end of your show, you can touch the programming button marked "home," and all the trays will rotate back to their starting positions.

Selective Focus/Rack Focus. Take a series of pictures, focus each one differently, and use them for a simple dissolve sequence. These dynamic effects are widely used in movies, and you can get some ideas for your slide programs by observing the variations good cinematographers and videographers have used.

Do your picture-taking with your camera on a tripod. Then, make a series of slides in which

Direct the audience's attention by changing the point of focus between dissolves.

the focus shifts gradually from a point of interest in the foreground to one in the distance. For example, the first image can be focused on some flowers 2 feet from the camera, leaving the background a blur. (Of course, to limit the area in focus, use a large lens opening or a lens with a focal length longer than 100mm.) The next image, taken from the same vantage point, will be focused on flowers 4 feet away, leaving the foreground flowers a blurred mass of color. The third picture will be focused on flowers 8 feet away, and the final one on a person 12 feet from the camera. In the slide show, with slow dissolves between each picture, this series will suggest that the camera is moving through the garden.

A variation of this technique is to use just two images, one focused on a foreground subject, the other on some object in the background. This is an emphatic way of directing your audience's attention to a point of interest. You'll probably want to experiment with fast and slow dissolve rates to see which works best. You might want to use such subjects as a speaker and the person being spoken to, or a person pointing and the object being pointed at.

Still another way of using your camera's focus control is to take a picture of a completely out-of-focus subject. Then take a picture of

it in focus. Dissolve between the two resulting slides. You can also make a series of three or four slides, gradually progressing from a blur to a sharply defined image. This is a good way to build suspense and interest in what's to come.

Superimpose. The difference between the freeze and superimpose effects is that in a freeze, the projector levels never reach maximum brightness simultaneously. In a superimposition the projector lamps are at full brightness.

A white or light-colored image from one projector will obliterate or burn into a darker image. This gives you the perfect vehicle for word slides. Have a background image on one slide; then superimpose a word slide with white letters on a black background. (Litho titles are best for this.) The result will be your words on the background. Scenics, out-of-focus shots, textures, abstracts, and solid colors can all make attractive backgrounds for titles and word slides. Put together a collection of them. When you are near the end of a roll of film and don't know what to photograph, shoot some abstracts. You'll appreciate having them.

You can do this on a single slide, but there is an advantage in doing it with two projectors. With

superimposition, you can hold the background slide on the screen while fading a succession of word slides in and out. You can also control the rate at which the word slides fade up, using fades or cuts, or a combination, such as fading in and cutting out.

Instead of changing the word slide, you can fade different backgrounds in and out. You can also use the "super" effect to paint a color change onto the screen. Colors combine optically, so you can turn a red image yellow by superimposing green, from the other projector, or change it to magenta by superimposing blue.

Here's another effect you might like to try. Start with a slide that has a white line drawing on a dark-colored background. Then fade in and superimpose, from the other projector, a neon image of the same subject, photographed so they are in register (see Chapter 3).

Time Lapse. You've seen movies of a flower that goes from a bud to a full bloom in a matter of seconds. The individual pictures were taken over a period of hours or days, but are projected without the intervals. This works with slide dissolve shows, too. The tools you need to do time-lapse photography are a camera, a tripod, and lots of patience.

This scene is the result of a dissolve. A shot of a dark skyline was projected simultaneously with a shot of a fireworks display, which had been sandwiched with an orange abstract slide.

Almost any event that proceeds so slowly that you normally can't see the change makes a good subject for time-lapse photography. Nature studies, especially, are well suited: plant growth, cloud and storm formations, sunsets, movement of light over a scene throughout the day, and seasonal changes. Try people-related events, too, such as the construction of a building. Some events require photography over a period of weeks or months. Obviously, you won't want to leave your camera anchored to one spot. Perhaps you can make marks on the sidewalk to indicate where your tripod must go. Your registration won't be exact, but it may be close enough.

Determine how long it will take for the event to be completed, and take your pictures at regular intervals within that period. You might want to photograph a sunset over a period of 30 minutes, shooting one frame every 5 minutes, and then every minute as the sun gets closer to the horizon.

A tripod and cable release are essential. You want the camera to be in exactly the same position for each picture. Without a tripod, you can't be sure the camera location will be precise; without a cable release, you may jolt the camera when pushing the shutter release. For closeups, you need a macro lens or closeup attachment. Time-lapse closeups of flowers blooming or eggs hatching make incredible sequences.

Transformation/Metamorphosis. In a series of steps, you can show one image transforming itself into something else. This artwork effect is really a form of animation. Make small changes on each of a succession of drawings. For example, change a frog into a prince. Draw the first picture on the bottom sheet of a pad of paper, keeping it in a horizontal position and remembering the 2:3 ratio of the film frame. Drop the next sheet of paper on top of the first, and make the second drawing. You'll be able to trace major lines and see where to change other aspects. Make a total of about five pictures, changing each one a small amount. Photograph these on the copystand or similar setup. The pad of paper ensures that the pictures are in registration when you draw them; tape it down to maintain that registration when you take the photographs. Project the sequence by dissolving from one to the other.

Zooms. There are several zoom effects you might like to do. One is to use a series of three or four slides (maybe more) each taken from the same place but with a different focal-length lens. Put the camera on a tripod so it stays in the same position. Only the focal length will change. Alternatively, for each picture, move closer and closer to the subject, using the focusing area in the middle of

© Jack Hollingsworth

The time-lapse sequence of the setting sun in Figures 1, 2, and 3 was the result of patience, a good vantage point, and a tripod.

Drawings by Jeanne Whitney

Depending on the order of Figures 4, 5, and 6, the frog can be changed into a prince or the prince into a frog.

Zooming during a long exposure adds an impression of motion.

small or small to large. Try various dissolve rates. For a really explosive sequence, take two pictures made by zooming the lens and program them at the fastest dissolve rate other than cut.

Other Dissolve Effects. Many transitions between images are enhanced by using a dissolve rather than a straight cut. Consider this one. With your camera on a tripod, take a series of photographs of the same subject, using a different color filter for each exposure. Using a color polarizer, which changes color when you rotate it, works easily. The subsequent color progression on the screen is fascinating.

A slide progression that goes from realistic to unreal, or vice versa, will also hold your audience's attention. You can make duplicate slides using infrared film or Vericolor slide film, distortion, and other special effects (see Chapter 3). If you have a darkroom, the knowledge, and the willingness, make posterizations, tone lines, or texturized images. Build up one color at a time into full color. There are more ideas in my book, *How to Create and Use High Contrast Images*, John Warren's *Experimental Photography* (Amphoto, 1984), and Kodak's *Creative Darkroom Techniques*. Some effects are spectacular when built into a sequence.

A color-polarizing filter was used to make the progression of colors in these very pleasing slides.

© Jack Hollingsworth

A slide progression from unrealistic to realistic is compelling.

your viewfinder to consistently center the subject.

Another method is to use a zoom lens and actually zoom it during the exposure. Repeat this several times, moving closer for each picture, making the subject slightly larger in the frame and centering it from picture to picture.

The results of zooming the lens are a bit unpredictable, so take several pictures before changing your position. Mount the camera on a tripod. Set the shutter speed for 1/2 or 1 second, and set the aperture accordingly. (You'll need a slow film for this long exposure.)

Choose a subject that has a lot of variation in color all over. When you zoom the lens, these colors become streaks. With no variation in color or brightness, you get a fuzzy blur instead of an explosion of streaks. Just before you press the shutter release, start moving the zoom control and continue the movement after the shutter clicks shut. This prevents a secondary image and produces a sharp central image with lines of color radiating from it. You can zoom from telephoto to wide angle or the reverse.

To edit and program a zoom sequence, progress from large to

Programming: A Caveat

The capabilities of programmers, and even of simple dissolve units, are mind boggling. When you first get your hands on a programmer, you will want to incorporate all of the flashing, fading, and twinkling effects into one show. But you won't astound your audience if you do. They may be irritated or even bored if the screen is always aglow with razzle-dazzle.

My advice is to sit down with the instruction manual and try out all the effects and combinations you can imagine. Get to know what the equipment is capable of. Make notes. It's a great help when planning a show if you can refer to an idea file. Use a looseleaf notebook to keep your ideas as well as clippings from photographic magazines that discuss special effects slides and programming.

Recording Sync Cues

Only certain types of tape recorders allow you to put your sound track on tape and add program cues that can reliably run your show. You can use a reel-to-reel stereo recorder if it gives you independent access to each track.

Another option is an AV recorder, a cassette recorder specially made for this purpose. It has a separate track to record cue information through an input dedicated to this specific task. The recorder also lets you to listen to the sound track while recording cues.

Most AV recorders are monaural, but some stereo models are available. I don't advise putting the sound track and cues on a reel-to-reel recorder and then transfering them onto a stereocassette. If you do, there is likely to be cross talk: the sound on one track being picked up by the other playback head. AV recorders separate the tracks to prevent crosstalk. Although not originally designed as an AV recorder, the Fostex X-15 Multitracker can be used as such. Put your stereo sound track on two of the tracks, use another one for cuings, and leave one blank to separate the sound tracks from the cue track.

Using new tape of the highest quality is important here. You want to minimize the chances of the programmer responding to sound from an incompletely erased tape and of a momentary

loss of sound that can cause missed cues. And because the audio and control tracks are narrow, even slight variations in tape width can result in crosstalk.

On your script, indicate dissolve times and other effects. Then, as you listen to the sound track, push the appropriate programming buttons and create all the effects you want. It's amazing how the recording system responds to every clever effect you feed it. Follow the manufacturer's instructions regarding setting the correct volume level. Play back the show by connecting the audio cable from the sync output of the recorder to the "tape in" or "sync in" socket of the programmer.

Remember, you must record the tape in *only one direction*. If you turn the tape over and record, that sound will get confused with the cue pulses.

Correcting errors here is similar to correcting errors in a simple slide/tape show. Fix them as they happen, or start from the beginning and correct each error as you come to it. You'll have to switch the cables from the playback position to the one for recording cues.

All-in-one Units. With all those cables and separate pieces of equipment, it's good that one piece of equipment lets you program the show and record the cues and the sound track. Several companies make tape recorders with built-in programmers. At present most of these machines don't provide the flexibility of a separate programmer and tape recorder; those that do, cost more than $1,000.

For example, Telex makes a Caramate slide projector that has a built-in tape recorder and a dissolve control with adjustable rates. It connects to other Kodak or Telex projectors using a dissolve slave unit. The Rolleivision 35 Twin has two projection lenses and a built-in dissolver, but no sound. It sells for less than $1,000. Features and prices keep changing.

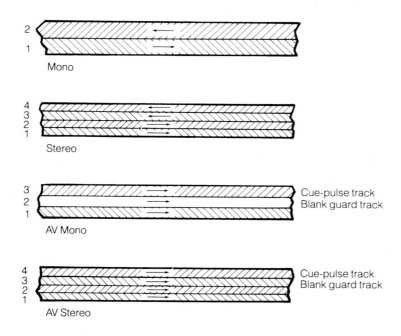

Cassette tape-recording formats.

Wild Sync Method. You have to be inventive when making slide shows. What happens when you don't have a tape recorder that allows you to record the sound track and cue track independently? If you have access to two recorders of any kind, you can use what I call the wild sync method.

Put the sound track on one recorder and the sync programming cues on the other. *If* you play back the tapes on the machines they were recorded on, *if* you plug both recorders into a common electrical outlet, and *if* you start them at the same instant, the chances are that slide changes and sound will remain in sync. Give yourself some latitude. Don't attempt to make a sound fall at the precise instant a certain visual comes on the screen; one of the tape recorders may not maintain its speed exactly as it was when you programmed the show. But if your demands are not too stringent, the two-recorder method will work.

Real Time/Leisure Time. With most equipment, you press the cue buttons in "real time"—at the actual time you want the slide changes or effect to take place. For example, if you want a slide to stay on the screen for 10 seconds, press the cue button for the first slide, wait 10 seconds, and press it again for the next slide. When the slide changes are slow, this is not too difficult.

But what if you want to change slides rapidly, vary the length of the dissolve time, or do a series of tricky effects? You have to concentrate, be nimble, and be willing to go back and correct the inevitable mistakes. It's not hard to do, but it's nice to know there is an easier way. This is called leisure-time programming because you do it at your leisure. You work with a computer-controlled programmer, such as the Memorizer from Tiffen, or your own personal computer interfaced with certain programmers, notably the Gemini from Pacific Micro Systems and Entre 2004 from Tim Simon, Inc. Then you simply instruct the computer as to what effect you want and how long the slide should stay on the screen. If you change your mind, merely enter changes with the computer keyboard. Transfer it to the controlling audiotape only when it's perfect.

Photography for Dissolve Presentations

Photography for a two-projector dissolve show has to be approached differently than for a one-projector show. There are similarities, but paying attention to the differences is what will make your shows more successful.

Picture Quantities. One of the most obvious requirements is that you use twice as many pictures when you have twice as many projectors. Sometimes you'll be able to use pictures you took at random, as the urge struck you, but it's better to plan your picture-taking. Because 80-slide trays are more reliable than those with a larger capacity, base your production on no more than 160 slides.

When you are taking pictures, focus on everything that looks interesting. Many pictures won't fit into the show, but you want to make sure you have enough that do—and do it well. Never take just one or two pictures; take five or six or more. You must be able to select pictures taken from a variety of angles and distances. This can make the difference between a great show and a mediocre one.

Sequences. Thinking in terms of continuity and photographing in sequences are the essence of a show using several projectors. When the slides are connected by dissolves or briefer cuts, images are linked on the screen. The screen presents continuous images. When they're related, they give you the chance to describe the subject visually and to hold the audience's attention. Remember to explore different camera angles and distances, moving your camera around the subject. One picture should not tell the whole story; let many pictures each tell a small part of it. Also, anticipate your audience's interest by asking yourself, "What shots would I like to see next?"

Image Shape. For all slide presentations, horizontal slides are more pleasing to look at than verticals. Some subjects, though, such as trees or skyscrapers, might look better on vertical slides. If you use them, orient the entire program this way. You might be able to get away with switching back and forth between horizontal and vertical in a one-projector show, but with two projectors, you'll get a distracting, cross-shaped image at the midpoint in the dissolve.

If you *must* switch orientations, you can disguise the change. If the background of one (or both) of the images is black, the audience will see only the image, not the format of the slide, and won't notice the change. When you don't have a black background, you may be able to use tape, a specially shaped slide mount, or a litho mask to put both images in square shapes of the same size. When none of these alternatives is possible, use a cut rather than a dissolve when changing slides. This will prevent the overlapping, cross-shaped image. *Special Masks.* You may want to place the images within specially shaped slide mounts or masks, as described on page 57. You have to plan your composition so you can size the image correctly. If you don't place it in the right portion of the frame, you can cut it out and tape it to the mask. Masks that have crisp, hard lines are called hard-edge masks. But you can also buy soft-edge masks, with feathered edges that make the images blend most attractively. These forgive any mistakes in aligning the images and projectors.

Masking opens the way to many creative effects. For example, use a series of images masked in quadrant masks. Begin with the first image in the lower left. Dissolve to an image in the lower right, then to the upper right, then the upper left (or in any other pattern). You can also use companion positive and negative masks in each projector. Try this method.

1. Sandwich several slides in masks having a clear circle within an opaque area, and put these in projector A.

2. In projector B, put one slide sandwiched with a mask having an opaque circle within a clear area.

3. Keep the image from projector B on the screen while you project the succession of slides from projector A. The result will be a series of changing images within a constant background.

The Third Image. The image that emerges when two slides blend on the screen is one of the outstanding reasons for making a dissolve presentation. Always be aware of it, and plan for it when you take and edit your photographs.

Many beautiful effects occur when similarly sized and shaped images are placed in the same position in the frame from one slide to the next: a round flower dissolving to a round sun, dissolving to a round balloon; a tall pillar replacing a tall tree; the curved edge of a wall becoming the curving shoreline of a lake. Place the image in the frame so major lines and shapes coincide. Replacing one object with another is intriguing during the transition stage.

The composition of a particular photograph may be pleasing in a one-projector presentation, but when it becomes part of a dissolve sequence, you must look at the effect the combined images have on each other. This can be beautiful, ugly, funny, or, worst of all, confusing. I saw a presentation in which one face dissolved into another, with just enough displacement so a strange creature with four eyes appeared during the transition. I don't think this was the intended effect. It would have been better if the faces had been placed in different parts of the frame, or if a cut had been used instead of a dissolve.

Sometimes you can't tell whether a dissolve effect will be pleasing until you actually try it. Practice making dissolves with a group of slides. Planning cards can help. You can sketch the position of the subject in the frame and make a note that it's important to position the subject exactly as drawn. Become aware of dissolves in slide shows, movies, and television. And, as you become familiar with the various possibilities, you'll be better able to plan your photography.

Light and Dark Images. Something else interesting happens during a dissolve: brighter parts of the picture appear on the screen faster and fade more slowly than darker areas. Because these lighter areas attract the viewers' attention first, you have a way to control the viewers' eye. You can keep their focus on one area for a succession of images, move it smoothly around the screen, or make it jump abruptly from one side of the screen to the other.

Because areas of light and dark come onto the screen at different rates, they sometimes add a sense of motion. In a sunrise scene, the glow of the sun is seen first because it is brightest. Gradually rosy clouds come into view, and then details of the houses, trees, and grass.

With two slides, elements from one can be superimposed on large dark or black areas in the other. For example, if one slide has a dark background, the dissolve temporarily places its foreground subject in a new setting. If both slides have bright areas against dark backgrounds, the bright elements from both slides are visible during the dissolve and can create a new third image. The third or altered image happens with lighter backgrounds, too. The texture of tree bark can transform the appearance of a house; a seascape can submerge a person when they blend.

You'll be able to figure out in your mind what some of the effects of superimposing will be; with others, you'll need to try them out on the screen. For example, you cannot see the effect of holding two slides over each other on the light box because each slide subtracts light. When two projectors beam at the screen at the same time, you are adding light. The effect of two projected images is similar to double-exposing in the camera.

Color, like texture and images, can alter the picture during the dissolve. Suppose you start with a picture that's predominantly blue and dissolve to one that's predominantly red. Instead of switching abruptly from the first to the second color, as you would in a one-projector show, the dissolve creates a pleasing range of magenta hues. Of course, other color modifications will result with the use of other hues.

Film Stocks. Different film emulsions are biased toward different colors. Ektachrome, for instance, emphasizes blues whereas Agfachrome produces warmer yellows. And faster-speed films, such as those with ISO 400 or 1000, generally show more grain than slower films. Most likely, you will want to change film stocks according to the existing illumination. If you keep all the pictures taken with one type of film together in a related sequence, the viewers will not notice the changes. When you mix film types, especially during dissolves, the differences call attention to themselves. Finally, all films fade, but some fade faster than others. It's best to use the same type of film throughout the entire show.

If several people will be taking

pictures for a show, decide what film you'd like them all to use. Then be sure everyone knows.

Visual Harmony. When you plan and take pictures for a two-projector slide show, keep in mind that you want the visuals to harmonize in terms of lighting, color, and sharpness, among other features. Although you may want a jarring element on occasion, you have to know how to make successive images harmonious in order to break the rules. You don't want to ruin the mood it may have taken 40 slides to establish.

Editing and Arranging Trays

The next step in putting together a two-projector slide show is to edit the slides and place them in trays. First, arrange all your slides on a lightbox. This is the best way to make putting the slides into trays go quickly and flawlessly. It's almost imperative that you make a layout/storyboard sheet with sketches of each slide. You can do this by following several steps:
1. Number the slides in the order they are to be projected.
2. Arrange them in vertical rows; start with number 1 at the top.
3. Make your layout sheet reflect this. If your show is programmed so successive slides always come from alternate projectors, your arrangement will follow a zigzag pattern. Additionally, you may find it helpful to number the slides with different color ink for each tray.
4. Make a dot with a pen on the lower left corner of the slide mount.
5. Then load the slides into trays, *one tray at a time*.
6. Put the odd-numbered slides into tray A, and label the tray; then put the remaining slides into tray B, and label it. (Review Chapter 1 about slide orientation.)
 Deviate from this layout if your show has some "hold" slides for a titling sequence or other effect.
1. Cut long strips of masking tape and stick them on your illumina-

tor, about 5 inches apart, and line up your slides as shown below right.
2. Mix odd- and even-numbered slides in both projectors if the holds make this necessary.
3. Number the slides consecutively, in the order of projection. You can also number them as A1, A2, A3 . . . B1, B2 and so on.
4. Note that the trays probably will not have the same number of slides. It's important that you verify the layout against your storyboard sheet.
5. Then *load one tray first and then the other*. It's the best way to prevent putting slides into the wrong trays.
6. Always put the first slide in tray A.
7. Use only 80-slide trays to prevent any hitches.

Projection and Presentation

Two projectors, a dissolve control, and a tape recorder all take up space. You need to plan the placement of the equipment so it is easily accessible—and so the show looks great. How do you arrange two projectors? You can, of course, place them side by side. To make the images overlap exactly, you have to angle the projectors slightly. This results in a bit of keystoning. The farther the projectors are from the screen, though, the less the keystoning is.

Projector Racks. Projection stands, also called "stackers" or "stacking stands," are ideal for multiprojector slide shows. They allow you to piggyback one projector on top of the other, minimizing the keystone effect. They have other advantages, also. The stands clamp the projectors in place so their position doesn't change after you've aligned them. Many are constructed so that you can adjust the platform rather than the projector feet to level, elevate, or tilt the projectors. You can buy these stands (see the list of suppliers at the end of the book) or build them yourself using Kodak plans.

For a two-projector dissolve slide show, lay the slides out on an illuminator as shown above.

If a show has "hold" slides for titling or other effects, arrange the slides on the illuminator as shown above.

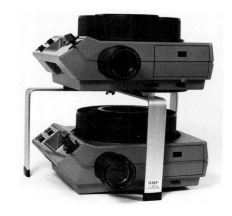

These RMF projector racks minimize the keystone effect.

An official alignment slide from the Association for Multi-Image.

Photograph this grid to make your own alignment slide.

Alignment Slides. A pair of slides with center and corner reference marks is essential for aligning the two projectors. The slide on the left is an official one the Association for Multi-Image (AMI) uses (to order these slides or similar sets, refer to the appendix). To make your own alignment slides, photograph the grid below on slide film, taking care to align all four sides exactly parallel to the edges of the viewfinder frame. Put a bubble level on your camera to indicate when the camera and copyboard are level. Mount the finished slides in pin-registered slide mounts. These mounts, made by Wess and Gepe, have tiny protrusions that fit into the film perforations, center the film in the mount, and hold it in place.

To use the alignment slides, put one in the last slot of each slide tray, after your final blank slide. Use the slide-advance mechanism of the projector to lower the alignment slide. Don't push the slide into the gate with your hand; if you do, it will position itself slightly differently. Center and focus one projector on the screen. Then turn on the second projector and adjust it so the center and corner markings coincide.

Tray Bands. Kodak makes paper tray bands that can help while you are projecting the show. Their big white numbers on a black background let you tell at a glance which slide is being projected.

There are two types. For a show in which odd- and even-numbered slides are in different trays, the bands are marked with corresponding odd or even numbers. For other shows, including single-projector shows, use bands numbered consecutively from 1 to 80.

Setting Up. Here are some final words on setting up the show.

- Use the same programmer and tape recorder that you used to program the show.
- Plug all the equipment into the same electrical outlet, making sure it can handle the required load.
- Secure the cords so people don't trip over them.
- Verify that slide tray A is on the projector connected to the cable marked projector A. Do the same for slide tray B.
- Turn the projectors on "fan" and advance each tray until the first slide drops into the gate. When the first dissolve cue is activated, the programmer brings up the first slide.
- Do a run-through after everything is set up, before the audience enters, to avoid any surprises. Then return the slides to their starting positions.

Multiple Images

Once you understand the programming philosophy and basic techniques, you can move from a simple show to one requiring more equipment. You are now entering the eye boggling world of multi-image. You'll learn how to truly astound your audiences. No longer will you confine your images to one screen; you'll increase their number to cover two or three screens. You'll also find out how you can do this with two, three, or all the projectors you can beg, borrow, or buy. You've seen these advanced, spectacular techniques in visitors' centers, at annual meetings, and at sales presentations. Some of these shows require more than 30 projectors; others can be done with two or three projectors, within the budgets of camera clubs and even individual photographers. If you do photographic work at your job, a six-projector show is a reasonable goal.

What is multi-image, anyway? The terminology is confusing.

Makers of multi-image shows, as well as manufacturers of equipment needed for them, can't seem to arrive at a single definition. the field is still too new. Some people think of a multi-image show simply as a slide production that uses two or more slide projectors on one or more screen areas. Others, though, don't consider a show multi-image unless three projectors are involved. Whatever the definition, *multi-image* certainly means *multiple* images.

(*Multimedia*, though, means something else. Although you may hear the terms used interchangeably, a multimedia show incorporates slides, sound, and one or more other media—such as a movie clip, an electronic flash, puppets, a spotlight on a dancer, laser beams, or just about any electronic or mechanical object.)

Why Use Multiple Images?

There are some good reasons for the growing popularity of multi-image shows. When photographers were first introduced to the astounding capabilities of state-of-the-art programming equipment, they found it hard to resist filling the screen with spectacular effects. As a result, many multi-image shows put razzle-dazzle first and communication second. But even "ooh and ahh" shows are worthwhile. They entertain, they excite, and they set a positive, receptive mood. Fast-paced spectacles, dozens of images on a screen the width of a room, images that pulse—all grab people's attention. Conversely, a single-projector slide show is relatively static; a motion picture, with its limited, rectangular format, is not as dazzling. The more projectors you have at your disposal, the more images you can show at one time and the faster these images can change. You can superimpose an explanatory word over a picture, or project a large border to act as a decorative frame for other images.

 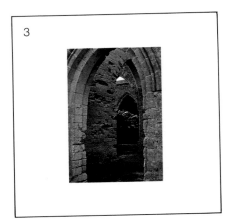

Multiple images can show different views of one subject.

Multiple images can show a series of slides chronologically.

You can also have a mosaic of dozens of pictures, and then replace them, in a pattern, by still more images. These techniques capture an audience's attention, too: they inform and emphasize.

But the best reason for doing multi-image shows is that they are fun to do.

Benefits. Multi-image shows, however, need not be spectacular to be effective; other features, such as their complexity, make them invaluable. The human brain can process far more information than is usually included in a one-projector show. A multi-image presentation, with its abundance of images and sounds, makes maximum use of the viewers' ability to receive and assimilate information.

Another advantage of the multi-image show is that it can present images side by side, thereby making them more meaningful. Suppose, for example, you want to compare or contrast certain objects or facts, such as architectural styles in different countries or current versus 10-year-old fashion trends. With two or three screens (or screen areas), you can hold a series of images on the screen. This is much more helpful for your audience: comparisons made during single-projector shows are limited by people's memories.

There are other benefits as well. The audience sees multiple views that can deliver the information more comprehensively. Each screen can show the subject from a different angle: high, low, front, back, and so forth. The screens can also show it from different distances, such as far away in its environment or closeup with emphasis on details.

Similarly, using several screens allows viewers to study and analyze a sequence of events, such as several chronological stages of an activity. To illustrate, instead of showing slides one after the other of preparing a Thanksgiving feast, you could show the stuffing, roasting, and carving of the turkey on the screen at the same time. The multiple-screen approach also works well when you want to show aspects of an event that happen simultaneously. You might show, for example, participants and spectators at a ball game.

Disadvantages. Multi-image shows take considerable time and dedication to put together. If you do decide to create one, be sure that it is the best medium to convey your message. It's easy to be seduced into using a superabundance of images and spectacular effects, when a simpler show or even a movie might be more appropriate.

Building Images. People often think of a multi-image show as consisting entirely of rapidly changing images. Another very effective way to use the medium, however, is to hold one image on the screen while changing the others. The stationary visual sustains interest and becomes a reference point, while related images show changes in or details of the main picture. You can also do a "build": on one part of the screen show the first step in a sequence, hold it while the next step is projected nearby, and then hold both pictures while still another step is shown.

Panoramic View. One of the most impressive uses of multi-screen projection is the panoramic view. The width of an ordinary slide (1 1/2 times its height) is not especially imposing when projected. But when two projectors are aligned for a panorama, the width of the projected image is three times the height. It is possible to expand the image even wider—around the entire room if you have enough projectors and screens. (See page 139 to learn how to make panoramas.)

Animation. The more projectors you use, the more effects you can create. For example, you can produce the illusion of motion by rapidly showing a series of slightly dif-

ferent images. We did this in a limited way in Chapter 9, by alternating between two slides. If you add more slides, you can see more complex motion, such as lights flashing on a marquee or a couple whirling around a ballroom. Because animation necessitates a series of small subject movements, and because of the amount of time it takes a projector to change slides, slides in three or more projectors are needed to make the animation effect convincing.

Equipment

Multi-image shows do get expensive. Undeniably, when you use more than two projectors, the dol-

lars add up. But you can create an exciting multi-image look with only two projectors, a simple programmer, and a tape recorder. When you understand the basics, equipment—or lack of it—doesn't have to be a limitation. If you become good enough, you may even be able to earn money producing shows for local organizations and businesses.

Required Equipment. The major pieces of equipment you need are screens, slide projectors, a programmer, a tape recorder, and a sturdy table to hold everything. For three or more projectors, you need stackers. The projectors

Some of the multiple images in "The New York Experience."

© Rusty Russell

ACQUIRING EQUIPMENT

- Try to persuade your employer to fund some of your purchases if you become the one-person photographic department. Many such departments have been created because an employee volunteered to take pictures needed for publicity and public relations purposes.
- Borrow equipment. You probably have access to one or two slide projectors and can round up others for occasional use if you invite their owners to the presentations.
- Buy equipment secondhand. People sell it privately or through commercial sources. Go to garage sales and flea markets. Check the classified ads in photography magazines, particularly *Shutterbug*.
- Join a photography club. If it doesn't already have an audio-visual section, perhaps you can become instrumental in developing one that will embark on group productions. The club I belong to has several special-interest groups, one of which is interested in slide productions.
- Avoid the temptation to buy the equipment needed for an elaborate show or to exceed your

budget, both in terms of money and the time it takes to do such a show. Don't try 30-projector extravaganzas until you are comfortable with modest productions. You can produce breathtaking shows with 6 or 9 projectors—or even 2.

Shopping for the equipment will take a little leg work, but it's pleasant research. Talk to the producers of multi-image shows about the programmers they've used. You should also consult the latest *Audio-Visual Equipment Director*, published by the International Communications Industries Association. It contains illustrated descriptions of most of the equipment related to slide shows and gives essential specifications so you can narrow your choices. You will also find sources in the annual buying guide put out by the magazine *Audio Visual Communications*, which is published in October. Write to manufacturers for literature, and then go shopping. For equipment not available in most photo stores, such as tone-control programmers, consult your telephone directory for dealers of secondhand audiovisual equipment.

must have lenses with similar focal lengths, and preferably not zoom lenses. The type of screen depends on whether your images will be shown side by side or all on one screen area; a matte-white wall can be quite satisfactory for a wide-screen presentation. The audio should be of the highest caliber to match the superb look of the images, so you may want to use reel-to-reel stereo and good-quality speakers.

Screens and Projectors. A multi-image presentation can have just one screen, or an equal number of screens and projectors. Large numbers of screens are usually limited to such places as world fairs and corporate and municipal visitors' centers. Although these productions are exciting, the logistics and economics of doing them make them impossible to consider. Most multi-image screen arrangements are more modest. Using either a very wide screen (with a width three times its height) or a conventional one is common.

If you choose to use a wide screen with two images projected side by side, you can, but four projectors are better. Two projectors per screen area allow you to change slides smoothly, using dissolves and cuts (review the techniques in Chapter 9). Two projectors per screen area seems to be enough; however, slide makers use three or four, and sometimes more, because projectors change slides very slowly. A delay of 1 to 1 1/2 seconds may not seem very long, but for a fast-paced show in which you want to produce the illusion of movement or keep up with the beat of the music, you need to change slides several times each second. This can't be done with two projectors. But it can be done with three, though using four is even better yet.

Programmers. The programmer is the key to the whole show. Like two-projector programmers, multi-image programmers do

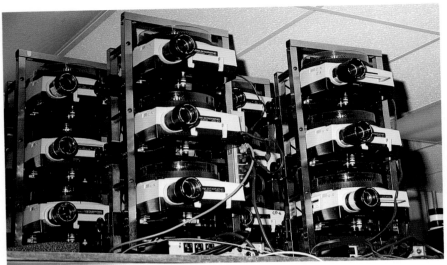

Projector racks are a must for multi-image shows.

A. Two projectors, manual control

B. Two projectors, dissolve control

C. Three projectors, manual control

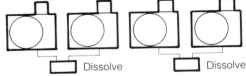

D. Four projectors, manual control of two, one dissolve control

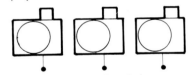

E. Four projectors, two dissolve controls

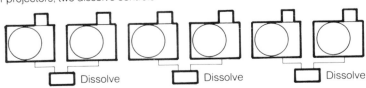

F. Six projectors, three dissolve controls

Multiple-projector setups.

nothing more than dim projector lamps and advance slides. But, of course, they do it in a very sophisticated way: a microcomputer usually controls the action and stores cues in its memory. Some programmers control the projectors directly; that is, you plug the projector cords into the programmer. With others, you connect the programmer to a series of dissolve units, letting each dissolver control a pair of projectors. Basic programmers may control 3, 6, or even 10 projectors, but the dazzlers can control 50 or more. Some programmers remember few cues, while others can remember 30,000.

Manually Controlled Shows

You can also produce a multi-image look—without any elaborate equipment—by controlling the projectors manually. Set up two or three projectors. Do all the slide advances yourself with the remote-control switches, or use a dissolve unit you control manually. You can use four projectors, connecting two of them to a dissolve unit, or six projectors, connecting three of them to a dissolve unit. Here are some ways to set up these systems.

Plan a simple show. Don't try, for example, to have rapid slide changes from one projector to an-

This improvised device, made by an ingenious person at Kodak, holds and actuates two remote controls.

other. You'll need a detailed storyboard or cue sheet in front of you, and you'll have to give your complete attention to what you are doing. You may also want to have an assistant button-presser—be sure to rehearse together. With practice and a realistic plan, you can tackle multiple projectors this way. And you will soon understand why mechanical and electronic systems came into being.

Two Projectors/Two Screens. Two projectors can be more versatile than you may have thought. They can give you two side by side images, an ultrawide-screen look, or a three-screen look. Here's how to go about this approach.
1. Focus your two projectors on one very large screen or on two side by side screens. If you use two screens, be sure they are the same type and are equally white and bright. A clean white wall is better than two dissimilar screens.
2. Use lenses of the same focal length; then the two images will be the same size, separated by only an inch or so.
3. Put the remote controls close to each other and tape them to the table so you can operate them easily.
4. Put a group of slides in each projector and advance the projectors simultaneously for a widescreen look. Both images can be pictures, or one slide can be words and the other a related picture. You can use complementary pictures, too, such as an overall view of a building and a closeup detail.
5. Assemble, if you wish, a device to hold the remote controls next to each other to simplify pushing the advance buttons. Include a handle that will actuate both forward buttons at the same time.

Here are some variations. Let one image area go dark while the other changes; put an opaque slide in the corresponding tray. If your projector has a dark shutter, just leave that tray slot empty. You

may also prefer to change the slides in a planned pattern rather than at the same time. With two images on the screen, advance the right projector, then the left, then the right, and then both at the same time. Try advancing the right projector twice, the left three times. Holding an image on one side of the screen while changing the other is an excellent technique for showing words and descriptive pictures, making comparisons, or displaying several features of an object.

Side by Side with Dissolve Control. Place the two image areas next to each other and see what effects you can make with a dissolve control. Put the projectors in the fan position and change the slides with a dissolver. First, one screen area will brighten and then the other. This is often referred to, derogatorily, as a "tennis-match effect," but you may want to use it occasionally. It becomes annoying when used too frequently.

Try producing different effects by turning the projector lamps on rather than putting them on the fan. Now, two pictures will be on the screen. First one then the other will change, with the brief, dark interval characteristic of projectors not connected to a dissolve. Put one projector on "lamp" and the other on "fan." The projector on lamp will change slides with the momentary dark interval. The projector on "fan" will fade off, stay dark while the slide is shown from the other projector, and then fade on. While this projector is on, two images will be on the screen; when off, just one. (I'm not particularly fond of the effect, but you may consider it appealing and may find an application for it.)

You can multiply the number of images on the screen by using masks judiciously. If you put slide fragments into multiple-opening masks, you can have as many images as you want on the screen.

Two-screen Overlap. Take two side by side projectors and move them so their images overlap in the middle. As you can see here, 1/3 of the screen is covered by the left projector, 1/3 by the right, and the middle 1/3 is an overlapped area showing half of each slide. Next, sandwich a litho mask over the outer halves of the slides in each projector. Work with the overlapped screen area, as you would in any two-projector dissolve presentation.

You can vary the image area several ways.
- Mask the outer halves of the slides when you want to put the action in the middle of the screen.
- Mask off the inner half of either projector's image to achieve a full image from one projector and a half image from the other projector.
- Add automation, if you wish, to the above two-screen techniques. Many two-projector pro-

grammers let you accomplish these screen effects without having to push the buttons during the presentation. If you want continuous images from both projectors, put the projector lamps on; if they are on "fan," the images alternate.

Three, Four, and Six Projectors. Adding projectors increases the number of screen areas you can use and the rapidity with which you can change slides on one

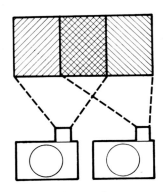

Two-screen overlap configuration.

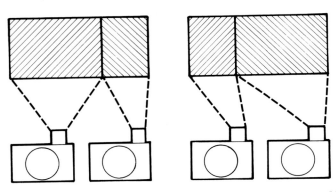

Masking the inner half of either projected image results in a half image from one projector and the whole image from the other.

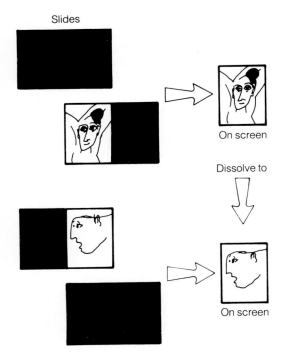

Masking the outside portion of the slides puts the image in the center of the screen.

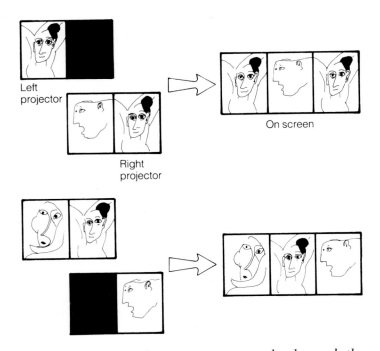

Split images, masking, and two projectors create dissolves and other effects in the overlapped-image area.

screen. With three projectors, you might want to use three screen areas. Keeping an image on at least one of the screens while you change the others will help avoid a choppy rhythm.

Again, you have some alternatives from which to choose. For a versatile screen configuration, try a two-screen butt, center-overlap format. Project two images side by side and let a third overlap them in the middle. You can project another image onto blocked off areas of the screen if you use litho masks with your slides. You now have seven screen areas on which to put your pictures and words. This is one of the most useful of all screen/projector configurations, and becomes even more so when you add more projectors. This is why most multi-image shows use projectors in multiples of three. Six projectors are excellent: they give you the overlapped area and allow the slides to dissolve.

To use vertical slides, place several projectors so their images are next to each other. The screen presents a wide image, and the verticals are pleasing to look at.

You can manage three projector controls by yourself or four projectors with one or two dissolve-controlled pairs. Arrange the equipment as shown in the configuration below, using the dissolve-controlled pair for the center area. All four projectors will be available for animation. You can also use two

The two-screen butt, center-overlap format is versatile.

dissolvers, assigning one pair of projectors to the center area and the other to the side by side areas. If you arrange the projectors as shown below but use a dissolve-controlled pair in place of the individual projectors, four projectors will give images in the center 1/3 of the screen.

Programmed Shows

When you want fast slide changes and special effects, leisure-time programming will become important.

As mentioned earlier, this feature is starting to become available in equipment for small shows. But it's a critical feature when you have more than three projectors. Suppose your sequence has a series of dissolves and a superimposed flashing effect. If these are to take place in rapid sequence, you must quickly put your fingers on the correct button at the exact time. That is, you must do this precisely if you are working in real time. In leisure-time programming you can work as slowly as necessary to assemble all the sequence cues. Set the programmer for the amount of time between the cues and how long the effect should last, so you don't have to be concerned about hitting the cue button.

A programmed show gives you speed and accuracy that is impossible with a show presented manually. And although the effects look complicated on the screen, programming them is getting simpler. You can learn how to do this from both the instruction manual and the dealer. Many manufacturers offer courses in multi-image production, and taking one will help you perfect your technique faster.

Photography for Multi-image Presentations

Multi-image photography has different requirements from any other kind of photography. First, it shouldn't be a repository for mediocre slides. It's too easy to think that with so many slides on the

screen for such a short time you can slip in some weak ones. A slide with even slightly poor exposure or focus can stand out and destroy a sequence.

When you plan your show, you'll make use of the extra dimension multi-image can bring to the screen: the ability to present the subject from many viewpoints and angles. As a result, you need to take many more photographs than you would for a one-projector show. Multi-image allows you to shoot a wide variety of pictures.

Use simple slides. Each one must make its point quickly. Whether a slide is a long shot or a closeup, the viewers may have only a fraction of a second to comprehend its message. Simple backgrounds, sometimes plain black; lighting that reveals details, showing only one item of importance; compositional lines that direct the viewers' attention—all help make sure viewers see the important subject immediately.

With multiple images, you may want them to be equally important, or you may want one to dominate. The largest area is usually most important, but if another area is lighter or has more intense color, it will capture attention.

You will frequently want to use identical slides several times during the show. You may even want to use a row of identical slides on the screen. Taking many identical pictures is certainly not the norm, but it can be considered a "must" in multi-image work. Unless you intend to duplicate the entire show, you should take many originals rather than make duplicate slides. Duplicates often look quite different from originals when screened together.

The hallmark of multi-image photography is sequences. The photos do not exist as single images; they are part of a group of images on the screen and part of a series of images. Time and space, simultaneous and sequential, are the challenge of such photography.

STORYBOARDING

Storyboarding Special Effects. The more projectors and screen areas you have available, the more dazzling the effects on the screen.

Animation. Simple animation can become more interesting as you add more projectors in a screen area. You can make a flag wave realistically, a ball spin on its axis, concentric circles radiate from a center, or lights chase around a border. Put each projector on "hold"; then program the lamps to cut on and off sequentially: ABC, ABC, ABC. . . . You can repeat the effect over and over quite quickly because you don't have to wait for the projectors to advance the slide trays. This programmed, repeated cycle is a "loop."

Another type of animation calls for the slides to advance so the subject's position continuously

As shown above, the more projectors used, the more rapid the animation effects can be.

The storyboard illustrating how to animate the image of a bird flying across a screen.

The storyboard showing how to create smooth animation.

changes. The more projectors aimed at a screen area, the faster the action can be. You don't have to change slides at the rate images change in a motion picture (although lip sync actually has been achieved with slides). The beauty of slide animation is its unique, somewhat choppy look.

With two projectors directed at a screen area, you must hold one image on the screen for a full second before the next slide is ready. With three projectors, that wait time is reduced to ½ second per image. You can make a bird fly across the screen quickly with the three-projector overlap configuration. Use one projector for each screen area. Put a picture of a bird in the left half of each slide. With only one projector available for the outer ends of the screen, the only way to get the bird over to the far right is to register the slides precisely.

If we use this same screen configuration but have six projectors, as seen here, we can move the bird in smaller increments and fly it completely across the screen. With this arrangement, we can do almost anything we want; it's extremely flexible. The usual programming procedure is to move from the left projector, to the center, and then to the right.

Fragmentation. Breaking the screen area into a mosaic of many small areas lets you add or remove pictures in interesting patterns of movement. Make a number of quadrant masks; you can orient them in four different ways over your slides, such as these. This can make it seem that you are using many more projectors than you actually are.

Add the images progressively from one side of the screen to the other, add them randomly, or design a pattern dependent upon the number of projectors and the screens they're covering. When the screen is full of images, change them. You may want to have some images cover areas larger than others.

You can use a gridlike litho

A quadrant mask can be oriented in any of four ways, which makes it useful.

A gridlike mask.

A gridlike mask can be sandwiched with four slide fragments, as in the shot on the left, or with one whole slide, as in the shot on the right.

Semicircular and circular masks can be used in positive and negative form to project images within images when used with an overlap screen format.

mask that adds black borders around the images. A cagey maneuver is to use small pieces of a slide in each section of the grid. Later in the show, sandwich a grid mask over a complete slide. The audience, now accustomed to seeing many different pictures, will also accept this as a multi-image slide.

Other Masking Effects. Here are some multi-screen ideas to spur

your imagination. Sandwich semicircular masks, so the slides appear on the left and right screens. Next, sandwich a circular mask with the overlapping slide. When you project the three slides together, the result will be an image projected within an image.

Don't restrict yourself to rectangles and circles. Mask the screen areas, like those shown here, or use any fancy shapes you

Masks can break up the screen into small areas. Pictures can then be progressively added or subtracted in interesting patterns of movement.

like. When showing an image in an unusual mask, do it several times during the show. This helps the audience learn to look at it and understand it.

Wipes. Wiping appears to remove the images, one after another, from the screen areas. You can do this from left to right, right to left, top to bottom, bottom to top, middle to sides, and sides to middle. Wiping to a black screen makes a good transition between sequences.

Create a wipe by programming a series of dissolves of the same length separated by a shorter time interval. For example, you might use a 2-second dissolve followed by a 1/2-second wait on each screen area, progressing from left to right.

Direction of Movement. Should pictures be added from the left to the right, or the opposite? Should images build from the bottom to the top? Does the audience interpret images differently if they are shown on the right side of the screen or the left? Good ques-

tions. In our culture, we read from left to right, and images are "read" more easily if they move across the screen in that way. But, to make a strong point, move the images from right to left.

If you're adding images progressively across the screen, it's well to do so several times rather than once. Decide how you're going to direct the viewers' eyes. After you've guided their attention from the left of the screen to the right, are you going to leave it there and present other images on the right while letting the left go black? Will you move the images back to the left? By making screens black or by changing images in one area, you direct the viewers' attention.

Some research indicates that viewers respond differently to visuals presented on left and right screens. They are more receptive to inactive subjects and familiar objects when they are on the left; they seem to prefer active material and unfamiliar subjects to be on the right.

Visual Choreography and Storyboarding. Button-pushing is only one facet of programming your show. An even more important part is the design: planning the images you want, the screens you want to show them on, and the way they are to move. Obviously, the images themselves do not move; the viewers' eyes move. And you determine the movement by controlling the placement of the images on the screens. You plan the patterns, the arrangement, and the direction. Because it's almost like dancing, it's often referred to as visual choreography.

Design the effects and movements of the show before you take the photographs. You'll need to know the general patterns of movement and the effects you want to use. You'll make refinements afterward, especially when you do the actual programming and discover something that works especially well or realize that a planned effect wasn't all you hoped for. Plan as thoroughly as

you can, envisioning what the images will look like on the screen. Allow sufficient time if you have a deadline.

Next, buy or make some storyboard sheets. You can use an empty slide mount as a template to trace the outline of a screen area. Simple shows are easy to represent by making a rectangle for each projector. When you use two or three projectors, you may want the rectangles to represent each screen area. You also need to show which projector is changing. You can use dotted lines to indicate overlapping projectors on one screen. The following suggestions are based on what slide makers have found helpful. Figure 1 is a storyboard sheet suitable for two screen areas with butted images, the two-screen butt format. Figure 2 is used with four projectors. Projectors with overlapped rather than butted images—two-screen overlap format—can be represented by figures 3 and 4. Figures 5 and 6 show storyboard sheets for three and six projectors. Each small rectangle in the middle of some of the storyboard sheets represents a group of projectors. By filling in the circles, you can indicate which projector is changing.

A storyboard sheet for the two-screen butt format, with areas for sketching the images and describing the rate and duration of slide changes.

A storyboard sheet for the two-screen butt format with four projectors. The circles can be marked to show which projector is changing.

A storyboard sheet for the two-screen overlap format with two projectors.

A storyboard sheet for the two-screen overlap format with four projectors.

A storyboard sheet for the three-screen butt format for three projectors.

A storyboard sheet for the two-screen butt, center-overlap format for six projectors.

There are other ways of laying out storyboards, and you may want to devise your own system after you've had some experience in producing a multi-image show. It's important that you have a very detailed plan on paper.

Let's take an example of how the system works with a two-screen butt, center overlap arrangement using six projectors. There are left, center, and right banks, each with two projectors. (You can adapt this for other configurations.) Here's what the notations mean in this illustration. The number in the upper right indicates what array of slides is on the screen. Each cue change indicates another array, although some of the slides may be holdovers from the previous array.

Next, the rectangles that look like traffic signals, in the middle of the page, indicate which projectors are changing. The circles are filled in to show which projector lamps will be on at the end of each cue. Written notations explain the specifics about the slide change, such as, "Wait two seconds; then use a three-second dissolve." Narration and comments about the music can also go in this space. On the left are notes of what will be on the screen. Sometimes a written description is faster; sometimes a sketch is clearer. You need to make a sketch to show any masking of a slide.

The small squares under each screen rectangle are helpful when you put the slides on the illuminator and then into the trays. Each square represents a projector bank—left, center, right—and indicates which lamp is on. The first number shows whether projector one or two has its lamp on; the second number represents the tray slot the slide is in. Therefore, "2-1" means the first slide in projector two is being shown, and "1-15" means the fifteenth slide in projector one is on the screen.

Make sure to alternate between projectors one and two. Note that when there is a "hold," the slide does not advance, so you do not need another tray slot. This is why some of the squares

have no numbers marked in them. Also, when a screen area is to go black, most programmers fade down the projector lamp and hold the slide in position. If yours doesn't, put a blank slide into the tray slot. Because of the holds, some trays have fewer slides than others.

This is just an idea of how to lay out the puzzle before you solve it.

Learn the capabilities of your programming equipment, diagram your setup, and assign images to the appropriate projectors. Put all the storyboard sheets together in a looseleaf notebook; this will be your "show book." Think logically and be organized. That's the secret. You may be working with hundreds of slides, and you must know where they belong.

This is how an actual storyboard sheet would look for a show using the two-screen butt, center-overlap format.

These pictures correspond to the storyboard sheet opposite.

Registration. A frequent need in multi-image is to have images coincide precisely on the screen—in registration. This is necessary for dissolves, animation, and positive and negative masks in superimposed slides.

Special cameras can put the center of the image in the same place in relation to the film's sprocket holes and will do this reliably picture after picture. These pin-registered cameras have small protrusions (pins) that engage the sprocket holds and nudge the film into the exact position. But ordinary off-the-shelf cameras sometimes do the job very well. (Old Nikon F-2 series cameras were often good in this respect.) To help hold the film in position, tighten the film by turning the film-rewind crank until you feel tension.

Along with the pins in the camera, you need slide mounts that have pins. Those made by Wess, Gepe, and Kaiser are the best known. Especially useful is the NR system from Wess. This allows you to put slides into registration manually when they were made under nonregistered (NR) conditions. Finally, you need projectors that push each slide into exactly the same position as the preceding one. Ektagraphic projectors do this; Carousels do not.

You can achieve registration, from camera to projectors, but at a considerably higher price than ordinary equipment. Unless you're making a serious commitment to multi-image, plan your shows so registration is not critical.

This hard-edge panorama covers two or three screen areas.

The original slide used to create the soft-edge panorama below.

Stokes Slide Services cropped and duplicated the original slide into these three separate images and sandwiched them in seamless masks.

The small protrusions on the Wess slide mount are pins that engage the sprocket holes on the film.

This is how the completed soft-edge panorama looks on the screen.

Panoramas. Panoramas—wide views of a subject that cover two or three screens—can be breathtaking. There are two types. In a hard-edge panorama, the images don't quite meet, leaving a narrow black border between adjacent images. A soft-edge panorama shows no demarcation between the images and looks like one continuous picture.

Making hard-edge panoramas is uncomplicated. Put your camera on a tripod, making sure it's level. Check with a bubble level. Center the camera on your subject, look for a landmark on the extreme left of the viewfinder, and take the picture. Rotate the camera to the left, lining up the right edge of the viewfinder with the landmark, and take another shot. If the lighting stays the same between exposures and the camera is perfectly level, the shot will look great on the screen. Any imperfections in matching the edges will go unnoticed because of the black borders between the images.

Soft-edge panoramas are projected with three projectors with two side by side images and one image overlapping in the middle. To make the images, do the following. Duplicate a slide so you have a right, a left, and an overlapping center section. Sandwich these images with special soft-edge masks. These masks are dense at the edge and feather out until they are clear. You can buy these directly from the manufacturers (see the list of suppliers).

You must be able to rephotograph your original slide so one image is centered over the line dividing the halves, and you must allow for the slide mount's hiding a bit of the picture. This can be tricky. I suggest sending slides to a lab that does such work, as Stokes Slide Services did for me.

What you may want to do yourself is take a set of soft-edge masks and sandwich them with three different—or identical—pictures. This will create an effective soft-edge, wide-screen montage.

Another way to make a panorama is to use a special anamorphic lens made by Schneider. Put the lens on your camera; it squeezes all the images so they appear tall and slender. Take that same lens and attach it to the projector. When you do, it will expand the pictures and project them 1 1/2 times as wide as they are high.

Editing and Organizing the Tray

Editing your slides and putting them into slide trays should progress smoothly if you've logged the slides on your storyboard sheets. The following is for the six-projector, overlap format. (You can adapt this to simpler shows.)
1. On your slide illuminator, run strips of masking tape vertically from top to bottom, allowing about 4 inches between the strips.
2. Next, lay out the slides exactly as they appear on the storyboard sheets. Use a black slide if you know the programmer requires it.
3. Work with short sequences while editing, perfecting one before you go on to the next.
4. Be willing to plan, to use trial and error, and to make changes.
5. Mark each slide's mount with a number corresponding to the storyboard.

Ektagraphic seamless slide masks for three-projector panoramas.

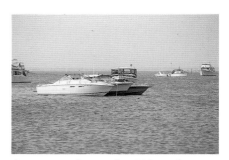

A picture taken with a 200mm lens.

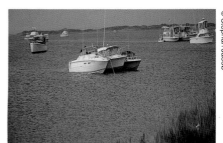

A picture taken with an anamorphic lens, which causes horizontal compression.

© Stephan Jacob

6. Label the trays L1, L2; C1, C2; R1, R2, and so forth. Since other people may use a different numbering system, make sure the person setting up your show presentation is aware of your coding system.

7. Load *just one* tray at a time. If you start with the L1 tray, take slide L1-1 and put it in the first slot; then do L1-2, L1-3. . . . When it's full, do the L2 tray, and so on.

8. Work slowly and methodically, rotating the slides so they're in the proper orientation in the tray. If you've done your preliminary organization and numbering carefully, this part should go flawlessly.

The Presentation

Multi-image presentations have requirements like those of other slide presentations—plus a few more. You need a large, sturdy table to spread all your equipment on. Try draping it with fabric so it looks neat from the front. Make the projectors rock steady. You also need projector racks for stacking each bank of projectors.

You need sufficient electrical current. One or two projectors won't draw much current, but a group of them does. The power must be uninterrupted; it must be dedicated solely to your equipment. To determine the electrical requirements—which is probably marked on each piece of equipment in watts rather than amperes—you need to know the total number of amperes. Remembering basic physics, *watts divided by line voltage equals amperes*. Commit this to memory. For the projector that requires 400 watts,

$$\frac{400 \text{ watts}}{110 \text{ volts}} = 3.64 \text{ amperes}.$$

Add the amperes for all the equipment. Count slide projectors, dissolvers, programmers, the tape deck, and the sound system. Obviously, you can't expect to run an elaborate show on a 15-ampere household line, especially when you must plug synchronous equipment into a common power source.

Aligning and registering the projectors is important to making the special effects successful. You need an alignment slide, such as that discussed on page 124, in the last slot of each tray. This is how to use them. First, position the stand so the center projector is at the same level as the center of the screen if you're using three projectors in a stand. Cycle the slide trays so the alignment slides drop normally into the projector gates. Next, starting with the projector closest to the center of the screen, adjust it so the image is in its approximate position. Adjust the lens for image size if you're using a zoom lens (though it's best not to) and focus it. Make the alignment of the projector precise. From this point on, do not touch or refocus the lens. One at a time, align each of the other projectors to the first one, adjusting their positions so the projected lines coincide. As a final check, turn on all the projectors.

Here are some final pointers:
• The longer the focal length of the lenses and the farther the projectors are from the screen, the less trouble you'll have with keystoning.
• Tray bands can be helpful in a multi-image show. Since you'll be standing behind the projectors, arrange the tray bands so the number "1" on the band faces you when the first slide is in the projector gate.
• Rehearsal is important. It's best to do this in the room where you'll be giving the show. If you must rehearse elsewhere, it is crucial that you use the same equipment during rehearsal as for the performance.

• Check everything before the audience arrives: trays on the proper projectors and in the right position, dissolve modules and programmer controls set correctly, volume level adjusted for optimum sound. Turn on all the equipment to see that it's operational and is not overloading the circuits. Make sure you have your flashlight and a copy of the script.

This really has been just an overview of multi-image presentations. You can learn more about this ultimate way of making slide presentations if you consult the books listed in the bibliography. But you'll learn most by loading your slides into projectors and designing a spectacular show.

It's Show Time

A day at the zoo or a month-long vacation in the Orient, 20 slides or 420 slides, one projector or nine—no matter how simple or complex your presentation is, a slide show can be a marvelous experience for you and your friends, relatives, or colleagues.

Not every presentation has to be elaborate, with synchronized dissolves and music. But remember: your slides deserve to be selected and organized carefully rather than being chosen more or less haphazardly.

If you follow the suggestions in this book, sitting within range of your projector will be a treat. Go beyond what's included here. Try unusual screen surfaces, such as balloons or odd-shaped foam board panels, or three screens placed next to each other at 45° angles. Gather weird or poorly made slides and couple them with a humorous commentary. Begin with a recorded dramatization and illustrate it with slides. Use your projector to bring your imagination to life. The best part of taking pictures is showing them.

List of Suppliers

AERIAL IMAGE TRANSFER
875 Ave. of the Americas
New York, NY 10001
Slide-to-videotape transfer

AMERICAN PROFESSIONAL
EQUIPMENT CO.
4243 Henderson Blvd.
Tampa, FL 33629
Projector racks

AMX CORP.
11999 Plano Rd.
Dallas, TX 75243
Wireless projector controls

APOLLO AUDIO-VISUAL
60 Trade Zone Ct.
Ronkonkoma, NY 11779
Photographic fluorescent lamps, screens

ARGRAPH CORP.
111 Asia Pl.
Carlstadt, NJ 07072
Projectors, slide duplicators, slide mounts, wireless projector controls

ARION CORP.
701 S. Seventh St.
Delano, MN 55328
Dissolve controls, programmers, tape recorders with built-in synchronizers

EMIL ASCHER MUSIC, INC.
630 Fifth Ave.
New York, NY 10020
Copyright-free music and sound effects

ASSOCIATION FOR MULTI-IMAGE
8019 N. Hines Ave., Suite 401
Tampa, FL 33614
Alignment slides

AUDIOTRONICS CORP.
7428 Bellaire Ave.
N. Hollywood, CA 91609
Dissolve controls, programmers, tape recorders with built-in synchronizers

AUDIO VISUAL LABORATORIES
56 Park Rd.
Tinton Falls, NJ 07724
Programmers

BELL & HOWELL CO.
7100 McCormick Rd.
Chicago, IL 60645
Rear-and front-screen projectors

BENCHER, INC.
333 W. Lake St.
Chicago, IL 60606
Copystands

BESELER PHOTO MARKETING COS.
8 Fernwood Rd.
Florham Park, NJ 07932
Slide duplicators

BOGEN PHOTO CORP.
17-20 Willow St., P.O. Box 712
Fair Lawn, NJ 07410
Copystands, slide duplicators

BRETFORD/KNOX MFG. CO.
9715 Soreng Ave.
Schiller Park, IL 60176
Lightboxes and light tables, screens

BRUMBERGER CO., INC.
1948 Troutman St.
Flushing, NY 11385
Slide-storage boxes

BUHL OPTICAL CO.
1009 Beech Ave.
Pittsburgh, PA 15233
Projector lenses, projector racks

CALIFONE INTERNATIONAL INC.
21300 Superior St.
Chatsworth, CA 91311
Tape recorders with built-in synchronizers

CARTWOOD PRODUCTS INC.
714 Highland Ave.
Charlottesville, VA 22903
Lite-A-Page lightbox

CHIEF MFG.
14310 Ewing Ave. S.
Burnsville, MN 55337
Projector racks

CLEAR LIGHT
123 Second Ave.
Waltham, MA 02154
Dissolve controls, programmers

COAST PHOTO MFG. CO.
118 Pearl St.
Mt. Vernon, NY 10550
Slide-storage boxes

COMCORPS
711 Fourth St.
Washington, DC 20001
Slide-duplication laboratories, word slides

CORELLI-JACOBS FILM MUSIC
25 W. 45th St.
New York, NY 10036
Copyright-free music and sound effects

CREATIVE MEDIA
P.O. Box 582
Glen Rock, NJ 07452
Title-slide-making kits

CREATRON INC.
504 Cherry La.
Floral Park, NY 11001
Programmers, projection and slide-making accessories, rear- and front-screen projectors, sound projectors

CRESTRON ELECTRONICS INC.
101 Broadway
Cresskill, NJ 07626
Dissolve controls, wireless projector controls

DA-LITE SCREEN CO.
State Rd. 15 N., Box 137
Warsaw, IN 46580
Projector racks, screens

D.O. INDUSTRIES
317 E. Chestnut St.
East Rochester, NY 14445
Projector lenses, wireless projector controls

DOUBLE M INDUSTRIES
P.O. Box 14465
Austin, TX 78761
Copystands, slide duplicators

DOVER PUBLICATIONS
180 Varick St.
New York, NY 10014
Clip art

DSC LABORATORIES
3610 Nashua Dr.
Mississauga, Ontario L4V 1L2 Canada
Shaped masks

DUKANE CORP.
2900 Dukane Dr.
St. Charles, IL 60174
Projectors, rear- and front-screen projectors, tape recorders with built-in synchronizers, wireless projector controls

DW VIEWPACKS, INC.
113 W. 85th St.
New York, NY 10024
Slide-filing pages

EASTMAN KODAK CO.
343 State St.
Rochester, NY 14650
Blank slides, panorama masks, programmers, projection and slide-making accessories, projector lenses, projectors, rear- and front-screen projectors, slide-duplication, slide-editing equipment, slide mounts, special purpose film, synchronizers

EDMUND SCIENTIFIC CO.
101 E. Gloucester Pike
Barrington, NJ 08007
Projection and slide-making accessories, screens

*Also available with glass and pin registration

ELDEN ENTERPRISES
P.O. Box 3201
Charleston, WV 25332
Lightboxes and light tables

ELECTROSONIC SYSTEMS
6506 City West Pkwy.
Minneapolis, MN 55344
AV tape recorders, dissolve controls, programmers, projector lenses, tape recorders with built-in synchronizers

ELMO MFG. CO.
70 New Hyde Park Rd.
New Hyde Park, NY 11106
Projector lenses, projectors

EMDE PRODUCTS
P.O. Box 10041
Torrance, CA 90505
Slide mounts

FOSTEX CORP. OF AMERICA
15431 Blackburn Ave.
Norwalk, CA 90650
AV tape recorders

FRANKLIN DISTRIBUTORS
Box 320
Denville, NJ 07009
Slide-filing pages

FREESTYLE SALES
126 Sunset Blvd.
Hollywood, CA 90027
Special purpose film

FROELICH FOTO VIDEO
6 Depot Way
Larchmont, NY 10538
Slide-to-videotape transfer

GENERAL AUDIO-VISUAL
333 W. Merrick Rd.
Valley Stream, NY 11580
Projector racks, rear- and front-screen projectors, tape recorders with built-in synchronizers

GENERAL ELECTRIC,
LAMP BUSINESS DIV.
Nels Park
Cleveland, OH 44112
Photographic fluorescent lamps

GEPE, INC.
216 Little Falls Rd.
Cedar Grove, NJ 07009
*Slide duplicators, slide mounts**

GTI GRAPHIC TECHNOLOGY
211 Dupont Ave., Box 3138
Newburgh, NY 12550
Lightboxes and light tables

HEINDL & SON
Box 150
Hancock, VT 05748
Lightboxes and light tables, shaped masks, slide mounts

KARL HEITZ, INC.
P.O. Box 427
Woodside, NY 11377
Copystands, slide duplicators, slide mounts

HP MARKETING CORP.
216 Little Falls Rd.
Cedar Grove, NJ 07009
Copystands, lightboxes and light tables, projectors, slide duplicators, slide mounts

HUDSON PHOTOGRAPHIC INDUSTRIES
2 S. Bukhout St.
Irvington-on-Hudson, NY 10533
Blank slides, screens

IDEA ART
740 Broadway
New York, NY 10003
Clip art

IMAGE CONCEPTS
2575 N.E. Kathryn St., #16
Hillsboro, OR 97124
Special effect slides

IMPACT COMMUNICATIONS
9209 Markville Dr.
Dallas, TX 75243
Copystands, slide duplicators, synchronizers

INSTANT IMAGE FILMS, INC.
4350 Artesia Ave.
Fullerton, CA 92633
Bubble film

KEYSTONE FERRULE & NUT CORP.
909 Milwaukee Ave.
Burlington, WI 53105
Slide-storage boxes

KIMAC CO.
478 Long Hill Rd.
Guilford, CT 06437
Blank slides

KIMCHUK INC., AV DIV.
Corporate Dr.
Danbury, CT 06810
Dissolve controls, wireless projector controls

KINEX CORP.
34 Elton St.
Rochester, NY 14607
Copystands

THE KINNEY CO., INC.
P.O. Box 1229
Mt. Vernon, WA 98273
Shaped masks

KLEER-VU PLASTICS CORP.
Kleer-Vu Dr.
Brownsville, TN 38012
Slide-filing pages

LASER COLOR LABORATORIES
Fairfield Dr.
West Palm Beach, FL 33407
Special effect slides

LEEDAL, INC., MATRIX DIV.
1918 S. Prairie Ave.
Chicago, IL 60616
Copystands, lightboxes and light tables, slide duplicators, slide-filing pages

E. LEITZ, INC.
Link Dr.
Rockleigh, NJ 07647
Projector lenses, projectors, slide mounts

LUMINOUS PRODUCTIONS
19 W. 21st St.
New York, NY 10010
Panorama masks, shaped masks

LUXOR CORP.
2245 Delanu Rd.
Waukegan, IL 60085
Lightboxes and light tables

PAUL I. MANN
137 Temple St.
W. Newton, MA 02165
Slide-storage boxes

MAST DEVELOPMENT CO.
2212 E. 12th St.
Davenport, IA 52803
Wireless projector controls

MAXIMILIAN KERR ASSOCIATES
2040 Highway 35
Wall, NJ 07719
Background slides, copystands, projection and slide-making accessories, shaped masks, slide duplicators

MEDIA EQUIPMENT INC.
7326 E. 59th Pl.
Tulsa, OK 74145
Projector racks

JOSHUA MEIER CORP.
7401 West Side Ave.
North Bergen, NJ 07047
Slide-filing pages

MILLERS/SOUNTAGE
1896 Maywood Rd.
South Euclid, OH 44121
Dissolve controls

NEGAFILE SYSTEMS
Edison-Furlong Rd., Box 78
Furlong, PA 18925
Slide-filing pages, slide-storage boxes

NETWORK PRODUCTION MUSIC
4439 Morena Blvd.
San Diego, CA 92117
Copyright-free music and sound effects

OMNIMUSIC
52 Main St.
Port Washington, NY 11050
Copyright-free music and sound effects

OPTICAL RADIATION CORP.
1300 Optical Dr.
Azusa, CA 91702
Projector lenses

OPTISONICS HEC CORP.
1802 W. Grant Rd., #101
Tucson, AZ 85745
Dissolve controls, programmers, tape recorders with built-in synchronizers

OSRAM
Jeanne Dr.
Newburgh, NY 12550
Rear- and front-screen projectors

PACIFIC MICRO SYSTEMS
160 Gate 5 Rd.
Sausalito, CA 94965
Programmers

PAKON INC.
106 Baker Technology Plaza
Minnetonka, MN 55345
Slide mounts

PERFECT PAN MASKS
369 Seventh Ave.
New York, NY 10001
Panorama masks, shaped masks

PHOTO AND VIDEO ELECTRONICS
1620 Hillside Ave.
New Hyde Park, NY 11040
Projectors, sound projectors

*Also available with glass and pin registration

PHOTOFILE
Box 123
Zion, IL 60099
Slide mounts

PHOTO SYSTEMS INC.
7200 Huron River Dr.
Dexter, MI 48130
Copystands, projector lenses, slide duplicators

PIC-MOUNT CORP.
40-20 22nd St.
Long Island City, NY 11101
Slide mounts, slide-storage boxes

PLASTIC SEALING CORP.
1507 N. Gardner St.
Hollywood, CA 90046
Slide-filing pages

POLAROID CORP.
549 Technology Sq.
Cambridge, MA 02139
Copystands, slide mounts, special purpose film

PORTER'S CAMERA STORE
Box 628
Cedar Falls, IA 50613
Copystands, lightboxes and light tables, panorama masks, projection and slide-making accessories, projectors, rear- and front-screen projectors, screens, shaped masks, slide-editing equipment, slide-filing pages, slide mounts, slide-storage boxes, special purpose film, wireless projector controls

PRINT FILE, INC.
Box 100
Schenectady, NY 12304
Slide-filing pages

QUICKSHOW
P.O. Box 1983
Santa Monica, CA 90406
Slide viewing devices

RADMAR, INC.
1263-B Rand Rd.
Des Plaines, IL 60016
Copystands, slide duplicators

RECORDEX CORP.
1935 Delk Industrial Blvd.
Marietta, GA 30067
Tape recorders with built-in synchronizers

REEL 3-D ENTERPRISES
P.O. Box 2368
Culver City, CA 90231
Stereo slide-making equipment

REYNOLDS/LETERON CO.
13425 Wyandotte St.
N. Hollywood, CA 91605
Title-making equipment

RMF PRODUCTS
1275 Paramount Pkwy., Box 520
Batavia, IL 60510
Dissolve controls, programmers, projector racks, tape recorders with built-in synchronizers

ROSCO LABORATORIES, INC.
36 Bush Ave.
Port Chester, NY 10573
Colored filtering material

SCHNEIDER CORP. OF AMERICA
400 Crossways Park Dr.
Woodbury, NY 11797
Projector lenses

SHARP ELECTRONICS CORP.
10 Sharp Plaza, P.O. Box 588
Paramus, NJ 07652
AV tape recorders, dissolve controls, sound projectors

TIM SIMON, INC.
20 Sunnyside Ave.
Mill Valley, CA 94941
AV tape recorders, programmers, tape recorders with built-in synchronizers

SLIDESCAN
1820 Briarwood Industrial Ct.
Atlanta, GA 30329
Slide-to-videotape transfer

SLIDE SHOOTERS
512 Nicollet Mall
Minneapolis, MN 55402
Slide-duplication laboratories

SMITH-VICTOR CORP.
301 N. Colfax
Griffith, IN 46319
Lightboxes and light tables, slide-storage boxes

SOPER SOUND MUSIC LIBRARY
P.O. Box 498
Palo Alto, CA 94301
Copyright-free music and sound effects

SPIRATONE, INC.
135-06 Northern Blvd.
Flushing, NY 11354
Alignment slides, copystands, dissolve controls, lightboxes and light tables, programmers, projection and slide-making accessories, projector lenses, projector racks, screens, slide duplicators, slide-filing pages, slide mounts, tape recorders with built-in synchronizers

STOKES SLIDE SERVICES
7000 Camaron Rd.
Austin, TX 78761
Panorama masks, projection and slide-making accessories, slide-duplication laboratories, special effect slides

TAMRON INDUSTRIES
24 Valley Rd., Box 388
Port Washington, NY 11050
Projector lenses

TASCAM
7733 Telegraph Rd.
Montebello, CA 90640
AV tape recorders

TELEGRAPHICS
1025 Arch St.
Philadelphia, PA 19107
Panorama masks, shaped masks

TELEX COMMUNICATIONS, INC.
9600 Aldrich Ave. S.
Minneapolis, MN 55420
Projector lenses, projectors, rear- and front-screen projectors, sound projectors, tape recorders with built-in synchronizers

TESTRITE INSTRUMENT CO.
135 Monroe St.
Newark, NJ 07105
Copystands, slide duplicators

TIFFEN MFG. CORP.
90 Oser Ave.
Hauppauge, NY 11788
Programmers, tape recorders with built-in synchronizers

TRF MUSIC, INC.
40 E. 49th St.
New York, NY 10017
Copyright-free music and sound effects

TWENTIETH CENTURY PLASTICS
3628 Crenshaw Blvd.
Los Angeles, CA 90016
Slide-filing pages

THOMAS VALENTINO INC.
151 W. 46th St.
New York, NY 10036
Copyright-free music and sound effects

VERILUX
35 Mason St.
Greenwich, CT 06830
Photographic fluorescent lamps

VISIRULE
P.O. Box 398
Maitland, FL 32751
Slide legibility slide rule

VISUAL HORIZONS
180 Metro Park
Rochester, NY 14623
Alignment slides, background slides, blank slides, copyright-free music and sound effects, lightboxes and light tables, projection and slide-making accessories, projector lenses, projector racks, projectors, rear- and front-screen projectors, screens, shaped masks, slide-editing equipment, slide-filing pages, slide mounts, slide-storage boxes, sound projectors, special effect slides, word slides

VOLK ART STUDIO
Box 4098
Rockford, IL 61110
Clip art

WELT/SAFE-LOCK, INC.
2400 W. 8th La.
Hialeah, FL 33010
Copystands, slide duplicators

WESS PLASTIC, INC.
50 Schmitt Blvd.
Farmingdale, NY 11735
*Alignment slides, panorama masks, projection and slide-making accessories, shaped masks, slide duplicators, slide-editing equipment, slide mounts**

WESTINGHOUSE CORP., LAMP DIV.
Westinghouse Plaza
Bloomfield, NJ 07003
Photographic fluorescent lamps

WILSON & LUND
1533 Seventh Ave.
Moline, IL 61265
Background slides, word slides

FRANK WOOLLEY & CO., INC.
529 Franklin St.
Reading, PA 19602
Polarized animation equipment

WTI CORP.
22951 Alcalde Dr.
Laguna Hills, CA 92653
Alignment slides, panorama masks, shaped masks

ZM SQUARED
903 Edgewood La., P.O. Box C-30
Cinnaminson, NJ 08077
Background slides, copyright-free music and sound effects, word slides

Index